CHRISTIE'S

ART
DECO

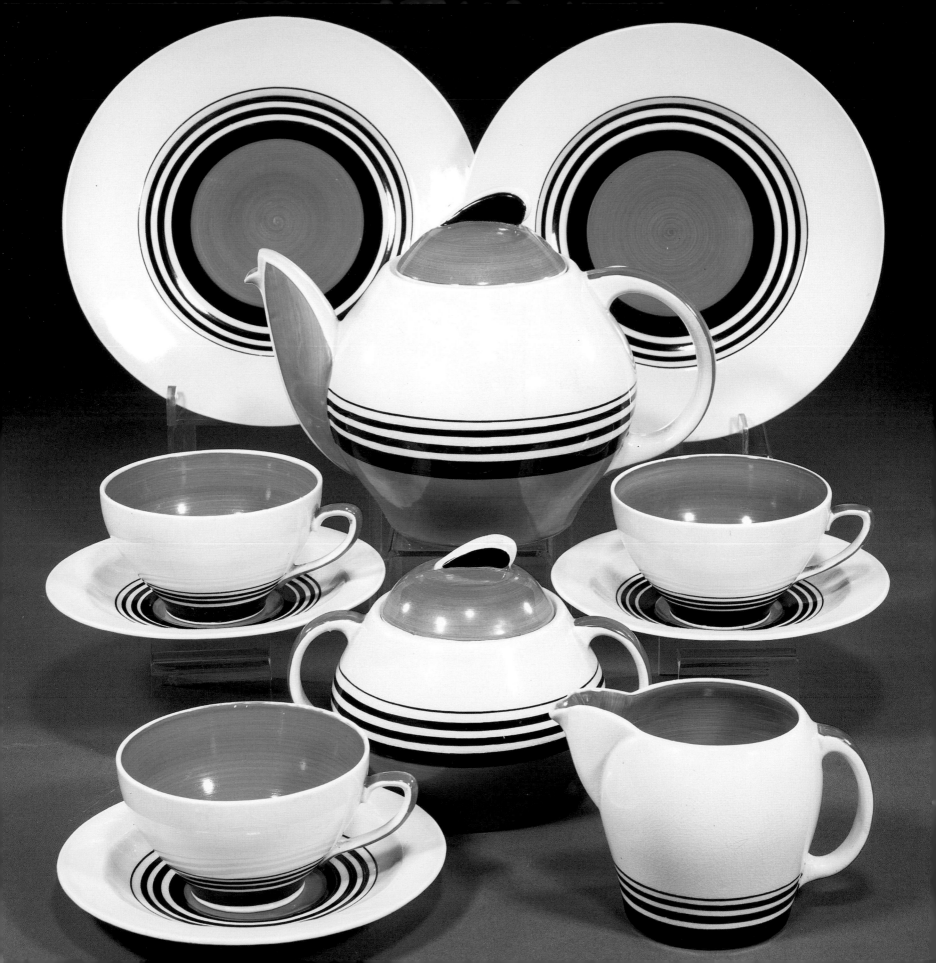

CHRISTIE'S
ART
DECO

EDITED BY FIONA GALLAGHER
CONTRIBUTORS: MICHAEL JEFFERY, SIMON ANDREWS,
AND NICOLETTE WHITE

WATSON-GUPTILL PUBLICATIONS
NEW YORK

First published in the United States in 2000 by

WATSON-GUPTILL PUBLICATIONS

a division of BPI Communications, Inc.

770 Broadway, New York, NY 10003

www.watsonguptill.com

DESIGNED BY: Balley Design Associates

Library of Congress Catalog Card Number: 00-104343

ISBN 0-8230-0643-3

First published in Great Britain in 2000 by

PAVILION BOOKS LIMITED

London House, Great Eastern Wharf

Parkgate Road, London SW11 4NQ

www.pavilionbooks.co.uk

Printed and bound in Italy by Conti Tipocolor

First printing, 2000

1 2 3 4 5 6 7 8 9/07 06 05 04 03 02 01 00

contents

ABOUT CHRISTIE'S

Christie's is a name and a place that speaks of extraordinary art, unparalleled service and international glamour around the world. In 1766, James Christie opened his London auction house and launched the world's first fine art auctioneers.

Christie's reputation was established in its early years, when James Christie's saleroom became a popular gathering place for Georgian society, as well as for knowledgeable collectors and dealers in England. Christie offered artists the use of his auction house to exhibit their works and enjoyed the friendship of leading artists such as Sir Joshua Reynolds, Thomas Chippendale and Thomas Gainsborough, who painted the famous portrait of Christie, now hanging in the J. Paul Getty Museum, Los Angeles. Christie's conducted the greatest auctions of the eighteenth and nineteenth centuries, including negotiating with Catherine the Great the sale of Sir Robert Walpole's collection of paintings, which would form the base of the Hermitage Museum Collection and the five-day sale of the contents of Sir Joshua Reynold's studio. James Christie's salerooms have been a popular showcase for the unique and the beautiful ever since.

Over its long history, Christie's has grown and diversified into the world's preeminent auction house. Christie's currently offers sales in more than 80 separate categories, which include all areas of the fine and decorative arts, collectibles, wine, stamps, motor cars, even sunken cargo. And while it is reputed for selling high-priced works of art, in fact, many of the items offered at Christie's are affordable to even novice collectors. There are hundreds of auctions throughout the year selling objects of every description for aspiring collectors, homemakers, and people simply looking to buy something distinctive and personal.

Christie's sales are held in more than 15 major cities around the world, from Amsterdam to Hong Kong, New York to London. Currently, Christie's growing operations are made up of 119 representative offices, including 16 selling centers, in 41 countries. At all of its saleroom locations, Christie's has a team of auctioneers who are capable of steering any sale.

Christie's success as an auction house is fueled by its two most important assets: renowned expertise and exemplary customer service. Christie's has hundreds of specialists with years of experience evaluating and researching thousands of objects in their respective areas. Many are distinguished lecturers and authors and all have an in-depth knowledge of their particular collecting field.

These specialists research, compile, and produce more than 800 auction catalogs each year. A catalog is a firsthand source of knowledge about your favorite subjects, or your introduction to new areas of interest. Lots, or articles for sale at auction, within a catalog are lavishly illustrated with beautiful photography and detailed descriptions, including provenance, exhibition history, literary reference notes, and estimated selling prices.

Buyers and browsers alike will find that during the auction season Christie's galleries are open to the public without charge, seven days a week, offering changing exhibitions to rival any museum. The public is welcome to examine property and ask questions of Christie's specialists who are always on hand to explain how to buy and sell at Christie's.

Otto Poertzel, **The Aristocrats**, *a bronze and ivory group, 1930s*

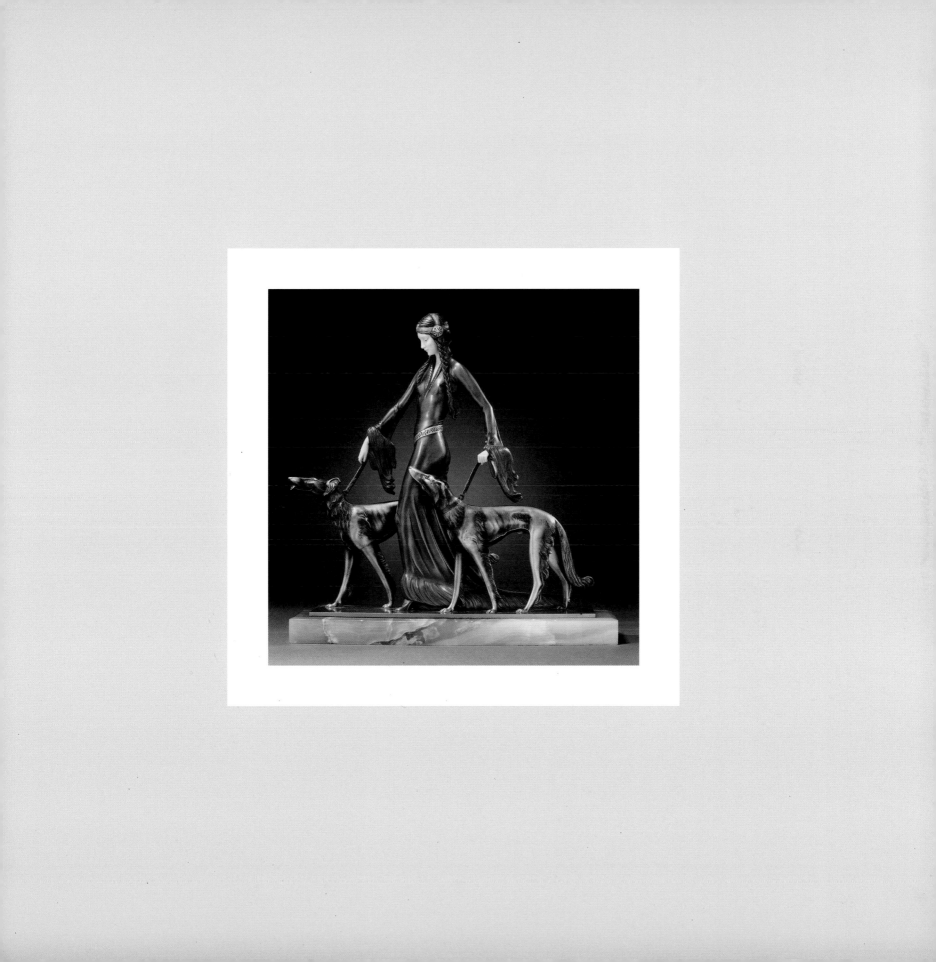

To enter *Christie's Art Deco* is to open a door on a world of vibrant colors and startling bold shapes. It is a world dominated by the desire for speed, luxury, and opulence. It is a world of changing social attitudes where liberated young women drink cocktails, listen to jazz, and dance till dawn. Nicknamed the "Roaring Twenties," it is a world where the chains of the past have been thrust aside and all eyes are raised eagerly to the future.

INTROD

Christie's Art Deco aims to unlock the door for the visitor, whether you are a first-time explorer or a seasoned traveler, and to guide you through the various paths and avenues that lead to what is one of the most important periods of design in the twentieth century. Its impact was felt in every sphere of the decorative arts, from interiors and furniture to ceramics and glass, from graphics and sculpture to metal ware and jewelry. It was international in its outlook, with designers from countries as separate as France, Germany, America, England, Denmark, Belgium, and Russia all contributing to its formation and development.

Often confused with its predecessor, the Art Nouveau style (predominant in the early 1900s), which is characterized by naturalistic and organic forms with sinuous lines and often erotic undertones, the Art Deco style conjures for most a cool, clean vision of interiors with angular forms, stylized figures, exotic woods and materials, linear

UCTION

decoration, and modern simplicity.

It is generally considered to have flourished in the 1920s and 1930s, reaching its zenith in the years between the First and Second World Wars. However, in reality the style was evolving as early as 1900 in reaction to other styles, but it was not until the 1925 Paris Exposition des Arts Décoratifs et Industriels Modernes that it was recognized as a separate movement that was totally detached in terms of intellectual stimulus and interpretation from other styles. The exhibition acted as a showcase for many new designers and interior decorators such as Edgar Brandt, Paul Follot, and Jacques-Emile Ruhlmann and was eventually to lend its name to the produce of this bold new era. Art Deco came into being partly as a fusion of various influences and partly as a deliberate rejection of previous traditional styles.

above: *Paul Follot, a lacquered and giltwood cabinet, circa 1931*

left: *Jean Puiforçat, a silver, vermeil, and rock crystal teapot, circa 1937*

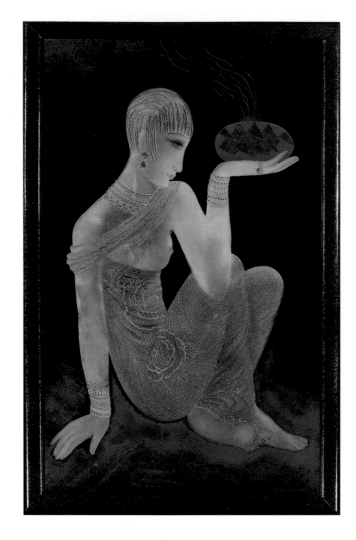

above: *Jean Dunand,*
a lacquer panel,
circa 1925

The finish of the First World War (1914–18) not only ended four years of horror and destruction but also heralded the birth of a new society with changing values and attitudes. Women, so often treated in preceding decades as second class citizens, had demonstrated the extent of their strengths and capabilities by safeguarding the homes and businesses while the men went away to fight. As a result the postwar years saw a new emancipated woman, earning her own money, who was ready to embark on an independent life and break with the traditional constraints of society. Throughout Europe, leading sculptors, artists and designers portrayed her dressed in fashionable clothes engaged in the new leisure activities of the day such as golf and tennis, driving fast cars, or merely smoking a cigarette.

In the United States, the designer Norman Bel Geddes created the Skyscraper cocktail service (1937), which, with its restrained, linear appearance mirrored the new streamlined architecture of New York and other American cities. The new class of nouveau riche increasingly demanded luxurious jewelry and accessories that would complement their newly acquired wealth. French firms such as Cartier, Van Cleef and Arpels, and Georges Fouquet combined

precious and semiprecious metals and stones to produce a range of objects from exquisite

cigarette cases and powder compacts to jewelry, many of which were influenced by Oriental,

Aztec, and Egyptian art.

below: *Goebel, a
pottery figure group,
circa 1930s*

The performing arts provided a constant source of inspiration for designers during the

1920s and 1930s. When *La Revue Nègre* opened at the Théâtre des Champs-Elysées in Paris in

1925, its leading lady, Josephine Baker, very soon became a regular feature in the work of

many artists and designers of the day. The introduction of African art and

culture to the masses left a deep and lasting impression and its influences

were soon reflected throughout the whole sphere of the decorative

arts, from chunky ivory necklaces to stylized figurative motifs on

vases. The widespread public appetite for jazz and dancers

from exotic continents such as India, Russia, or Turkey

inspired a wide range of decorative bronze or ceramic

figures.

Sergei Diaghilev's Ballet Russe, which arrived in Paris

in 1909, bursting with vibrant colors and sound,

preceded the emergence in the art world of the

Fauvists (the "Wild Beasts") with their striking

use of pure color and the Cubists with their emphasis on geometry and streamlining. These influences were quickly absorbed by the leading interior designers of the day.

Increased technological advances in the years immediately following the war marked the dawn of mass communication via newspapers, magazines, advertising, and the radio and cinema. It was the Golden Age of Hollywood where film stars were regarded by their adoring public as icons of good taste and fashion. They were shown wearing stylish clothes and exotic costumes by leading fashion designers and dramatic jewelry by the young avant-garde jewelers of Paris. The actors and actresses were filmed in luxurious interiors filled with macassar ebony, lacquer, or shagreen furniture; although well out of the reach of the average cinemagoer's pocket, their influence eventually filtered through into less-expensive furniture and fittings.

Travel and speed were also dominant features of design and decoration during the Art Deco period. In the 1920s and 1930s there was a tremendous increase in the amount of travel undertaken by all the classes—either by train, car, ship, or plane. The leading designers and artists of the period were commissioned to produce luxurious interiors with

below: *A Jean Dunand lacquer vase, circa 1928*

extravagant furniture and fittings. René Lalique's glass was incorporated in the railway carriages of the French Compagnie des Lits while the interior of the ship liner, the Normandie, which was launched in 1935, was a fusion of murals by Jean Dunand, furniture by Jules Leleu and Jacques-Emile Ruhlmann, silverware by Georg Jensen and glass by the firms of Sabino and Lalique.

Under the direction of the architect Walter Gropius, the students of the Bauhaus school in Germany began to reconsider furniture and product design through the use of new or untested materials,

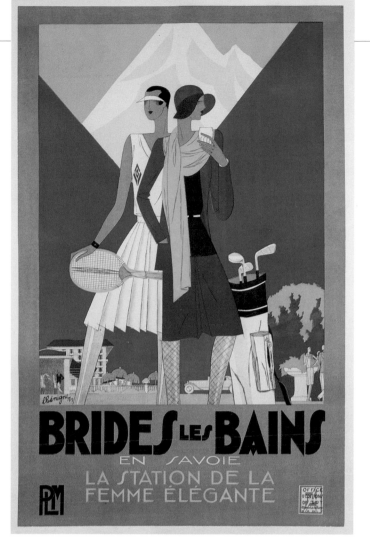

such as tubular steel or glass, and to explore the suitability for mass production of these objects. Their experiments laid the foundations for progressive design throughout the rest of the twentieth century. The Art Deco style, which swept across the world in the 1920s and 1930s, was a vibrant and bold new movement reaching every corner

above: *Leon Benigni,* Brides les Bains **PLM**, *lithograph in colors, 1929*

of the decorative arts. It reflected an advancing society that shook off the cobwebs of the previous century and embraced the twentieth century with a vigor that still vibrates today.

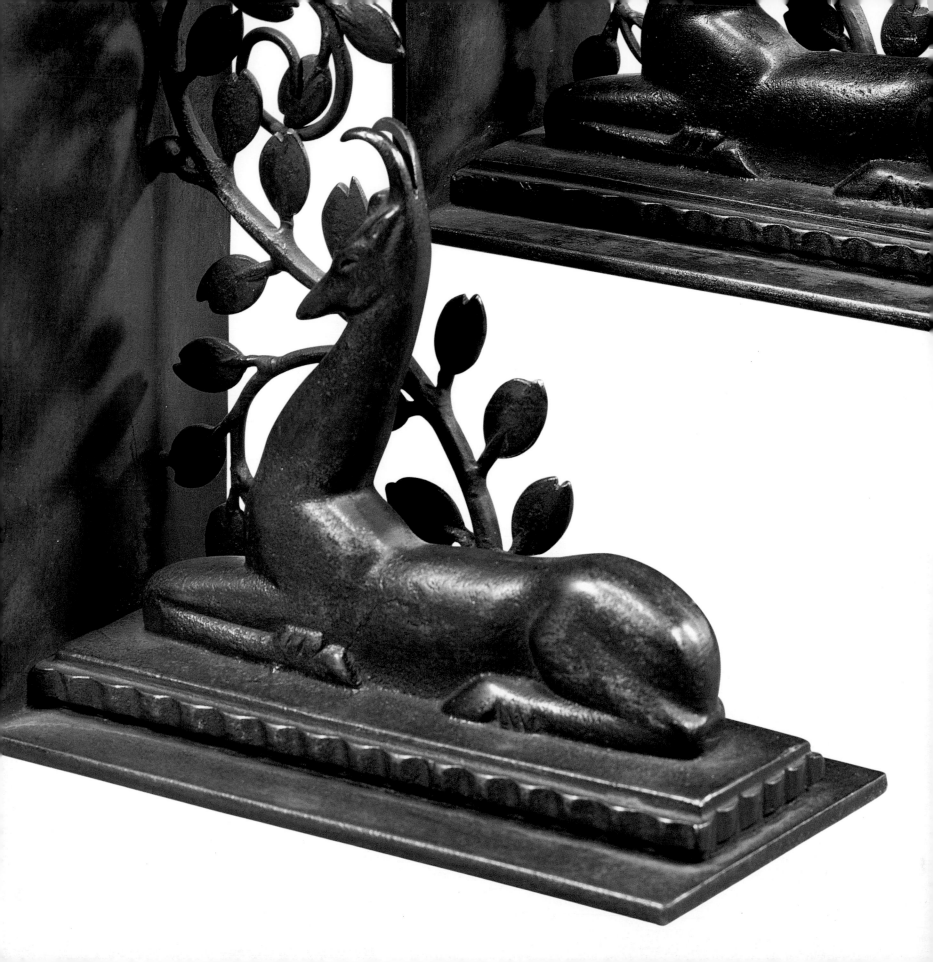

ARCHITECTURAL
DETAILING

chapter one

The Art Deco period of the 1920s and 1930s saw a clear partnership develop among architects, designers, and craftsmen in the production of decorative schemes for the interiors of the new Modernist and Art Deco style buildings and apartments. Interior designers employed furniture manufacturers, metalworkers, ceramic factories, and the textile industry to produce individual items that, when placed together, would create an overall coherent scheme for a room or building. The new breed of Art Deco designers were quick to reject the natural rhythm and flower inspired designs of the Art Nouveau style in favor of a more masculine geometric style that was in keeping with the modern industrial age. There were two contributing strands that, when woven together, helped develop this distinctive stylistic approach. The first stemmed from the

below: *Bagge et Peters, a silvered bronze clock, circa 1920*

ideal of the machine built, mass-produced, essentially modern item, made possible by rapidly developing technology, while the second came from the long tradition of the hand-crafted item made from opulent and expensive materials by the individual artist. As with many major aspects of the Art Deco style, it was the Exposition Internationale des Arts Décoratifs et Industriels Modernes, a commercial exhibition held in the heart of Paris, in 1925, that proved the catalyst for the emergence of the new architectural style. The 1925 Paris Exhibition, although heavily weighted in favor of French designers, was truly international with European, African, and Russian participants all attending. Designers and architects in the 1920s and 30s had become very mobile, producing their work in many different continents and countries, from their native lands to the prosperous and growing cities of the United States of America.

In architecture, as with many fields of the decorative arts, the 1925 Paris Exhibition can be seen as the spark that ignited the new Art Deco style. Following the success of previous international exhibitions, such as 1851 Great Exhibition in London and the 1900 World Exhibition in Paris, it was arranged that the 1925 exhibition would be held in the center of Paris. The exhibition itself was originally scheduled for 1908 but due to the political uncertainty that eventually led to the First World War it was delayed until 1925. Its aim, as set out by its chief designer, the Frenchman Charles Plumet, was an international display of modern avant-garde design. Although calling for completely new design, Plumet himself did not have the benefit of a blank canvas—the site chosen was heavily populated with buildings and monuments—and he was forced to plan the exhibition layout around these preexisting structures.

Walking through the exhibition, with all its different design schemes and architectural visions, it is possible to see how the Art Deco style emerged and gain a glimpse of how it was going to develop. Following on their arrival at the entrance

gates on Place de Concorde, the general public was greeted with eight monumental square pillars and a bronze sculpture by Louis Déjean (b. 1872) of a huge stylized female figure. The pillars were carefully arranged around a series of trees that were cleverly linked into the design by the addition of a series of clipped trees in square planters placed at the base of the pillars. Both sets of trees emphasized the monumental scale of the sculpture and the pillars and their stark simplicity. The main entrance gate, designed by Edgar Brandt, the leading French exponent of wrought-iron metalwork, consisted of a similar construction of fluted columns and wrought-iron fencing. Brandt's original design for the fencing, displaying the popular Art Deco theme of waterfalls, had been for wrought iron but this proved to be too expensive to produce and the fencing was actually executed in a cheaper metal, plated aluminum. Once the visitor had entered the site via the main entrance he or she would have encountered a series of modern-shaped buildings, many of which were produced in the versatile new material of reinforced concrete. A good example was the Pavillon du Tourisme, designed by the French avant-garde architect Robert Mallet-Stevens (1886–1945), which included a clock tower that was visible from most parts of the exhibition site.

The 1925 Paris Exhibition, as well as being a forum for new design, was a commercial venture that saw many companies renting buildings to display and retail their current products. These buildings ranged from small shops, more than 40 being erected on the Alexandre III Bridge alone, to large pavilions named after some of the leading retailers, a country, or a particular product such as perfume.

The Art Nouveau Grand Palais had survived from the 1900 Paris Exhibition and was reused in 1925 to house several smaller stands such as the Pavillon des Parfums Fontanis that was designed by the architectural firm of Raquenet and

above: *Albert Cheuret, a pair of patinated bronze and alabaster table lamps, circa 1925*

Maillard. Most of the leading perfume manufacturers, including Worth, Roget et Gallet, and Isabey, displayed their new range of products in this modern octagonal space crowned with an illuminated waterfall designed and made by the French master glass designer René Lalique (1860–1945). Lalique, who had displayed Art Nouveau jewelry in Paris twenty-five years earlier at the 1900 World Exhibition, had since developed techniques of press molding glass into dramatic three-dimensional designs that were both suitable for architectural fittings and also for the smaller and more precise commercial scent bottles on display. Lalique's glass was extremely popular, and clearly demonstrating the constant interaction between architecture and the decorative arts in the Art Deco period, several of the leading architects commissioned him to create doors, lights, glass panels, and fountains for other buildings at the exhibition. The dramatic Pavillon de Printemps designed by Henri Sauvage (1873–1932) and Wybo rose up as a pyramid from behind a large ironwork gate and was crowned with a glass summit and pierced with small glass window panels set into the tiled walls of the building. These glass panels, designed by Lalique, incorporated a variety of decorative motifs, including stylized flowers, animals, and water, all later classic Art Deco images. The motifs, some of which had been used by the Art Nouveau movement, were now modernized and treated more stylistically as a geometric form of decoration rather than as a living individual item.

right: Edgar Brandt, a wrought-iron fire screen, 1925

Jacques-Emile Ruhlmann (1879–1933), the French furniture designer, was commissioned to organize several pavilions, including the Salon pour une Ambassade and Pavillon d'un Collectionneur, at the 1925 Paris Exhibition. They provided a good opportunity to demonstrate his firm's, the Ruhlmann Group, interior design capabilities. In both buildings he used rich and opulent works of art to create an exotic setting for his own furniture designs and the accompanying furniture and metalwork by Paul Follot (1877–1941), and Jean Dunand (1877–1942). The Ruhlmann Group's Pavillon d'un Collectionneur, designed by the architect Pierre Patout (1879–1965) was dominated by *Les Perruches*, an oil painting by the French painter and poster designer Jean Dupas (1882–1964). The painting, which hung over the fireplace in the music room and depicted nude females holding exotic parakeets, was of a monumental scale. The central ground of the room was filled with a grand piano designed by Ruhlmann, in exotic Macassar ebony and amboyna applied with ivory detailing. The extravagance of *Les Perruches* set off the sophisticated design of the piano and showed how designers and artists were increasingly looking outside their own sphere of the decorative arts, producing work that would complement and accentuate the overall interior scheme. The exterior of the Pavillon d'un Collectionneur was decorated with metalwork by Edgar Brandt and a bas-relief panel by the French sculptor Joseph Besnard (1886–1931). Much of the opulent textiles, furniture, ceramics, and metalwork that were on display in Ruhlmann's pavilions at the 1925 Paris Exhibition were set with prices well beyond the pockets of the majority of the visitors to the exhibition, instead aimed at the visiting ambassadors and international collectors that were drawn to it. Following his success at the exhibition he quickly rose to prominence as one of France's preeminent interior designers. Commissions, such as the prestigious contract for the decorations of the tearoom on board the ocean liner Ile de France and the creation of a *verre églomis* panel for the liner Normandie in collaboration with Jean Dupas, flowed in. Ruhlmann's use of exotic woods and veneers and his skillful employment of leading metalworkers and lacquerists to produce harmonized stylized interiors were perfectly suited to the luxurious tastes of the emerging nouveau riche classes of the 1920s.

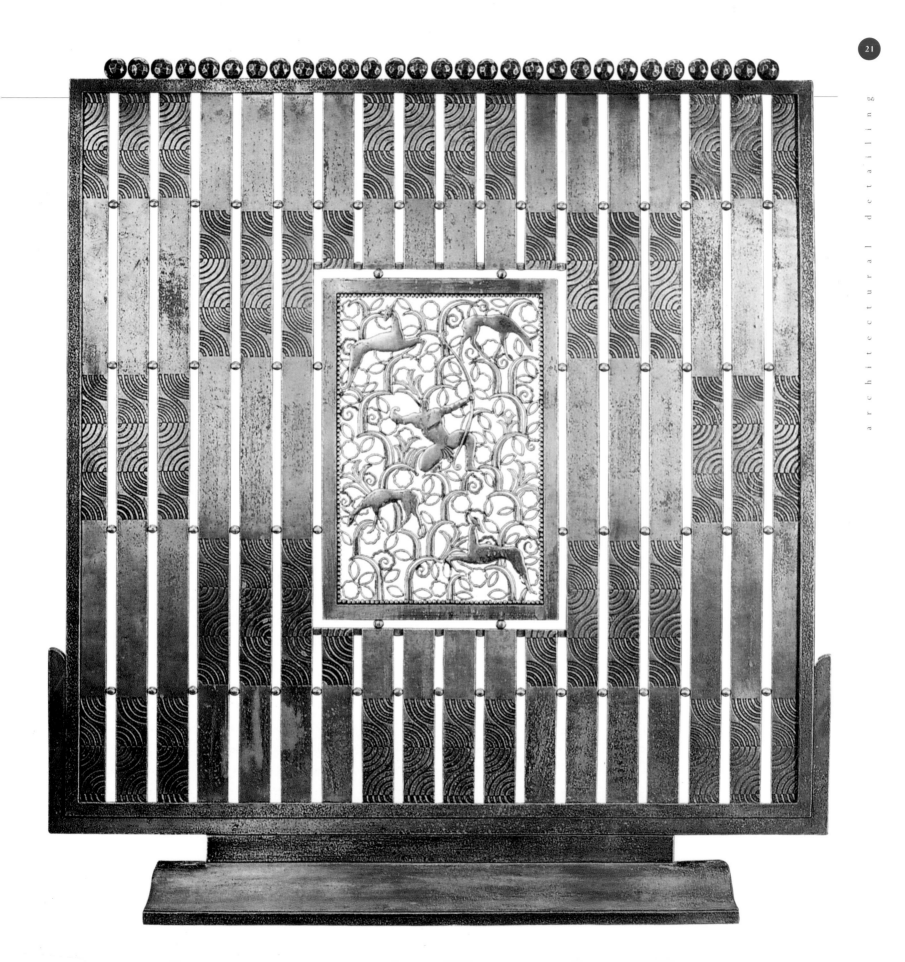

architectural detailing

The interior design work of the Modernist architect Le Corbusier (1887–1965) was in stark contrast to that of his contemporary Jacques-Emile Ruhlmann. He had studied briefly under the German industrial designer, Peter Behrens (1868–1940) in Berlin in 1910 where he had learned some of the problems associated with industrialization. In 1920 he wrote *Towards a New Architecture—Guiding Principles* in which he criticized modern architecture for not producing the primary forms that he deemed were beautiful because they could be clearly appreciated. The house, according to Le Corbusier, was a living, machine-made environment that was designed to be mass-produced as a small but important subset of the city. These ideas were to become the main tenants of Modernist thinking. His Villa Savoye (1928–1931), which he designed and built for Madame Savoye, basically a weekend retreat twenty miles outside Paris, illustrated his fundamental belief in light, open design. Primarily a simple rectangle, the villa was mounted on thin pillars that enabled a motorcar to drive right under and into the heart of the building. A window extending across the width of the building provided natural light to all areas, with the internal levels being linked by open ramps. In this modern house Le Corbusier rethought most

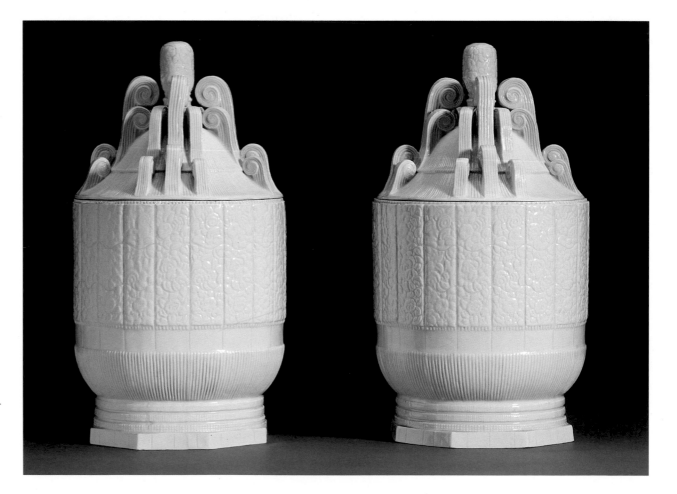

right: *A pair of Sèvres covered urns, designed by Emile Roucheret, 1925*

aspects of conventional house design in order to assimilate it into the age of machine production.

Often taking ideas and inspiration from the design of ships and industrial factories, Le Corbusier was the prime example of the visionary Modernist architect whose principles demanded mass production of all materials and minimal decoration. The 1925 Paris Exhibition gave him the opportunity to illustrate his design theories and ideas. Though not popular with the public and antagonizing the exhibition organizers, his Pavillon de L'Esprit Nouveau, in its use of modern shapes and materials proved inspirational for the next generation of architects, especially those in America. With mass production in mind everything displayed in the pavilion, apart from the Cubist paintings hung on the wall, was to be standard and freely available. The Art Deco period saw Le Corbusier's ideas gradually assimilated, and even in the later opulent interiors of Ruhlmann, it was possible to see the influence of the Modernist style in the use of angular features and flat planes of uninterrupted color.

Edgar Brandt (1880–1960), the French metalworker, had built up a strong core of commissions in the period between 1920 and 1925 and, with his success at the 1925 Paris Exhibition, his market continued to expand. Working in close association with Ruhlmann, producing various architectural fittings for his interior designs, Brandt at his workshop had revived the use of wrought iron as well as steel, aluminum, and other metals that could be patinated in gold, green, or black. He embraced the use of wrought iron for both large and small interior decorative features, from standard lamps to door-plates, incorporating modern machinery to update the medium from its craft tradition. His designs were characterized by open-work stylized flowers interspaced with leaping exotic animals or figures. Mastering the stubborn and awkward raw material also enabled him to produce decorative ironwork suitable for exterior commissions. Quick to develop new

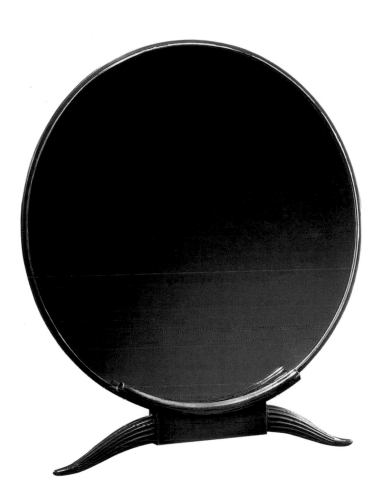

markets, he worked closely with the glassworks of the Daum Frères and to a lesser degree René Lalique, both producing the glass shades for his metal wall, table, or chandelier lights. Daum produced mainly monochrome shades that set off the decorative elements of the metalwork. The shade could sometimes contain a simple color swirl or be molded with a geometric design complementary to the metal fitting, a style that contrasted with the cameo and inlaid glass shades as seen during the preceding Art Nouveau movement.

above: *Antelope, a Jacques-Emile Ruhlmann silvered bronze mirror, 1925*

Following his success at the 1925 Paris Exhibition Brandt opened Ferrobrandt Inc. on Park Avenue in New York. Before

starting his American venture he had already won an important commission to provide the metal fixtures for the Cheney textile store on Madison Avenue in New York. His designs for America were intrinsically linked to the designs supplied to the 1925 Paris Exhibition and included fountains and exotic palm trees as the decorative elements. The popularity of Brandt's work saw the new French fashion for decorative ironwork transfer across the Atlantic. Other American commissions included those from the architects of the new high-rise buildings such as the Madison-Belmont building in New York. The success of these projects in turn encouraged other French designers, such as Raymond Subes (1893–1970) and Paul Kiss (1885–1962), to work in close collaboration with established architects on new American architectural schemes. Brandt also executed fixtures for the Ile de France and Normandie liners.

Lacquer and *dinanderie* were two of the many new decorative mediums that interior decorators employed in the Art Deco period. The leading exponent of these techniques was Jean Dunand, the Swiss metal worker and laquerist, who was a regular exhibitor at the Paris Salons before the 1925 Paris Exhibition, the Exposition Coloniale of 1931 and then in America the 1939 New York World's Fair. After initially working as a traditional sculptor, he developed an interest in the decorative arts through his experiments with copper and brass. His style developed with the inlay of mixed and precious metals into the base metal, a technique known as *dinanderie*, into his designs. His early metal vases and bowls were decorated with simple floral friezes including fir cones and thistles. Dunand's use of lacquer started in 1917 simply as a layer of protection for the mixed-metal pots, but by 1921 he had developed a more decorative lacquer for use on small items of jewelry as well as large architectural panels. As the Art Deco style gained international favor his *dinanderie* work became

right: *Jacques-Emile Ruhlmann, an alabaster, gilt bronze, and black marble lamp, circa 1925*

more opulent with the incorporation of eggshell, silver, and brightly colored lacquer and the geometric designs on his objects made more abstract.

Dunand's commercial and technical success led to his involvement in the 1925 Paris Exhibition as both an exhibitor and as vice president of the class for metalwork. He was in high demand for the most exclusive and expensive projects of the day. At the 1925 Paris Exhibition his larger-scale commissions included the lacquer panel decoration for the smoking room in the French Embassy Abroad pavilion and the lacquer decoration for a Ruhlmann-designed cabinet. The smoking room panels in particular received much critical acclaim and led to numerous commissions after the exhibition had closed, such as Templeton Crocker's apartment in San Francisco. In 1927 he collaborated on designs for the liner Ile de France, which in turn led to commissions on both the L'Atlantique and Normandie. His work for the L'Atlantique consisted of large panels for the entrance hall and dining salon, each depicting exotic birds and animals, the scale being such that Dunand had to extend the size of his workshop. Unfortunately the designs were lost when the ship caught fire and was left to burn in 1933. The Normandie, launched in 1932, was the largest and most lavish liner built— a true floating city. Dunand's commission was to produce panels for the smoking room and sections of the first-class saloon. Despite initially being rejected as too modern, the rooms were decorated in the newly fashionable Egyptian style and depicted fishing, sports, dancing, horse taming, grape picking, and hunting scenes. Dunand's lacquer panels were the ideal decoration for these new luxurious liners in that they covered the total interior wall making it a complete decorative unit, but unlike a hanging picture, could be safely attached to the structure. The advances made during this period in producing high-quality lacquer were equally suited for large panels, folding screens, or smaller items of jewelry and vases, lacquer's

flexibility being best displayed in a series of unique portrait panels that Dunand created for clients such as the actress Josephine Baker in 1927.

Thus France took the lead in championing the Art Deco style in architecture and interior design. Britain followed more slowly and produced a more eclectic product. 1930s Britain saw an extremely diverse range of architectural styles from the neoclassicism to mock-Tudor suburbia, the latter including a string of Art Deco buildings based around the extension of the underground train network in London. The Underground was reaching into the suburbs and the new suburban housing estates produced did not conform to Le Corbusier's idealized vision of concrete and glass. Instead these houses, though designed for mass installation and including features and styling that reflected the clean lines and stylized shapes of the Art Deco movement, relied equally on traditional building methods such as bricks and timber cladding. Works produced for local council and public office often varied considerably in style. The ticket halls for the newly extended underground stations at Uxbridge (1933–34), built by the firm of Adams, Holden, and Pearson, had a huge semicircular forecourt that literally swept commuters into the vast concrete ticket hall and onto the platforms. This scale was in complete contrast to the suburban commuter stations of Ruislip just a few stops along on the Metropolitan line. Here the station was constructed out of brick and timber, with a wooden bridge that echoed the surrounding estates.

The architect Berthold Lubetkin (1901–1990) did, however, develop a more modernist form of architecture in 1930s Britain. His commissions were as diverse as the penguin pool at Regent's Park Zoo, two bungalow houses at Whipsnade Zoo, and Highpoint I and II, tower blocks at Highgate. Built in 1936 of reinforced concrete and glass the bungalows echoed aspects of Le Courbusier's teachings while also taking on the

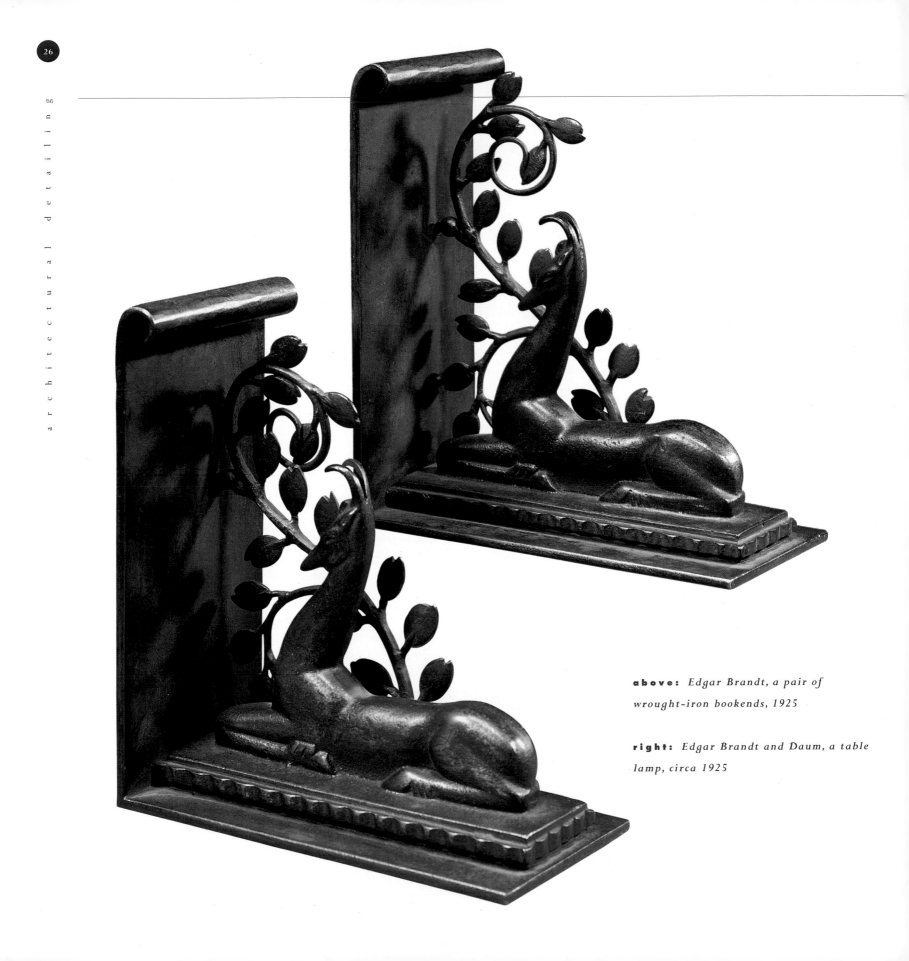

above: *Edgar Brandt, a pair of wrought-iron bookends, 1925*

right: *Edgar Brandt and Daum, a table lamp, circa 1925*

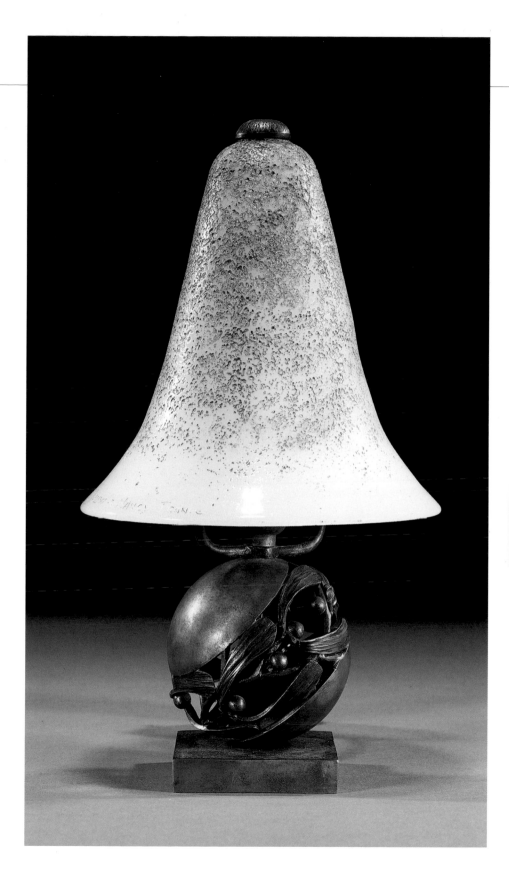

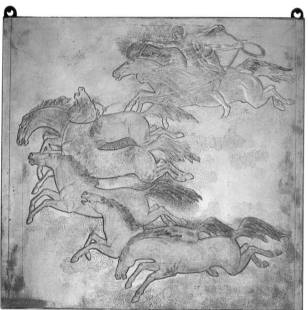

above: *Jean Dunand,* Taming the Horse, *a lacquer panel, circa 1935*

characteristics of ocean liner design; the roof deck, steel ladders, curved concrete suntrap walls, and portholes being present both in the bungalows and the penguin pool. His interiors were light and airy with built-in furniture and complementary bentwood freestanding furniture designs by

below: *Jacques-Emile Ruhlmann, detail of a wool carpet, circa 1925*

Alvar Aalto (1898–1976). Lubetkin's long, expansive windows, reflecting those of Le Courbusier's at the Villa Savoye, created a vast open space with wide vistas. Door furniture was kept minimalist with the cast metal functional designs having no ornamentation.

The spread of the modern architectural style could be seen in the De La Warr pavilion, at Bexhill on Sea, which was designed by Eric Mendelsohn (1887–1953) and Serge Chermayeff (b.1900) between 1933 and 1936 for the Earl De La Warr, a

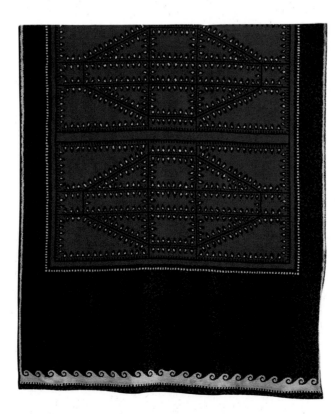

patron who had strong Modernist sympathies. The clean-lined pavilion, with its curved balconies and glass walls, again echoed the ideas of Le Courbusier, but also illustrated the designers' own virtuoso style. Chermayeff had previously, in 1929–30, redesigned the interior of the Cambridge Theatre in London. Here, the preexisting space was modernized with carpets, radiator grilles, a box office façade, and auditorium doors, all using a repeating design of overlapping circles and reflective mirror surfaces.

In 1934 F.R.S. Yorke had published the influential book *The Modern House*. The book was clear in its stylistic approach and highlighted 57 designs from the German architect and designer Walter Gropius (1883–1969) and other prominent European designers. Yorke understood the potential of modern materials and their role in shaping the modern house and living environment. More commercial houses could be seen in the British art magazine *The Studio*, the most dramatic being the Murus House designed by R. Myerscough-Walker A.R.I.B.A. This house, designed to be built in Yorkshire, and based on a circular plan, was classed as an "experiment towards standardization for production in numbers." It was designed around a central stanchion support that housed waste and ventilation shafts, its built-in furniture and outward appearance of three decks with railings and curved external stairs once again reflecting the strong influence of maritime design on contemporary British architects.

The Studio emphasized the use of alternate materials such as Bakelite, chrome, steel, and mirrored glass. These had slowly entered mainstream interior design and could be seen in the modern cocktail cabinets and bars that were produced in the early 1930s. New materials, such as the glass-based Vitrolite, were used to make bright, clean reflective surfaces in permanent colors. These surfaces were durable, easily kept clean and, like the colorful enameled ceramics of the period,

provided brightness in a period of general economic and political gloom.

The greater emphasis during the Art Deco period on complete room design coupled with an overall scheme led to the increased importance of carpets and floor coverings, in some instances becoming the focal point of the interior. Many of the larger Parisian department stores had textile workshops. Galerie Lafayette and Printemps Primavera produced designs by designers such as Paul Follot, while artists such as Fernand Léger (1885–1979) were commissioned to produce designs for tapestries, hangings, or general furnishing fabrics. The larger textile firms, for example Aubusson, commissioned outside designers as well as using their in-house design teams to create new patterns. English artists such as Edward McKnight Kauffer (1890–1954) and Frank Brangwyn (1867–1956) designed work for factories like Templeton's while the American-born Marion Dorn (1899–1964) produced designs for Wilton Royal Wessex in England. The latter's versatile designs were produced as either hand-tufted rugs retailed through department stores or larger-scale industrial carpets for hotels. She created a series of rectangular carpets that contrasted geometric linear designs with interlinking free-flowing motifs for the first-class lounge of the Orion liner in 1935. Dorn's abstract designs were in stark contrast to those of Brangwyn, which, being extremely floral and colorful, occasionally bordered on the chintzy. By the 1930s the color in most textile designs had subsided to more muted tones, complementing both the furniture and the un-settled political climate in mainland Europe.

The 1920s and 1930s, as well as witnessing the construc-tion of many new houses, shops, and offices, saw an explosion in the building of theaters, picture palaces, hotels, and the so-called mobile hotels—ocean liners and long-distance trains. These created new problems for the architects and interior designers but also provided a new challenge to produce work in

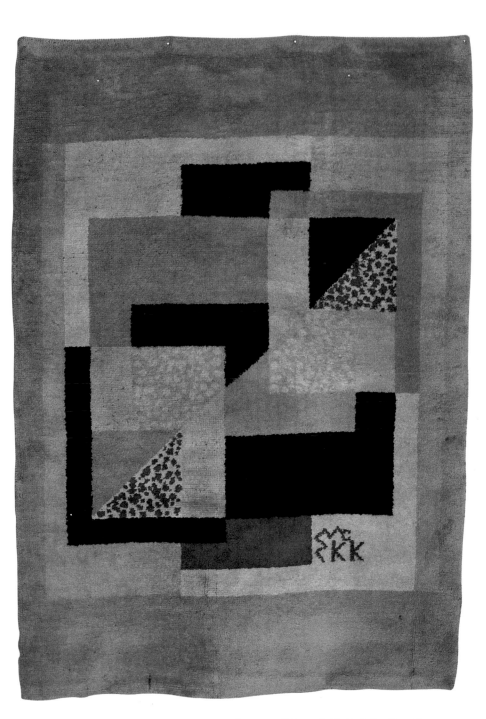

above: *Edward McKnight Kauffer, Wilton hand-knotted woolen carpet, 1929*

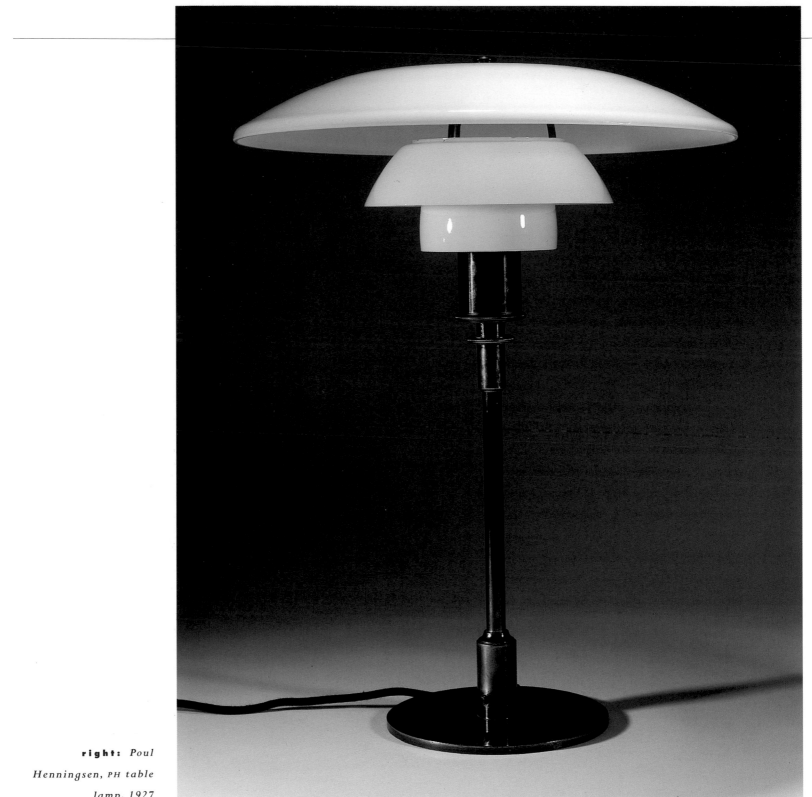

right: *Poul Henningsen,* PH *table lamp, 1927*

keeping with the modern spirit. Britain had introduced a new class of A4 locomotives, designed by Sir Nigel Gresley (b. 1897), in 1935. The Silver Jubilee was capable of speeds of 90 miles an hour, which was accentuated by its sleek, streamlined profile. Later the Coronation locomotives, also designed by Nigel Gresley, in 1937 had fairings covering the gaps between the carriages that increased the train's streamlined bullet-shaped appearance. The exteriors were adorned with chromium plate while the interiors had comfortable swivel chairs in first class and armchairs in second; luxury was the byword of the day. Though the new breed of fast, clean steam trains of the mid-1930s cut down travel time dramatically, they were eclipsed by the record-breaking 126 miles per hour of the Mallard train in 1938. In 1934 the Mercury steam train was introduced in the United States of America, its streamlined form only broken by its visible wheels, a design that was highlighted at night when the wheels were illuminated.

Likewise, on the waves the ocean liners provided luxury accommodation, comparable to that found in the best hotels. The German ships Europa and Bremen and the more familiar Cunard Queen Mary from Britain acted as floating hotels with swimming pools, gymnasiums, and ballrooms. As well as the afore-mentioned larger technological developments the Art Deco period was marked by the introduction of radiators, fans, and electrical household appliances. Just as the trains and liners provided designers with the opportunity to create overall design schemes, so these modern inventions were designed to amalgamate into the stylized modern look through their streamlined shapes and brightly colored or highly polished finishes.

The architect Walter Gropius at the Bauhaus in Dessau, Germany, had similar strong views to those of Le Courbusier in his call for design to be totally unified, from the simplest appliance to the finished dwelling. Much of the designs produced at the Bauhaus never developed past the initial

drawing stage due to the inflationary economy, mass unemployment, and poverty that marked postwar Germany. However, this conflictingly led to increased artistic freedom and the production of futuristic designs such as Ludwig Mies van der Rohe's glass skyscraper design of 1922. His clean-lined, light construction is similar in thought to the purist ideals of Le Courbusier and the Constructivist

below: *Wilhelm Wagenfeld, MT8 black-painted and nickel-plated metal and glass table lamp, 1928*

sculpture of László Moholy-Nagy (1895–1946), but structurally heralded some of the more abstract designed objects of the period such as Maison Desny's designs for lights. Although

designed for cheap mass production Wilhelm Wagenfeld's (1900–1990) table lamp MT8, proposed in 1924, never passed preproduction examples, but with its simple domed shade and cylindrical column it showed the Bauhaus emphasis on industrial design.

America looked to Paris rather than England and Germany for inspiration and, as already discussed, the New York office of Ferrobrandt was a catalyst for the incorporation of metalwork fittings into American interior design. Many American designers took on the challenge to produce metalwork for interior and exterior design after seeing the traveling exhibition of those items originally displayed at the 1925 Paris Exhibition. From the late-nineteenth-century downtown areas of the major east-coast cities had seen a boom in real estate prices. Coupled with the increased use of steel frames, elevators, and the builders' newfound ability to accurately measure stress on materials, between 1922 and 1925 America saw a boom in the construction industry as skyscrapers rose in all the major cities. American architects were influenced by Walter Gropius' Modernist entry for the Chicago Tribune Building and Le Courbusier's influential text "When the Cathedrals Were White" of 1936. As the cities of America flourished the new skyscrapers were proudly seen as displays of corporate wealth and national confidence and, though the 1929 Wall Street crash put a brake on some of these architectural projects, many, due to already signed contracts, went ahead in the 1930s.

Designed by William Van Alen (1883–1954) for William Reynolds, the Chrysler Building's brief was to "pierce the sky not just reach up and scrape it." Chrysler was capped with a seven-storey domed finial surmounted with a steel spire that was soon surpassed by the Empire State Building, designed by William Lamb. The latter was built in less than two years in a somber style reflecting the depressed economic climate of 1929. In contrast the Radio City Music Hall, which was begun in the same year, 1927, and which was housed in the Rockefeller tower, displayed large decorative panels depicting the arts and television in the main entrance hall while outside bronze statues boldly adorned the façade and stood in triumph in the plaza. Oscar Bach, born in Germany, produced metal ware comparable to the French metalworkers of the twenties. He had already received the important commission for the Berlin Music Hall before leaving for America in 1914 where he worked on a number of important

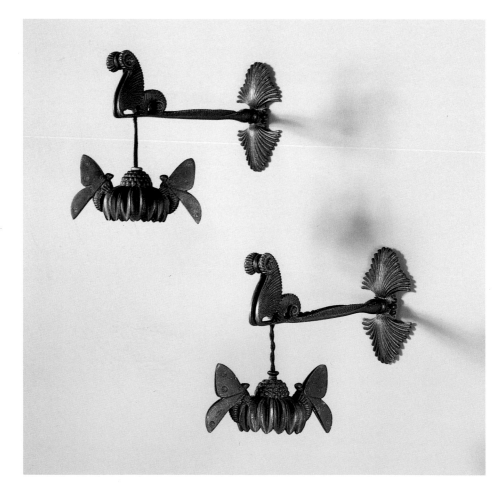

left: *A pair of Armand Albert Rateau patinated bronze wall sconces, circa 1920*

Art Deco buildings in New York City such as the Chrysler and Empire State buildings as well as Radio City Music Hall.

These modern American buildings of the twenties and thirties had no precedent in history and thus required a new style of ornamentation. Aspects were lifted from designs shown in international exhibitions such as the 1925 Paris Exhibition; fountains, sunrays, stylized flowers, and foliage were all regularly employed as subjects for the decoration of entrance halls, elevators, or doorways. E.H. Faile produced polychrome aluminum panels of swans before stylized fountains of water for the entrance of the Goelet building in 1930.

Rich American patrons who had visited the 1925 Paris Exhibition commissioned leading European artists to design specific interiors for their American apartments. Aline Meyer Liebman purchased work by François-Emile Décorchemont, Emile Lenoble, and Armand-Albert Rateau (1882–1938) at the 1925 Paris Exhibition, which she had shipped back to her Fifth Avenue New York apartment. Through Maison Geo. Rouard in Paris and the traveling exhibition at the Metropolitan Museum of Art in 1926, further purchases were made, Ratteau in fact receiving a further commission to design Liebman's bedroom, from wall fittings to carpets.

Throughout the 1920s and 1930s following the general building boom—the development of various architectural styles from skyscrapers to the bungalows of Lubetkin—lighting played an increasingly important role in interior and exterior design. Light could be diffused, direct, or specifically directed through anglepoise lamps and uplighters and was developed by designers to create new atmospheres. René Lalique produced a series of hanging *plaffonier* bowls, molded in clear and colored glass with abstract and floral designs. These designs, like his glass vases and tableware, were often highlighted with

right: *René Lalique, a glass Soleil* **plaffonier,** *1926*

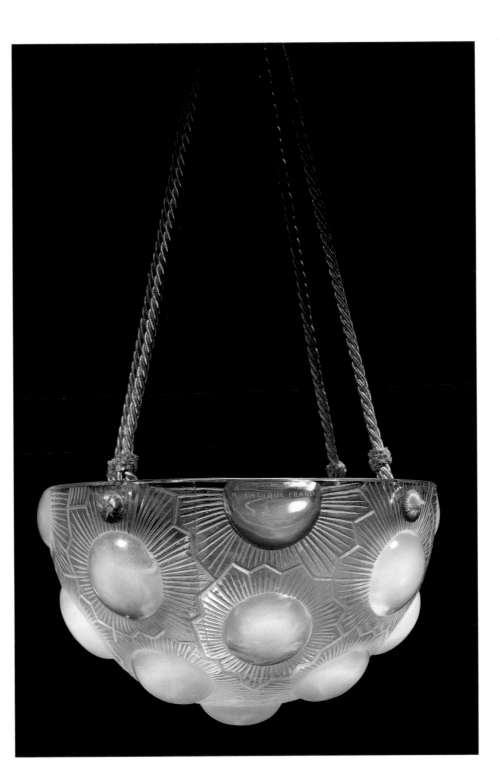

staining and opalescence. Glass table lamps by Daum, Lalique, and the Scottish glass manufacturers Monart often contained lights inside the body of the glass object that heightened the design when lit, and new techniques enabled the creation of illuminated glass sculptures. Bronze foundries, including those of Simonet Frères and Albert Cheret, realized that the increased supply of electricity created a new and lucrative market. Such companies quickly transferred part of their production over to light creation in order to satisfy demand. Originally sculptural in form, these designs soon became more abstract or in some cases futuristic, such as those of the French firm Maison Desny.

In America Walter von Nessen (1889–1943), a refugee from Germany, brought over the Modernist style taught to him

below: Joseph-Gabriel Argy-Rousseau, a pâte de verre *glass and bronze table lamp, 1928*

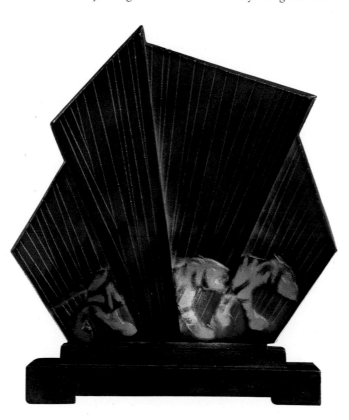

by the German architect Bruno Paul (1874–1968). His table lamps were produced in the modern materials of cast aluminium, glass, and Bakelite, and were modeled as geometric towers where shade and base were intrinsically linked. The designs often incorporated pivoting shades that could cast both direct and indirect light. His diverse and flexible designs led to increased orders throughout the economic recession. Many others designers, including Walter Dorwin Teague (1883–1960), produced streamlined lamps inspired by cars, trains, and the sci-fi adventures of comic-book heroes. These asymmetric pieces such as the folding desk lamp, model number 114, produced in 1939 for the Polaroid Corporation, were often designed for offices or the workplace. Donald Deskey (1894–1989) produced abstract architectural lights to rival those by Maison Desny in Paris. In 1931 Deskey was commissioned to decorate the Roxy Rothafel apartment in modern Radio City Music Hall. An overall scheme of black Bakelite and polished chrome lights was designed to provide brilliance that would contrast with the cherry wood wall panels.

The architecture, architectural detailing, and interior designs developed in the 1920s and 1930s follow a path from the 1925 Paris Exhibition through the Modernist ideals of the late 1920s to the high Art Deco style. The Art Deco style was intrinsically linked to contemporary political and economic changes and reflected the rapidly changing outlook. It developed the use of modern materials and techniques that enabled the construction of such diverse buildings as the skyscrapers of 1929 New York and the reinforced concrete and glass single-storey buildings of the Bauhaus. These new buildings provided new shapes and opportunities for interior designers and the manufacturers of new consumer products such as lights and carpets. The Art Deco interior designers took full advantage of the freedom offered by wealthy patrons and produced a wholly new homogenous style that defined the period.

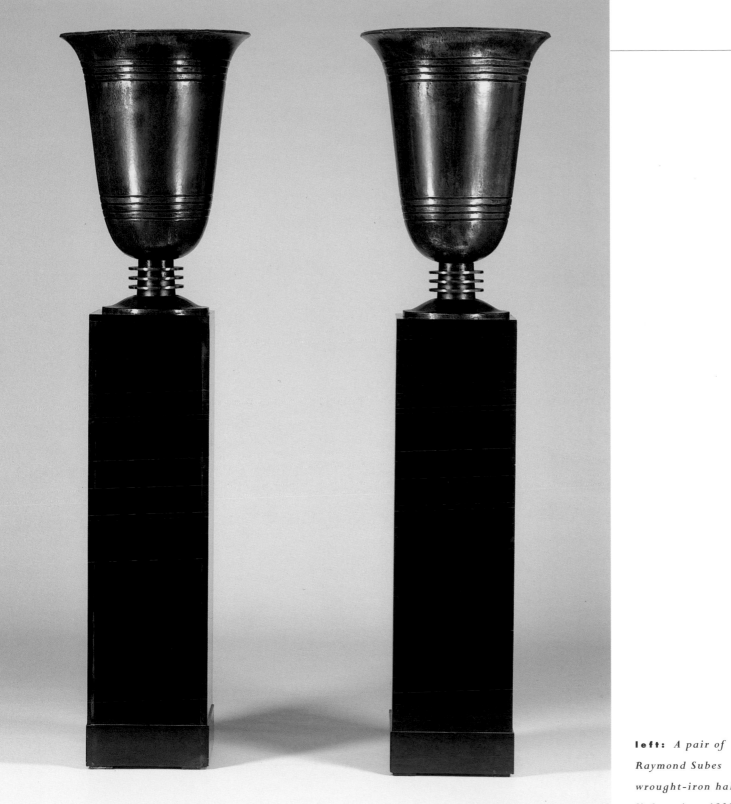

left: *A pair of Raymond Subes wrought-iron hall lights, circa 1933*

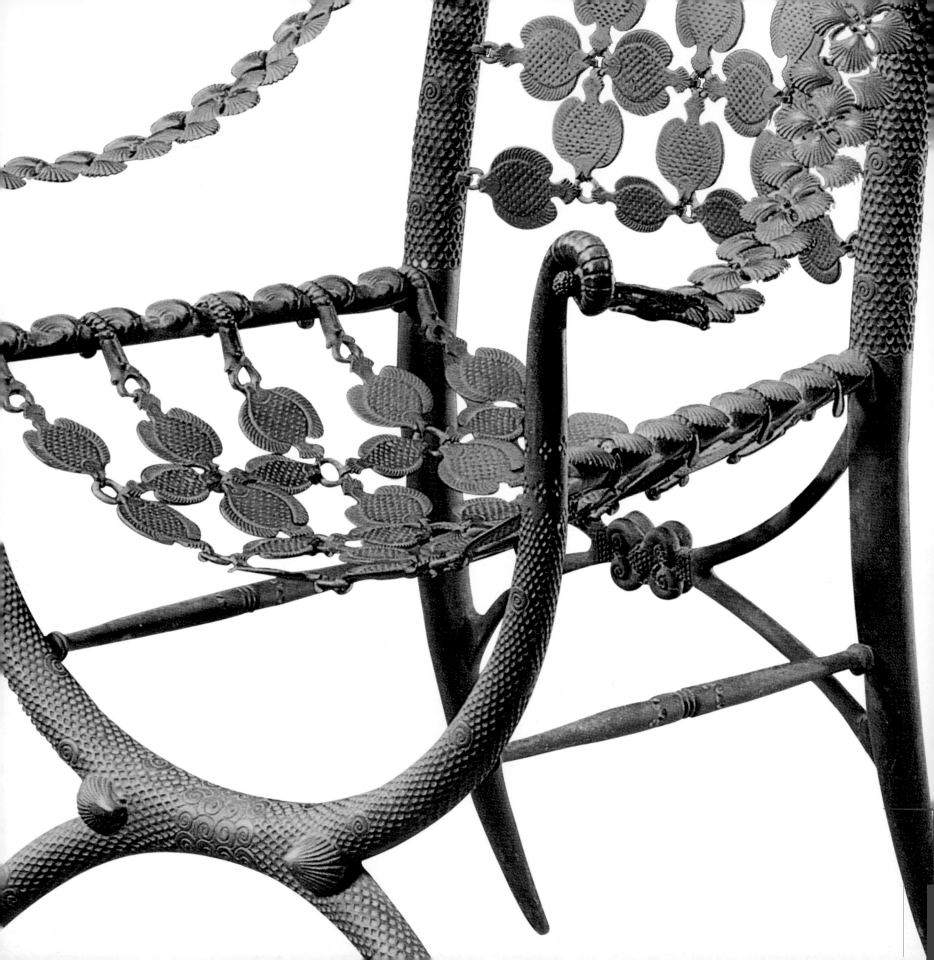

FURNITURE

by which time influences that can be traced to the functionalism of the early German industrial movement began to be the determining criteria. By the early 1920s the stylistic preoccupations embodied by the pioneering French designers had provided inspiration to foreign furniture designers and retailers, propagating a movement whose influence was to be felt throughout Europe and the United States.

The death of the prolific French furniture designer and glass worker Emile Gallé in 1904, whose work had characterized the Art Nouveau spirit, together with the closure the following year of Samuel Bing's influential Parisian shop L'Art Nouveau, precipitated the adoption of a new mood in furniture design. A new direction had been preempted by the 1899 opening of the Paris shop La Maison Moderne, which sought to challenge the Art Nouveau styles advocated by Bing. During this early period, the new attitudes were most clearly expressed by Paul Follot, who designed furniture of simple form but with rich surface treatment; Maurice Dufrène (1876–1955), who favored the adoption of industrial techniques to furniture production; and Clément Mère (b. 1870). The son of a Parisian wallpaper manufacturer, Paul Follot created pre-1914 furniture that embodied the spirit of early Art Deco through the adoption of neoclassical forms allied to rich surface treatment. The Musée des Arts Décoratifs correctly anticipated his significance by purchasing several of his designs directly from the 1912 Salon, notably a chair whose pierced and carved back, depicting a basket of fruit, first utilized motifs that were to become commonplace by the 1920s. Clément Mère was a member of La Maison Moderne, and his designs articulated a transposition of the fine arts to the applied arts, together with an Oriental

The origins of a redirection in furniture design can be identified in both France and Germany soon after the turn of the century. The major proponents for change in France advocated firstly a style that was to be rooted in a purely French tradition, and secondly sought inspiration from the luxuriously veneered and highly finished furniture of the late eighteenth and early nineteenth centuries. This was supported by a desire to create a new style that was liberated from the obsession of the curve, which had been the primary stylistic expression of Art Nouveau furniture. These characteristics were to determine progressive French furniture design until well into the 1920s, and to a lesser degree continued to be expressed in the 1930s,

above: *Dominique, a pair of lacquer cabinets with ivory handles, 1930s*

right: *Jacques-Emile Ruhlmann, Nicolle, a Macassar ebony, tortoiseshell, and ivory inlaid cabinet, 1926*

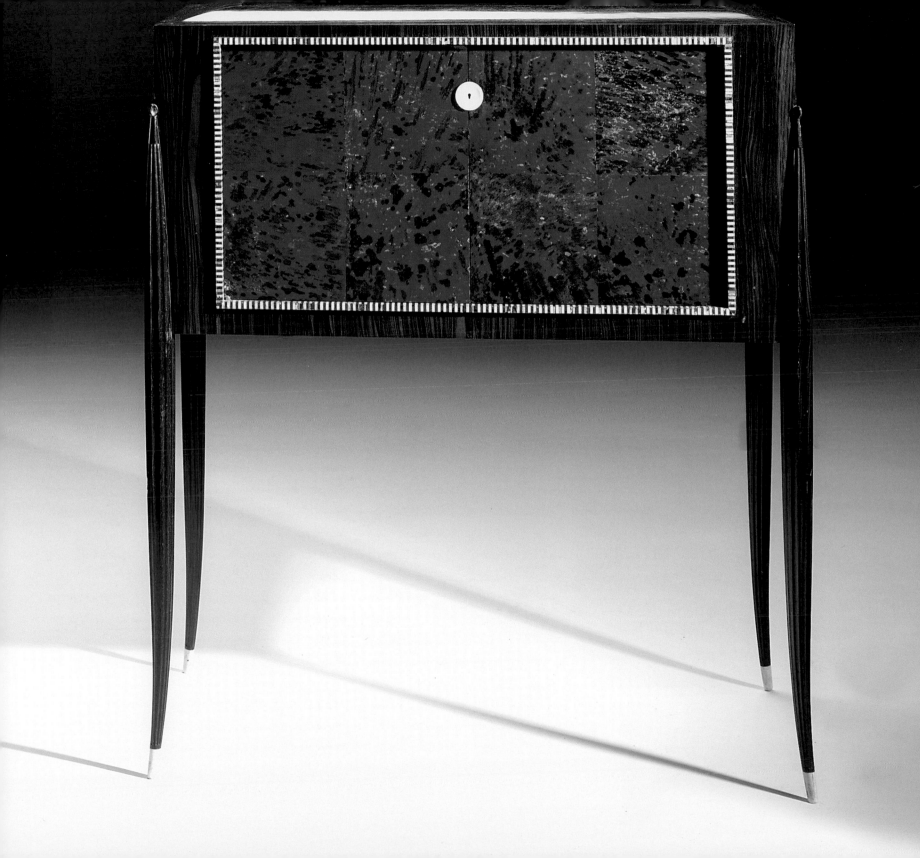

influence, through his skilled use on furniture of embossed leather and sharkskin surfaces, often with ivory details. Initially a student of philosophy, Maurice Dufrène joined La Maison Moderne in 1900, and in 1904 became a founding member of the influential Société des Artistes Décorateurs. The foundation of the Société was instrumental in the presentation of new furniture design through the annual Salon exhibition. The Société included many designers, such as Francis Jourdain and Pierre Chareau, who were to become leaders of the Art Deco movement in the 1920s. Other influential designers active during this early formative period include Léon-Albert Jallot (1874–1967), Paul Iribe (1883–1935), and Jacques-Emile Ruhlmann, all of whom during this period produced highly accomplished designs.

Were it not for the hiatus caused by the First World War, it is probable that the Art Deco movement would have reached maturity by 1920. During the period between 1910 and 1920 there was experimentation with the forms and patterns now synonymous with Art Deco.

The use of decorative sunbursts, zigzags, and chevrons, usually applied as veneers to the surfaces of furniture, became prevalent, and the imaginative use of bold color in furnishings became a characteristic feature. Two significant factors influenced this redirection, most notably the opening in Paris of Sergei Diaghilev's Ballet Russe in 1909, with brightly colored and geometrically patterned sets designed by Léon Bakst, and secondly the tendencies in fine art, specifically the bold and bright colors selected by the Fauvist artists. Both these factors helped designers to move towards an increasingly unrestrained palette. The materials selected for furniture projects were likewise increasingly exotic. Timbers such as rosewood, Macassar ebony, and amboyna became desirable, often veneered to accentuate the dramatic differences in grain and visual texture.

Snakeskin, shagreen, parchment, and lacquer were frequently applied to large surfaces to enhance the impression of opulence.

The First World War created immense social upheaval throughout Europe; however, it did indirectly encourage the development of furniture design in certain areas. The highly abstract camouflage patterns applied to ships and aircraft were exercizes in pure color and pattern. Artists, required by their governments to assist the war effort, made practical use of the soon to be familiar motifs of zigzags, chevrons, and interlocking colored motifs. The war had also prompted the development of new industrial materials, such as steel, aluminum, and plywood, all of which came to be used stylishly in the furniture of the late 1920s and early 1930s. The early 1920s saw the increasing influence of the major Paris retail stores, notably Au Printemps, Le Louvre, Au Bon Marché, and Les Galeries Lafayette. All of these stores were instrumental in the promotion of the new styles in furnishings. In order to meet the needs of their clients, and to develop their own identities as retailers, the stores established their own studios in which to design and manufacture furnishings. These studios attracted many of the most significant young French designers, for example Louis Sognot (1892–1970) and René Prou (1889–1947). The competitive nature that existed between these stores was essential to the development of new furniture, and all four stores exhibited designs at the landmark 1925 Paris Exhibition.

French furniture design during the 1920s and 1930s can be grouped loosely into two categories, that of the traditionalists and the Modernists, although strict delineation was not rigidly followed. The primary influence for designers working in a traditionalist idiom was a reinterpretation of late-eighteenth- and early-nineteenth-century French cabinetry. Modernist furniture design evolved from several sources, to include the art movements of Cubism, Futurism, De Stijl, and the Bauhaus.

Other sources, as diverse as American jazz, tribal African and Oriental art, and industrial mass production influenced both categories of design. Foremost amongst the traditionalists was Jacques-Emile Ruhlmann, whose firmly neoclassical style and manipulation of luxurious materials is regarded by many as the epitome of Art Deco. Ruhlmann first exhibited a series of wallpaper designs at the 1910 Salon d'Automne, but was rapidly developing a profound interest in furniture design. Despite his lack of formal training as a cabinetmaker, his ebony corner-cupboard of 1916 attracted considerable interest for its use of exotic timbers and fine decorative inlay work. It was at the 1925 Paris Exhibition, however, that Ruhlmann's veneration within France was assured. His pavilion at the exhibition, entitled Residence for a Rich Collector, was a series of chambers, each of which displayed sumptuous and luxurious furnishings executed to the highest standards by the most skilled artisans of the time. Prior to this exhibition, Ruhlmann's work had been known only through select private commissions. Ruhlmann's significant reputation had evolved through his crisp understanding of form and proportion, which was enhanced by

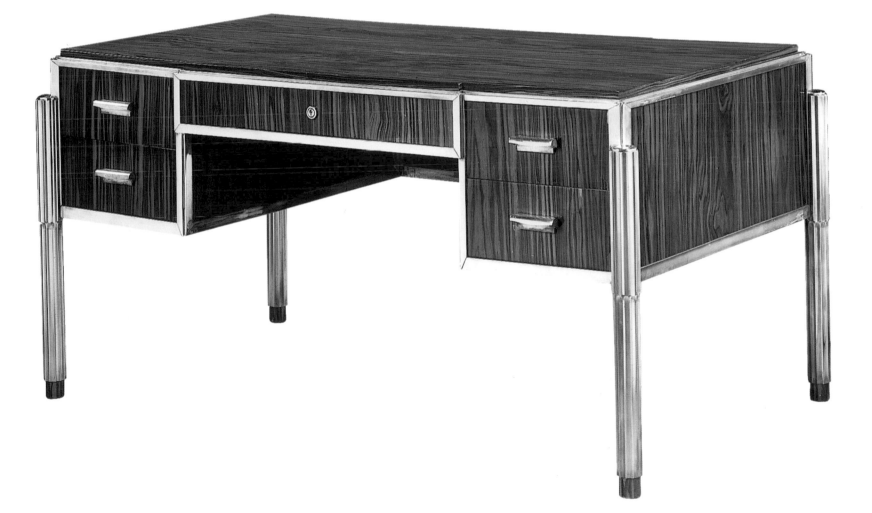

the use of exquisite materials such as palissander and Macassar ebony, and accentuated with ivory and tortoiseshell. Although essentially a traditionalist, Ruhlmann did respond to the increasingly popular use of metal in his furnishings, as exemplified by the desk and chair that were produced in 1932 for the Maharaja of Indore. Highly expensive to produce, Ruhlmann's furniture was accessible only to the wealthiest of clients or in limited numbered editions. Upon Ruhlmann's death in 1933, the firm was dissolved.

The firm of Süe et Mare was one of the most successful collaborations for furnishings design during the 1920s. Having first met prior to the First World War, Louis Süe (1875–1968) and André Mare (1887–1932) founded in 1919 the Compagnie des Arts Français. The partnership immediately attracted the attentions of a wealthy clientele, and at the 1925 Paris Exhibition their impressive ebony desk was acquired by New York's Museum of Modern Art. Süe et Mare's furniture remained traditionally inspired and expressed details characteristic only to them, notably the frequent use of squared scroll feet or of inlaid floral bouquets. The firm of Süe et Mare invited collaboration from other designers, and produced a wide range of objects in addition to furniture. The partnership continued until 1929, when Jacques Adnet assumed directorship. The furniture designer and decorator Jules Leleu (1883–1961) exhibited his early designs at the Salon d'Automne in 1922, and two years later opened his first gallery. Working with exotic timbers, Leleu exhibited at the 1925 Paris Exhibition and had by the 1930s established a strong client base that included embassies and government ministeries. Leleu gained further prestige through his interior schemes for the ocean liners Ile de France, L'Atlantique, and Normandie. Although then approaching fifty years of age, Maurice Dufrène proved to be one of the most versatile of the designers who exhibited at the 1925 Paris Exhibition. Unlike Ruhlmann,

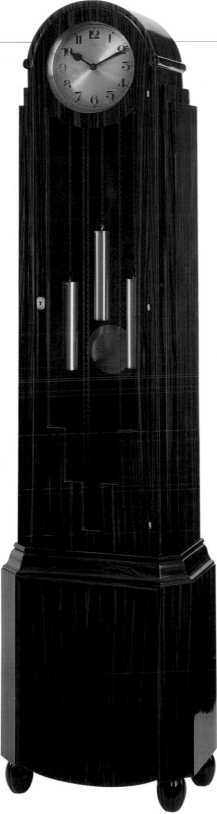

left: *Maurice Dufrène, a palissander longcase clock, circa 1925*

far left: *Jules Leleu, a Macassar ebony veneered and ivory inlaid cabinet, circa 1925*

established an important lead over France in the field of the decorative arts. The organizers of the 1925 Paris Exhibition had stipulated that every object should present "a modern inspiration and real originality," but in reality there existed tremendous stylistic diversity, and consequently no unifying style to the exhibits. Although it was ostensibly an international exhibition, Germany was not invited to exhibit, and the United States declined an invitation to exhibit on the grounds of economics. Many of the furnishings displayed at the exhibition were in a style relevant to the nation that had produced them, and were sometimes stylistically remote from Art Deco; however, the exhibition did succeed in showing that Art Deco was to become an established international style, in tune with popular taste.

Other designers operating in an essentially traditionalist idiom who exhibited at the 1925 Paris Exhibition included André Groult (1884–1967), whose refined shagreen furnishings were of an anthropomorphic form, the brothers Léon-Albert Jallot and Maurice-Raymond Jallot (b. 1900) and Henri Rapin (1873–1939), who had been appointed artistic director of both the Sèvres Manufactory and the Ecole des Arts Décoratifs by 1924. Taking as their inspiration France's cabinetry tradition of the eighteenth and early nineteenth centuries can also be included Paul Follot, Eric Bagge (1890–1978), Jean Pascaud (b. 1903), Marcel Guillemard (1886–1932), Suzanne Guiguichon (1900–1985), Alfred Porteneuve (1896–1949), who was the nephew of Ruhlmann, and Louis Majorelle (1859–1926). The work of André-Léon Arbus (1903–69) expressed neoclassical origins, seeking inspiration from Louis XIV furniture models that were redesigned through the removal of all extraneous detailing and heightened by luxurious surface treatment, often of lacquer, parchment, or shagreen, and with tufted damask upholstery.

Dufrène felt that the use of machinery in furniture production would not compromise an aesthetic vision, and advocated the use of new technology to produce large editions of machine-made furniture at inexpensive prices. Dufrène exhibited prolifically at the 1925 Paris Exhibition, and had by the 1930s enhanced his portfolio through the incorporation of both glass and metal for furniture production.

The first proposals for an international exhibition of decorative art had been raised on several occasions prior to the First World War. All had been swiftly dissolved on various grounds, notably in 1910 when it was felt that Germany had

left: *Léon-Albert Jallot, a lacquered screen, 1920s*

By 1930 Arbus had allied himself with the Modernist tendencies in furniture design, and he continued to produce some of his finest pices of work in the 1940s and 1950s.

Like many of his contemporaries, Jean-Michel Frank's (1895–1941) distinctive style evolved from a respect for the proportions of late-eighteenth-century furniture, although the forms were stripped to their simplest expression, and the surfaces finished with sumptuous veneers. Supported by a substantial inheritance, Frank established himself in Paris's fashionable inner circle, establishing contacts with the sculptors Alberto and Diego Giacometti, Salvador Dalí, Pablo Picasso, and the couturier Elsa Schiaparelli. Schiaparelli proved to be one of Frank's most enduring clients, first commissioning the interiors for her apartment in 1927, then later her shop in the Place Vendôme. Sought out by many of France's wealthiest patrons as an arbiter of good taste, Frank had overseas clients that also included the noted collector Templeton Crocker in San Francisco, and Nelson Rockefeller in New York. The most distinctive characteristic of Frank's work was his imaginative use of veneers and unusual materials for surface treatment, which included straw marquetry, suede, cane, sharkskin, and vellum. Often these surfaces were not solely confined to the furnishings, but applied to the doors, walls, and fireplace surrounds of his interiors. Of German-Jewish origins, Frank fled France for the United States in 1939, and in one of his frequent bouts of depression tragically jumped to his death from a New York building in 1941.

Armand-Albert Rateau, like Jean-Michel Frank, worked in a highly distinctive style, and his most fluent designs articulate his profound interest in Antiquity and the Orient. Appointed director of the Atéliers de Décoration de la Maison Alavoine in 1905, Rateau oversaw the furnishing of the New York home of George and Florence Blumenthal, who were later to become important private clients. In 1919 Rateau became an independent decorator, and was invited to furnish the interiors of the Blumenthal's three French homes. Increasingly acquainted with wealthy patrons, Rateau first introduced his

below: *André-Léon Arbus, a shagreen and gilt metal day bed, circa 1930*

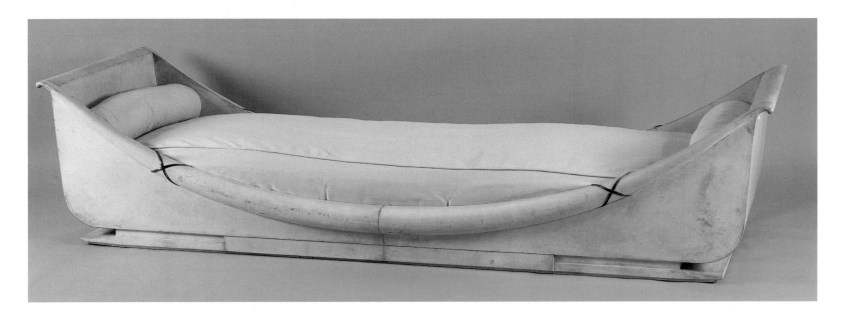

characteristic bronze furniture in the apartment of Jeanne Lanvin in 1920. The distinctive cast and patinated bronze furniture was probably inspired by Rateau's prewar visits to Pompeii, and as a result of examination of archaeological artefacts. Pheasants, butterflies, gazelles, and acanthus leaves were consistent motifs in Rateau's work, which was frequently limited to production in editions of three. Although he remained active until his death in 1938, Rateau undertook his most significant work in the 1920s.

The second category of French furniture designers during the 1920s and 1930s were the Modernist designers who rejected their compatriots' allusions to neoclassical furniture design. The most significant redirection towards a truly modern interior was established at the Pavillon de l'Esprit Nouveau at the 1925 Paris Exhibition. Designed by the Swiss-born architect Le Corbusier (whose given name was Charles-Édouard Jeanneret), the pavilion was a spacious geometric construction with part-glazed walls. The crisp white-painted open-plan interior was furnished with sparse modular cabinets and cheap mass-produced Thonet bentwood chairs. The minimalist interior, together with the honest furnishings, which Le Corbusier described simply as "equipment," advanced the architect's theories on standardized housing. Aspects of Le Corbusier's minimal and functionalist vision can be traced back to his prewar meetings with the German industrial designer, Peter Behrens, who had recently revitalized German product design. Behrens had emphasized the need for rational and correct design through the use of appropriate materials and the rejection of superfluous ornament. The public's reaction to the pavilion was predictable, especially in the context of the luxurious interiors presented by Ruhlmann and others. Despite their claimed commitment to "modern inspiration," the commissioners regarded the interior as too clinical and too intellectual, and a high fence was erected

right: *Jean-Michel Frank, a cupboard with double doors, circa 1928*

around Le Corbusier's pavilion. Initially, Le Corbusier found few adherents to his aesthetic and social theories; however, by the late 1920s the initial resistance had begun to wane, as increasing numbers of designers championed the use of simpler forms and industrial materials in furniture. During the late 1920s Le Corbusier designed, in collaboration with his brother Pierre Jeanneret and Charlotte Perriand (1903–99), three chairs that were immediately the subject of universal acclaim, the Gran Confort and Basculant armchairs, and a celebrated chaise longue. All models utilized chromed tubular steel, fitted with either soft leather or fur-hide upholstery. Despite the designers' aspirations for the affordability of their furniture, all models proved expensive to manufacture, and were accessible only to the wealthy. The use of industrial materials, such as tubular steel or aluminum for furniture production, became increasingly popular with French designers through their familiarity with the progressive Bauhaus school in Germany. Despite their exclusion from the 1925 Paris Exhibition, the rational and modern aesthetic advanced by the German Bauhaus designers had since begun to determine contemporary European furniture design.

Jacques Adnet (1900–84) emerged as one of the most prolific of French Modernist designers. Acquiring directorship of Süe et Mare's Compagnie des Arts Français in 1929, Adnet immediately began to disassociate the company from its traditionalist leanings, and was one of the first designers to anticipate the incorporation of glass and metal in his furniture designs. Although Adnet's furniture continued to incorporate fine and exotic timbers, his output became increasingly streamlined, and began to follow a rigid functionalist aesthetic. Together with his twin brother, Jean, Jacques Adnet presented an exhibit at the 1925 Paris Exhibition that had attracted considerable interest primarily through its display of geometric tubular glass and chromed metal light fittings. The importance

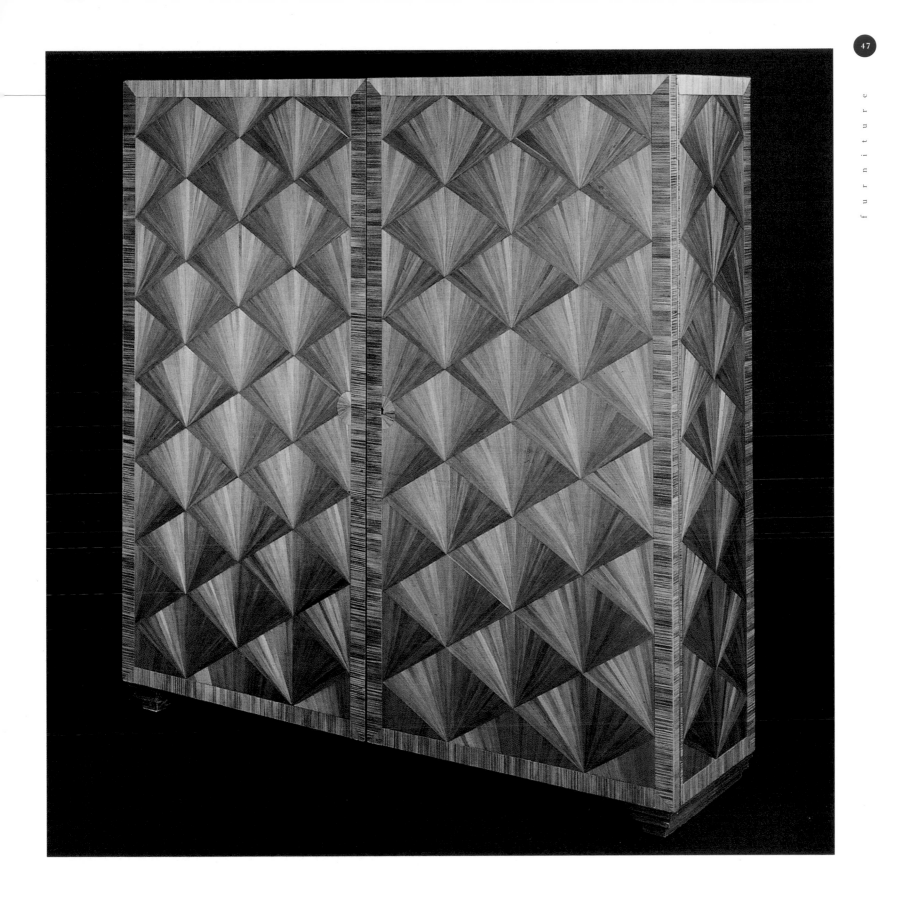

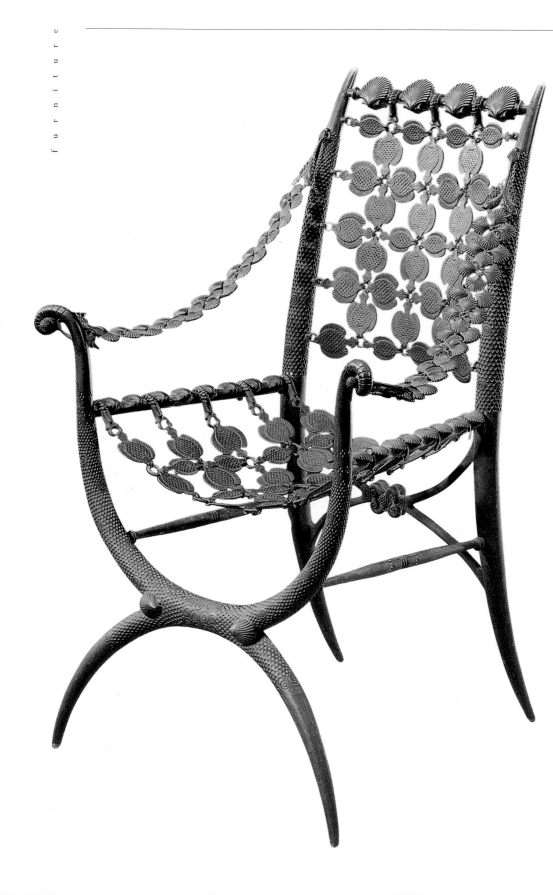

of Louis Sognot to French Modernism had been established by his widespread introduction of metal in his furnishings. Sognot had originally designed furniture for the Paris department store Au Printemps, and exhibited at the 1925 Paris Exhibition. In 1929 Sognot cofounded, together with René Herbst, Robert Mallet-Stevens, Francis Jourdain, Pierre Chareau, Le Corbusier, and others, the Union des Artistes Modernes (UAM), which was committed to the promotion of a rationalist French aesthetic. Many of Sognot's furnishings from the early 1930s were designed to perform dual functions. Sognot produced commissions for the Maharaja of Indore, and in 1932 was one of the first designers to make use of the newly available types of plastic in furniture production.

Robert Mallet-Stevens established himself as a renowned designer and decorator after the First World War through numerous prestigious commissions, and attracted further attention at the 1925 Paris Exhibition. Mallet-Stevens possessed a clear vision for his furniture: that it was to be of simple form and lacking in ornamentation. Mallet-Stevens heavily championed the use of metal in furniture design, and in 1930 was appointed president of the newly formed UAM. He continued to exhibit internationally until the advent of the Second World War. René Herbst (1891–1935) began experimenting with metal, glass, and mirror as an alternative to wood for furniture design as early as 1926, and his Sandows chair of 1929 was the first metal chair to make innovative use of elastic straps for the seat. Together with Ruhlmann, Sognot, and Eileen Gray, Herbst was commissioned to design furniture for the Maharaja of Indore. As well as furniture design, Herbst produced numerous successful designs for lighting. Other French designers who made significant use of metal during the late 1920s and early 1930s include Adrienne Gorska, Claude Levy, and Emile Guenot.

Not all of the influential furniture designers associated with French Art Deco can be readily classified into the two

spheres of traditionalism and Modernism. Foremost amongst those designers whose individuality prohibits classification are Marcel Coard, Pierre Legrain, Pierre Chareau, Eileen Gray, and Eugène Printz. The inspiration behind much of Pierre Legrain's (1887–1929) brief output is an unusual blend of tribal African and Cubist tendencies. Pierre Chareau (1883–1950), who exhibited at the 1925 Paris Exhibition, produced striking functionalist furniture that employed a combination of solid timber with wrought iron. The woods employed were often palissander, walnut, or sycamore, the soft tones of which contrasted with the deliberately exposed raw steel surfaces. Many of these furnishings were designed to serve multiple needs. Trained as an architect, Chareau created the Maison de Verre, which was designed in 1932 as a steel frame hung with opaque and clear glass panels as the home of a noted Parisian doctor and was one of the most articulate examples of his vision.

Of wealthy Irish parentage, though resident in France since 1902, Eileen Gray (1879–1976) had a pioneering style that proved highly influential during the 1920s. Her luxurious and often theatrical creations illustrated her early training in Oriental lacquer techniques, and responded to her interests in tribal African art. Significant amongst her most prolific designs are screens, either of geometric lacquer designs, perforated metal, or Perspex, and the dramatic folding "S" chair of 1932. Eugène Printz (1889–1948) served his apprenticeship in his father's traditional cabinetry workshop in Paris. His decision to move into contemporary furnishings coincided with the 1925 Paris Exhibition, during which he briefly collaborated with Pierre Chareau on the furnishings for the Ambassade Française. Printz's energetic style was accentuated by his selection of the finest timbers, most frequently palmwood, and his use of bright metal mounts. By the early 1930s Printz had established a solid client base, for whom furnishings were produced in a number of limited editions. Of particular note is

his design for a modular table, the hinged elements of which could be compressed to form a bookcase.

French designers notable for their exceptional handling of their chosen medium are Jean Dunand, whose skills with lacquer resulted in numerous prestigious commissions, including collaboration with Léon-Albert Jallot at the 1925 Paris Exhibition, and decorative panels for the ocean liners Ile de France, L'Atlantique, and Normandie. Edgar Brandt, Raymond Subes, and Gilbert Poillerat (1902–88) all excelled in the use of wrought iron for furniture design, taking inspiration from both the traditionalist and Modernist tendencies.

British furniture design during the 1920s was primarily conservative, and remained dominated by the theories and handcraftsmanship of the Victorian Arts and Crafts movement. Both Gordon Russell (1892–1980) and Ambrose Heal (1872–1959), designers who had first achieved prominence earlier

left: *Armand-Albert Rateau, a cast bronze chair, 1925*

in the century, continued to exercise designs that were essentially traditional in terms of style, construction, and materials used (which were usually the traditional timbers oak, walnut, and mahogany). Aspects influenced by the popular French style could be identified in the work of both designers by the late 1920s, although formally the furniture still remained traditional. Gordon Russell Ltd and Heals continued to retail their characteristic furnishings, alongside more Modernist-inspired lines, until the Second World War. The firm of Bath Cabinet Makers produced well-made furniture that was heavily inspired by the French model, making extensive use of luxuriously veneered surfaces, and employing ivory details that acknowledged a debt to the work of Ruhlmann.

The British Modern movement began to gather momentum during the early 1930s, this being primarily due to the arrival of a number of émigré designers such as Serge

Chermayeff, Wells Coates, and Marcel Breuer. Born in Russia and trained initially as an artist in Paris, Chermayeff married into the furniture manufacturing family of Waring & Gillow, and in 1928 staged a groundbreaking exhibition of modern French and English furniture that was to revolutionize British attitudes to contemporary furniture. Chermayeff designed furniture, carpets, and often decorations for Waring & Gillow throughout the early 1930s, but from 1931 onwards practiced mainly as an architect.

Inspired by the French and German precedents, chromed tubular steel furnishings generated a brief interest in Britain. Furniture manufactured by companies such as PEL (Practical Equipment Ltd) was at its most popular amongst the wealthy elite from 1931 to 1934; however, interest was soon displaced by the increasing use of plywood for stylish furniture production. A new spirit in British furniture design was further advanced by the visit to the Bauhaus made by the industrialist Jack Pritchard (1899–1992) and Canadian architect Wells Coates (1895–1958) in 1931. Stimulated by European experiments, Pritchard and Coates established the Isokon company for the design and manufacture of progressive furnishings in 1936, employing the talents of the former Bauhaus master Marcel Breuer. Working for a few brief years in the mid-1930s, the self-taught designer Gerald Summers (1899–1967) produced some of the most exceptional and innovative plywood furniture of 1930s Britain.

Tubular steel and plywood furniture attracted a progressive, though limited, market

during the 1930s. There were, however, designers and manufacturers who attained widespread acclaim producing furniture that was more closely related to the model of the French Modernist designers. Notable is Betty Joel (b. 1896) whose distinctive style is characterized by curved contours, the elimination of ornament and contrasting veneers. She received many significant private commissions, notably the redecoration of Lord Louis Mountbatten's London flat in 1937, and also produced a range of affordable furnishings that were aimed specifically at the working woman. The two London furniture manufacturers Hille and Epstein both produced fashionable furniture for the middle market, often incorporating the stepped form and sunray motifs now characteristic of mid-1930s British Art Deco.

Both Denmark and Sweden exhibited at the 1925 Paris Exhibition, although Norway did not participate. The commissioners of the exhibition drew special attention to a neoclassical lounge chair designed by the Swede Gunnar Asplund (1885–1940). Although some French-inspired furniture was designed in these countries throughout the 1920s and 1930s, the Danish furniture industries maintained an emphasis on crafts-based traditions. Sweden proved more receptive to the Modernist aesthetic, notably expressed by the landmark 1930 Stockholm Exhibition, which displayed many furnishings that owed a stylistic debt to the Bauhaus. Finland provided only a partial display for the exhibition and it was not until the early 1930s that Finland established a position of prominence in European furniture design through the revolutionary Modernist plywood designs of Alvar Aalto. In Italy, the seeds of

right: *Pierre Chareau,* **La Religieuse,** *a standing lamp, circa 1925*

left: *Marcel Coard, a large lacquered cupboard, designed for the brother of Jean Cocteau, 1935*

Modernism had been first sown by the Futurist group of artists, whose leader, the poet Tommaso Marinetti, had in 1909 proclaimed that "the beauty of speed a roaring automobile, which seems to run like a machine-gun, is more beautiful than the Victory of Samothrace." Marinetti's advocation of a machine-inspired aesthetic would be practiced by progressive European and American furniture designers during the 1930s. Italy did produce some notable furniture designs for the 1925 Paris Exhibition, but these were predominantly of a neoclassical spirit, and it is later in the 1930s, primarily through the work of Gio Ponti (1891–1979), Pietro Chiesa (1892–1948), and Franco Albini (1905–77) that a cohesive Modernist style is established. In contrast to the minimalism favored during the 1930s by the progressive northern European designers, Italian Art Deco furniture is typified by a refined elegance achieved through the use of burled veneers and the frequent employment of reverse-decorated glass panels and metal fittings.

The displacement by Modernism of the revivalist furniture that had characterized French furniture design in the 1920s grew from the theories put forward by the De Stijl group in Holland and then developed by the Bauhaus in Germany.

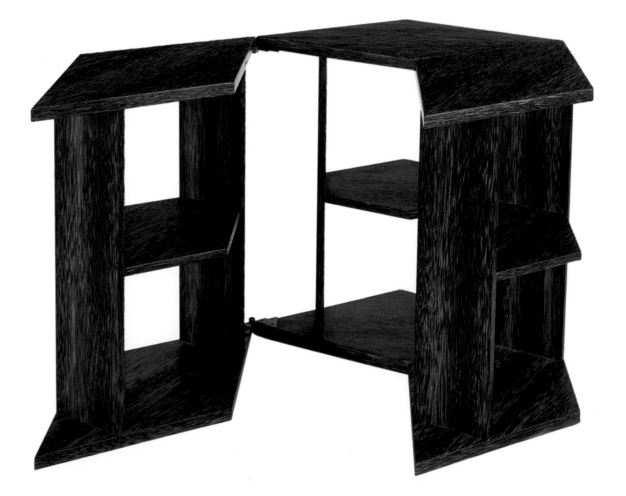

Formed in 1917 by the artists Piet Mondrian and Theo van Doesburg, the De Stijl group advocated a simple style of furnishings that were designed to compliment their concepts for utopian interiors. Characterized by open geometric forms, simple plank construction, and often painted in bright primary colors, the furniture designed by group member Gerrit Rietveld (1888–1964) was essential to the development of the Modernist furniture of the 1930s. Rietveld's reduction of chair design to the basic mathematics of form and proportion proved inspirational to many of Europe's progressive furniture designers, notably to Marcel Breuer (1902–81), then a student at the Bauhaus in Weimar, Germany. Established in 1919 as a progressive arts and crafts school, the Bauhaus proved to be one of the most fertile environments for the reassessment of art and design. Under the directorship of the architect Walter Gropius, the students of the Bauhaus were encouraged to reconsider furniture and product design through the use of new or untested materials, such as tubular steel or glass, and to consider the suitability for mass production of these objects. By the late 1920s the experiments undertaken at the Bauhaus had been disseminated throughout Europe, prompting designers such as Herbst and Sognot to assert Modernism in France. Considered seditious, the Bauhaus was closed by the Nazi regime in 1933; however, this had the immediate effect of widening the influence of Modernism, as talented former students and masters fled to France, Great Britain, or the United States.

It was in the United States that the vocabulary of European Art Deco was ultimately most enthusiastically embraced, producing the first unified American design movement. Still a relatively new nation, American decorative arts in the first decade of the century had tended to express the national identity of the country's immigrant population, resulting in an absence of a national unifying style. Exceptions are the architect Frank Lloyd Wright (1867–1959), Arts and Crafts furniture designer Gustav Stickley, and Louis Comfort Tiffany, all of whom had been influenced by recent movements in European design. Despite the display of selected exhibits from the 1925 Paris Exhibition by the Metropolitan Museum of Art in 1926, many critics within the United States considered the French Art Deco style as being too exuberant for American tastes. By the early 1930s, however, domestic economics together with an influx of émigré European designers had combined to prompt the growth of an identifiably American interpretation of Art Deco.

By 1920 America was in advance of Europe in terms of technology. Electric lighting and central heating were both pioneered in America, developments that inevitably influenced furniture design, however, it was contemporary urban American architecture that most noticeably stimulated a fresh vision. The Viennese immigrant designer Paul Frankl (1886–1958) had remarked in 1928 that the reason why America had not participated in the 1925 Paris Exhibition

left: Eugène Printz, a small hexagonal palmwood veneered occasional table, circa 1930

was because he felt that the country possessed no decorative art of its own. He elaborated by noting that in the building of skyscrapers America expressed a form of modern art that was of greater magnitude than all the combined efforts of the European designers. The stepped ziggurat form of the New York skyscrapers inspired Frankl to design his own "skyscraper" furniture of painted wood and often featuring metallic finishes. Produced from 1925 to 1930, Frankl's cabinets embraced the New York skyline as a decorative motif. Following the Wall Street crash, however, the designer quickly denounced his creations as a "monument to greed." Other characteristics of American culture that were to provide fertile inspiration for furniture designers included the stepped forms and geometric patterns of the ancient Inca, Aztec, and Mayan cultures. Both Frank Lloyd Wright and Walter von Nessen incorporated motifs and forms into their furniture that were derived from native

American symbolism. The widespread popularity of American jazz, together with the presence in Europe of black musicians and dancers, provided both American and European designers with an additional source of inspiration, in tune with modern culture.

America's prosperity and potential as a new nation attracted talented and ambitious European designers. One of the most influential furniture designers and theorists was Eliel Saarinen (1873–1915), who emigrated from his native Finland in 1922. Saarinen became director of the influential Cranbrook School of Art and Design, his aesthetic drawing on French Modernist design. German immigrant Kem Weber (1899–1963) had been an American resident since the First World War, and established his own design studio in Hollywood in 1927. Describing himself a Modernist industrial designer, Weber produced distinctive furniture, most notably the green-painted bedroom furniture for the Bissinger residence in San Francisco, and his streamlined self-assembly Airline chair of 1934.

Operating in a style that was a synthesis of the technology of the Bauhaus with the luxury of French Modernism, Donald Deskey became established primarily through his furniture and interiors for the Radio City Music Hall in New York in 1932. Using aluminum, Bakelite, chromed steel, and other industrial materials, Deskey pioneered the American Modern style. In America, tubular aluminum was used for furniture design by Warren McArthur during the 1920s and 1930s, notably his light and elegant furnishings for the Biltmore Hotel in Arizona. In Germany, aluminum's light weight ensured it was ideally suited for airship furniture, a factor that enhanced the material's acceptance within fashionable circles.

The economic depression that wracked America during the early 1930s encouraged the more versatile designers to consider the necessities of the mass production of furniture. This, together with the emigration from Germany of Bauhaus-trained designers after 1933, resulted in the increasing use of industrial materials for furniture production, and a machine-inspired aesthetic swiftly overtook the luxurious Modernism that had characterized the furniture design of 1930. Deskey, Weber, Wolfgang Hoffmann (1900–69), and Gilbert Rohde (1894–1944) all produced quality modern furnishings that were both affordable and innovative, often incorporating elements of "streamlining" in their designs. The theory of "streamlined" forms had first been championed by the Italian Futurist movement before the First World War.

The furniture produced between 1920 and 1940 by the progressive European and American artists, designers, cabinetmakers, and furniture retailers articulated the transition from the revivalist designs of the nineteenth century to the almost universal acceptance of a Modern style in the post-1945 period. The Art Deco furniture of the 1920s was the first style to embrace a truly Modern aesthetic, based on the use of new or unlikely materials, allied to the prevalent trends in fine art and contemporary society, and increasingly suitable for mass production. The traditional cabinetry techniques adhered to by the majority of French designers during the 1920s were able to ease the acceptance of this new style at the highest levels of society, encouraging an appreciation of stylish modern design. Although the global economic depression of the early 1930s stalled the popular suitability of ostentatious materials, marquetry, and inlay work, a more refined vision of furniture design began to emerge, expressed most notably by the German and American schools of design. Although related in form and style to 1920s furniture design, the products of the 1930s were through necessity more suitable to mass production, and consequently were accessible to wider tracts of society. These economic, sociological, and aesthetic shifts between 1925 and 1935, succeeded in providing a fertile and robust foundation for the development and acceptance of new furniture concepts in the economic boom following the Second World War.

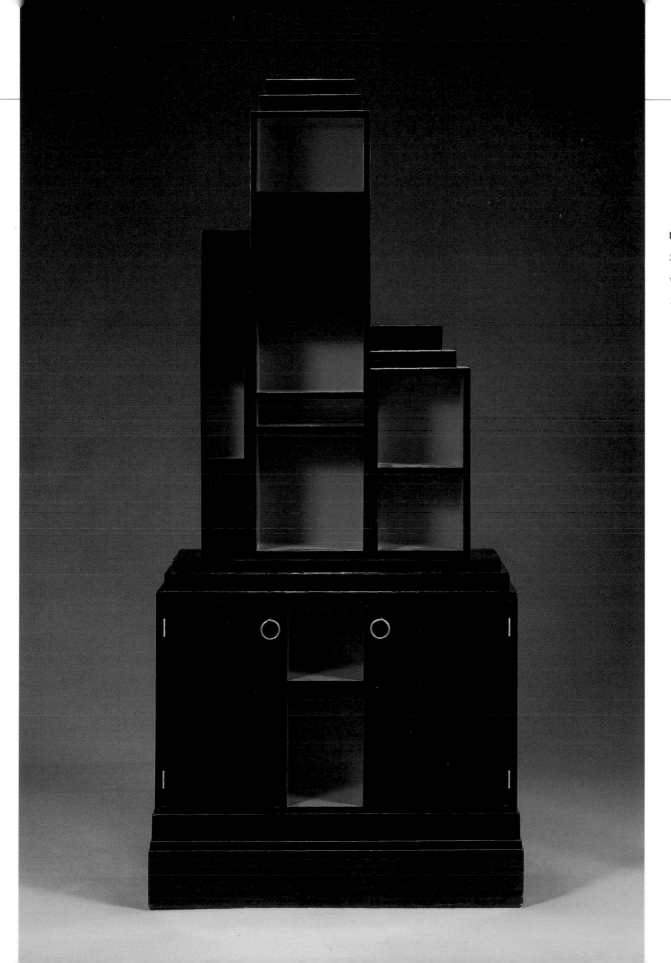

left: *Paul Frankl,*
Skyscraper lacquered
wood bookcase, circa
1928

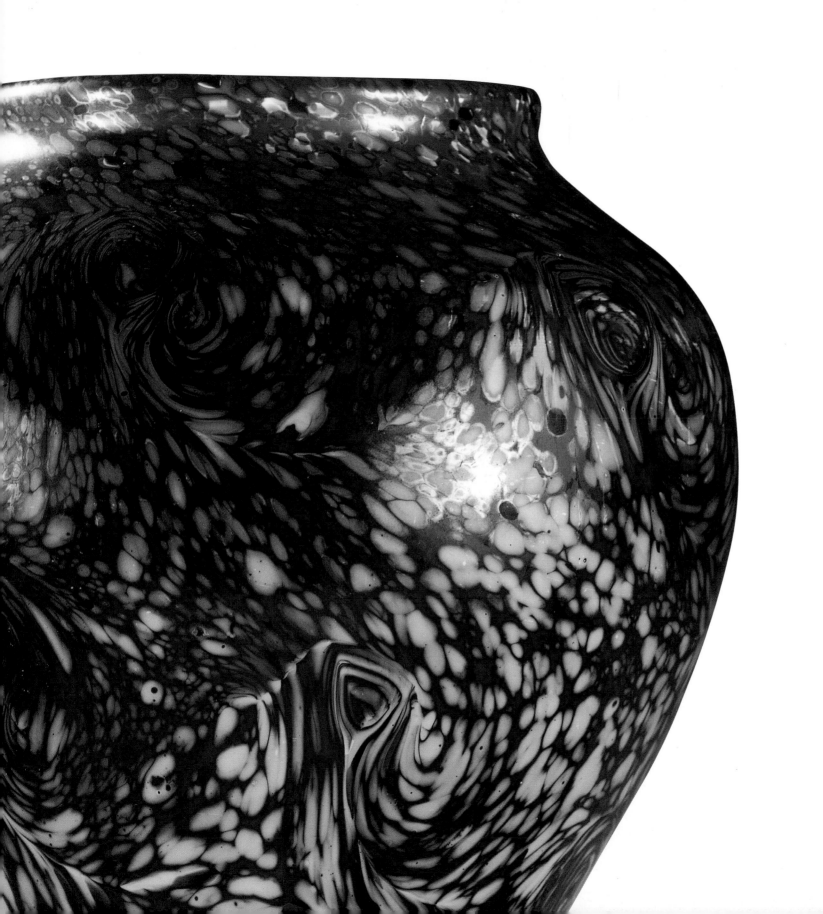

GLASS

chapter three

The Art Nouveau period witnessed the creation of unparalleled masterpieces throughout the various fields of the applied arts, but perhaps no other sphere could claim to have produced quite so many obvious combinations of technical mastery and breathtaking beauty as that of glass. It was an area of the decorative arts that had largely been ignored by artists and craftsmen during the nineteenth century, and it had taken the inspirational and innovative work of glassmakers such as Emile Gallé, Louis Comfort Tiffany, and the Loetz factory gradually to bring about a quiet revolution in the public's perception of glass as an art form. Unencumbered by preconceived ideals, both in terms of style and technique, these glassmakers had fully explored the artistic possibilities of the scientific discoveries at the beginning of the century. The glassmakers of the Art Deco period took up the reins from the innovators of Art Nouveau glass and they continued to exploit the

right: *René Lalique, a clear and frosted car mascot, 1930s*

very latest technological developments in this field for their own artistic purposes.

In France, making the easy transition from the Art Nouveau to the Art Deco style was the gifted René Lalique. Although he had started his career working as a jeweler in the last decades of the nineteenth century, he eventually progressed to become one of the most important glassmakers of the Art Deco period. Lalique was a talented painter, sculptor, chemist, designer, engineer, architect, and inventor as well as being a shrewd businessman. He managed to become the favorite of the privileged nobility while at the same time cater to the tastes and demands of the ever increasing middle classes. As a jeweler Lalique was highly individualistic in his approach to his work. He believed that the idea, composition, and form of each and every item were more important than its rarity or price tag. In Paris, as in the majority of the European cities, the fashion among the upper classes was for a style of jewelry that was more traditional, decorated with expensive stones and jewels. Impervious to this attitude, Lalique concentrated more on the decorative element and craftsmanship of a piece, and to this end began to incorporate a wide variety of nonprecious materials such as horn, bone, ivory, wood, enamel, and mother-of-pearl into his jewelry designs. It was this search for new materials that eventually led him to the decorative potential of glass.

After the opening of his new workshop at 20 Rue Thérèse in 1890, Lalique began to experiment with glass, and according to the stories, it was here that he created his first ever piece made entirely from glass. This early tear-shaped vial and stopper was produced using the *cire-perdue* (lost wax) process whereby a mold was taken from a wax model after which the wax was melted out and replaced with molten

glass. As the mold had to be broken in order to retrieve the glass, each piece was unique.

Although Lalique displayed a limited number of *cire-perdue* figures and vases beside his jewelry in his shop on Place Vendôme, and in 1903 he designed doors for his house that were cast at the Saint-Gobain glassworks, the real turning point in his career was not until 1907 when he was commissioned by the perfumier François Coty to create labels for his scent bottles. Until then perfume had been sold in boring, dull brown bottles with applied paper labels. Coty, who also had a shop on Place Vendôme, was an astute businessman who saw the potential of adapting Lalique's jewelry designs to metal and paper labels. These labels were an instant success and in 1908 Lalique received a further commission to produce elegant but affordable scent bottles for Coty's wide range of perfumes. The first bottles were executed at the Legras & Cie. Glassworks but in 1909, after a period of renting, Lalique purchased the Combs-la-Ville glassworks at Combs (Seine-et-Marne). Commissions started to flow in, not only from Coty, but also from other perfume manufacturers such as Forvil, D'Orsay, Roger & Gallet, and Worth. By the start of the First World War Lalique had almost completely broken with the production of jewelry. The growing demand for his glass meant that he needed larger premises from which to work and by 1918 he had purchased a larger factory at Wingen-sur-Moder from which to start the mass production of his glass designs.

Lalique's early work reflected the influence of the Art Nouveau style but he was soon creating pieces that drew on a wide range of sources for their inspiration. The natural and animal world adapted particularly well to stylization and he frequently used single floral motifs or animals such as greyhounds or fish to create simple but highly striking designs. Birds, insects, flowers, snakes, plants, sea urchins, the female form, as well as geometric shapes were all incorporated. As the

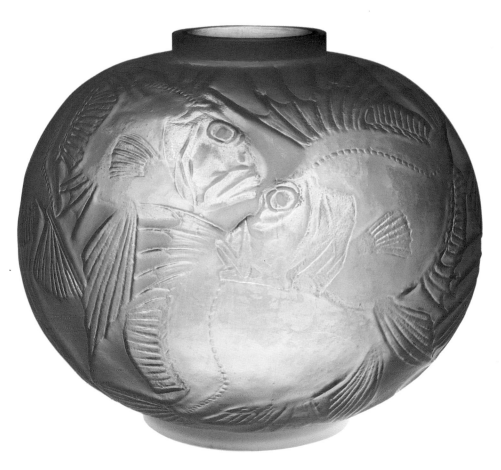

Art Deco period progressed and the taste for elegance increased Lalique employed more graceful and exotic animals such as gazelles or parakeets instead of his earlier grotesque lizards, serpents, frogs, and beetles.

Lalique produced a never-ending range of items: vases, bowls, boxes, statuettes, jewelry, carafes, drinking glasses, plates, mirrors, clock cases, ashtrays, jugs, trays, menu holders, ceiling lights, table lamps, doors, and decorative panels. With the increased popularity of the automobile in the 1930s he introduced a range of car mascots that were retailed in England through his agent, the Breves Gallery. These mascots, which include Victoire and Cinq Cheveau, are typical Art Deco with their

above: *René Lalique, glass vase, 1930s*

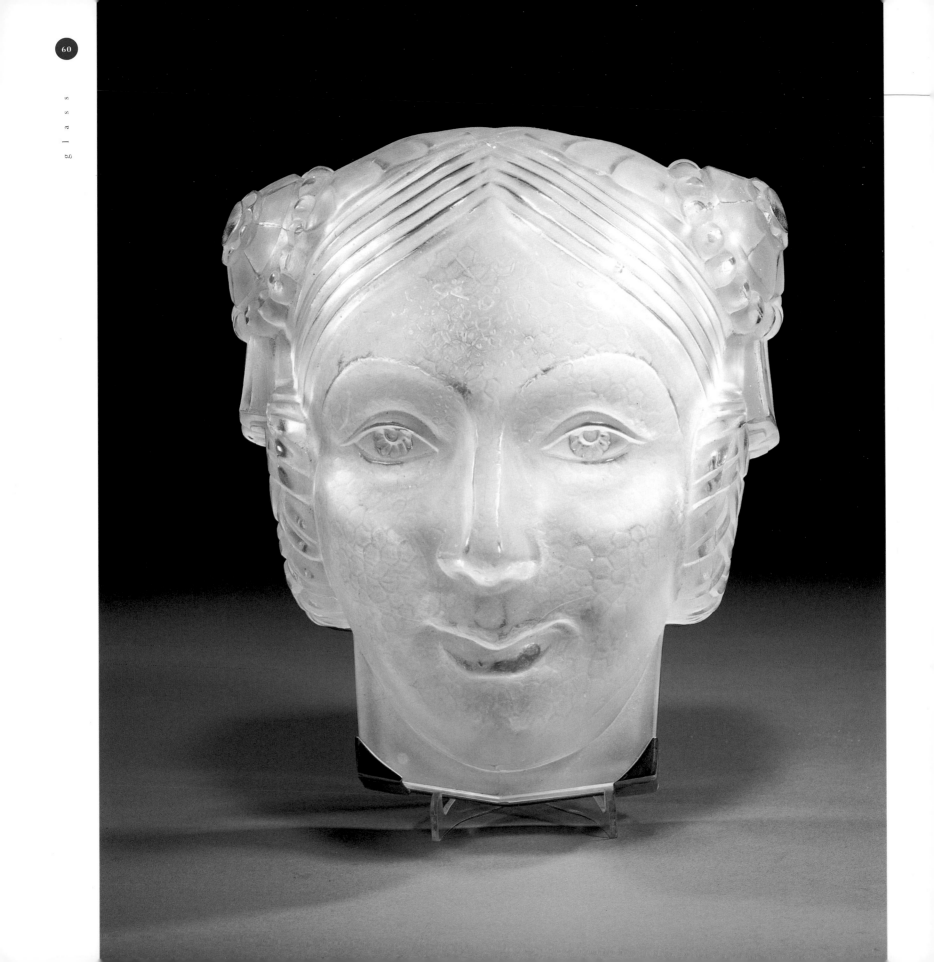

streamlined contours and overstylization. Likewise, throughout the 1920s and 30s Lalique received many large architectural commissions, such as the windows for the Worth store in Cannes, an outdoor fountain for the Rond Point des Champs Elysées, light fittings and glass panelling for the luxurious cruise liners Paris, Ile de France, and Normandie, as well as the interior of St Matthew's Church in Jersey.

Lalique rejected the traditionally used lead crystal in favor of demicrystal. He ignored the cries of the critics who said that it was impossible to mass-produce well-designed and good-quality pieces and to this end was constantly developing new machines and experimenting with different techniques to achieve the desired effects. The majority of his pieces were either in clear glass, which he would often enamel or apply with a color stain to accentuate the relief-molded design, or in opalescent glass, which is recognizable for its milky blue tinge. Occasionally he produced pieces in colors such as blue, green, yellow, amber, black, or red.

At the 1925 Paris Exhibition, in addition to his own pavilion, Lalique designed the dining room for the Sèvres pavilion and a spectacular fountain in the Cours des Métiers. As well as receiving great critical acclaim for these exhibits he also successfully displayed tiles, light fittings, and scent bottles in various locations throughout the exhibition. He entered the vase Tourbillon (Windswirls) into the category of Artist-designed Industrial Glass, which, in combining varying depths of relief, simple form, and striking outlines, is typical of Art Deco. Despite being created for mass production it had the quality of a studio piece; a clear indication that Lalique had achieved all that he had set out to do.

A number of firms were inspired by Lalique, in particular his use of press-molded or opalescent glass. The firm of Marius-Ernst Sabino (1878–1961) manufactured a wide range of vases, figurines, tableware, chandeliers, floor, and table lamps, electroliers, and wall appliqués. All of these were created in molds using mass-production techniques, often mounted with ornate bronze, brass, and wrought-iron fittings also made in Sabino's workshops. Although many of his pieces were produced in opalescent glass, his technique was not as subtle as Lalique's, instead tending to be a milky white, which graduated in turn to a deep blue and amber. Aimed at a cheaper market, Sabino's figurines of female nudes, fish, birds, and animals along with his vases and lampshades were slightly less well executed with mold lines often still visible.

As well as commissioning and retailing bronzes and ivory statuettes by leading Art Deco sculptors such as Demetre Chiparus and Maurice Guirard-Rivière, the firm of Edmund Etling & Cie (flourished 1920s and 30s) also produced a range of decorative items in molded glass. The figurines of nudes, ships, birds, and fish tended to be in highly polished opalescent glass while the vases and bowls used contrasting polished and frosted areas for decorative effect.

The success of Lalique's architectural glass and the increasing collaboration between architects, craftsmen, and artists in the Art Deco period provided the stimulus that saw a number of firms concentrate their efforts on the production of glass light fittings, wall panels, and decorative interior schemes.

left: *Marius-Ernst Sabino, a frosted glass wall appliqué, 1920s*

Two such firms were Genet & Michon and that of Albert Simonet. Inspired by Lalique, they used press-molding techniques to produce a variety of lamps and light fixtures, often combined with decorative bronze bases and frames. The opalescent and press-molded glass of the firms of Paul D'Avesn, André Hunebelle, Verlys, and Jobling & Co. in England was also testament to the far-reaching influence of Lalique's glass during the Art Deco years.

The inspirational work of glassmakers in the Art Nouveau period often left a strong foundation upon which the Art Deco

glassmakers simply had to build. This was particularly true in the case of *pâte de verre* glass, which, having undergone a revival of interest in the late 1900s under the hands of Henri Cros and Georges Despret, achieved its full potential in the Art Deco period. This ancient technique involved the mixing together of finely powdered glass particles, metallic oxides, and a binding agent into a malleable paste that was then tightly packed into a prepared mold and fired at a specific temperature. During firing the colors internally fused within the vitrified glass. The resultant glass had a degree of translucency that felt slightly waxy to the touch.

below: *François-Emile Décorchement,
a* **pâte de cristal** *glass vase, 1920s*

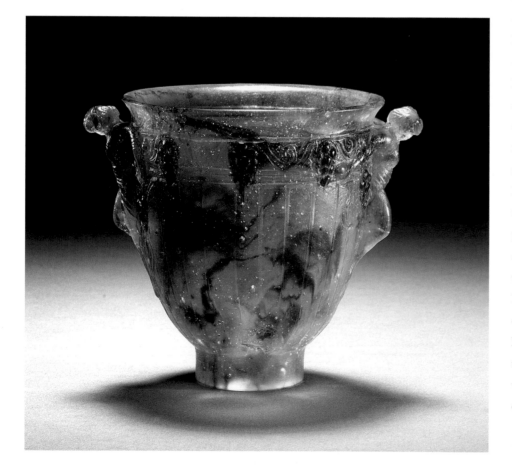

Before the outbreak of the First World War in 1914, the Daum factory at Nancy had established a *pâte de verre* workshop under the direction of Alméric Walter (1859–1942). Aided by designers and modelers such as Henri Bergé, Victor Prouve, Jules Cayette, and Jean Bernard Descomps, his work was still largely Art Nouveau in style, using naturalistic or animalistic motifs for inspiration. He created a range of vases, ashtrays, bowls, and *vide-poches* that were decorated with lizards, goldfish, beetles, frogs, and occasionally nudes.

Similar to Walter, François-Emile Décorchement's (1880–1971) early pieces were in the Art Nouveau style. Originally a ceramicist, he was stimulated by the delicate *pâte d'émail* glass of Albert-Louis Dammouse whose thin-walled *pâte de verre* with open cloisonné sections was filled with translucent paste rather like brilliant enamels. Though his early vases and bowls were similar in style to the latter's work, by 1910 he was producing large, thickly walled pieces that were more crystalline in their appearance. Referred to as *pâte de cristal*, this glass was characterized by its use of strong internal colors that were frequently bubbled, streaked, swirled, or veined to create the illusion of jade, marble, agate, or another semiprecious stone. Decorative motifs such as fish, dragonflies, leaves, serpents, flowers, and nudes became increasingly stylized. Using a rich palette of colors, he created vases and bowls that became simpler in form, eventually graduating to geometric shapes in the early 1920s. By the time he exhibited his wares at the 1925 Paris Exhibition, Décorchement had virtually abandoned decoration in favor of heavy, chunky vessels with angular handles and internal swirling colors. In his later years, he was mainly preoccupied with the production of large decorative window panels in *pâte de verre* that allowed for greater richness of color and translucency than traditional leaded glass.

A competent student, Joseph-Gabriel Rousseau (1885–1953) won a series of scholarships that enabled him to attend

the National High School for Ceramics at the Sèvres Factory. It was here that Henri Cros had established his glass workshop and Rousseau was quick to become enamored with the technique of *pâte de verre* with all its accompanying qualities. Though on graduation he went on to manage a small ceramics factory, he continued to experiment with *pâte de verre*. After his marriage in 1913 he adopted part of his wife's surname, subsequently being known as Argy-Rousseau.

The financial backing of Gustave-Gaston Moser Millet, a Parisian decorative arts gallery owner, enabled Argy-Rousseau to establish his own independent firm in 1921 for the large-scale production of *pâte de verre* glass. Under the name Les Pâtes-de-verre d'Argy-Rousseau, he set about manufacturing an extensive range of objects: vases, bowls, lamps, jars, pendants, inkwells, perfume burners, paperweights, night-lights, bookends, and decorative panels. Richly colored and noticeably light, these opaque pieces combined stylized floral, animal, and neoclassical figurative motifs with geometric friezes and banding. In 1928 he produced a number of *pâte de cristal* figures that were designed by the leading French Art Deco sculptor Marcel Bouraine.

The 1929 financial crash in New York and the subsequent worldwide depression, led to the closure of Les Pâtes-de-Verre d'Argy-Rousseau in 1931. Henceforth he concentrated on producing small religious plaques, a selection of enameled vases and a range of translucent geometric vases and bowls that, with their jeweled colors and black or burgundy streaking, bore close similarities to Décorchement's glass.

Like *pâte de verre*, the technique of enameling on glass enjoyed a revival in the Art Deco period. Marcel Goupy (1886–1954 retired) was one of the first to use brightly colored

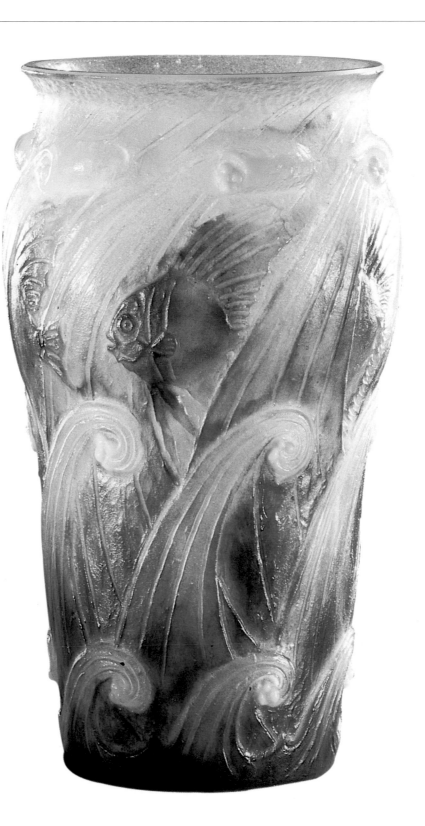

right: *Joseph-Gabriel Argy-Rousseau*, **Vagues et Poissons,** *a* **pâte de verre** *glass vase, circa 1925*

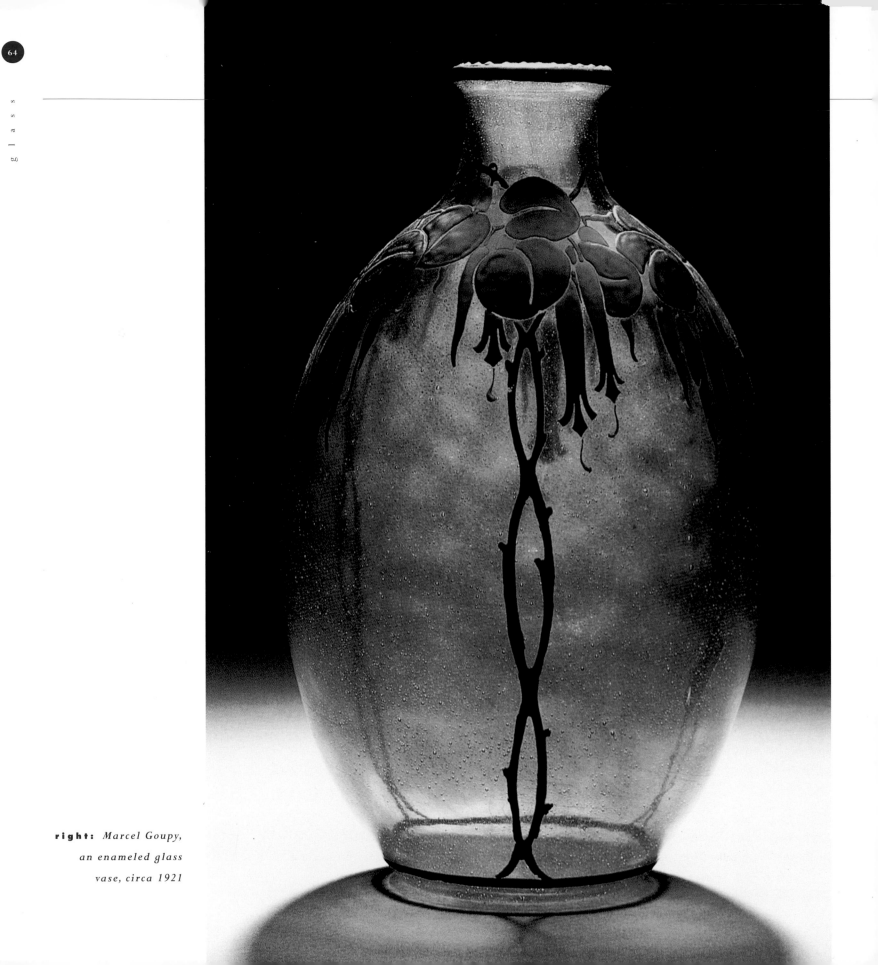

right: *Marcel Goupy,
an enameled glass
vase, circa 1921*

enamels to decorate his clear glass vases, bowls, decanter sets, boxes, and jugs. Working for the firm of Geo. Rouard as artistic director, he designed a wide range of highly stylized decorative motifs that were perfectly suited to the crispness and clarity of outline that enameling allowed. Between 1919 and 1923 Goupy's stylized birds, jazz players, female nudes, landscapes, mythological figures, or animals were all painted by Auguste-Claude Heiligenstein (1891–1976), even though the vessels would bear Goupy's signature. Heiligenstein later went on to pursue a solo career, exhibiting at the Salon des Société Artistes Français as well at Rouard's and Edgar Brandt's galleries. He is particularly noted for his finely detailed enameled and gilt pieces decorated with a neoclassical theme, such as a dancing female figure, together with stylized waves, clouds and geometric motifs. Jean Luce (1895–1964) produced a number of enameled pieces decorated with highly stylized floral motifs before abandoning enameling to create geometric designs using contrasting matt and polished areas through engraving or sandblasting. André Delatte is also known for his enameled glass in the Art Deco period.

Inspired by the success of René Lalique's glass scent bottles in the early decades of the twentieth century, leading perfumers began in earnest in the 1920s and 30s to compete with one another via the originality and opulence of their perfume bottle designs. The beauty industry in France had particularly flourished in the postwar years as it benefited both from increased international economic aid and from the public demand for luxurious and extravagant items to celebrate the general sense of joie de vivre. Many of the American soldiers returning home after the First World War brought back gifts of perfume and cosmetics to their wives, girlfriends, and mothers, and much of the French perfume industry was adapted to cater to this growth market. Likewise leading couture houses, such as that of Paul Poiret, Chanel, Callot Soeurs, Lanvin, Martial et Armand,

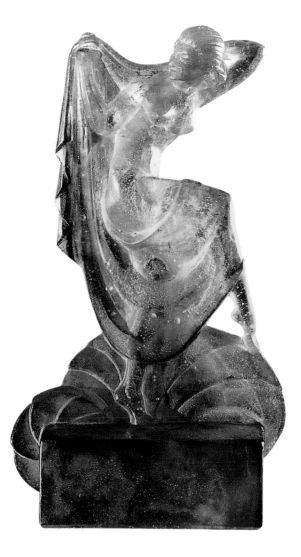

left: *Joseph-Gabriel Argy-Rousseau, a* **pâte de verre** *glass figure, circa 1928*

Worth, and Patou, began to produce in the Art Deco period their own in-house perfumes, which they first presented to their most prestigious clients as gifts before later selling them to the more mainstream commercial market. These luxurious perfumes, in their lavish packaging, were the ideal way to promote the fashion house and create a brand name for a larger audience.

The variety of perfume bottles, most usually of glass, produced in the 1920s and 30s was as varied as the range of different artistic and cultural influences that had led to the

development of the Art Deco style. The craze for the ancient cultures of Japan, China, and India prelevant at that time, was reflected in the large number of bottles designed in the form of a seated Buddha, elephants, Chinese hats, snuff bottles, or Japanese inro boxes. Many perfumers gave their products exotic Far Eastern inspired names such as Ming Toy by Forest or Chin-Li for Gabilla. Both the bottles and their presentation cases were frequently decorated with faux lacquer or shagreen surfaces. Le Jade, for example, designed by Lalique for Roger et Gallet circa 1926 of opaque green glass, was molded in the form of a Chinese jade snuff bottle, while its inro-shaped box was applied with a silk tassel to complete the Oriental theme.

Similarly affected by current crazes, the popularity for the Egyptian culture in the early 1920s was translated into bottles decorated with stylized hieroglyphics, sphinxes, lotus flowers, or pharaohs. The general enthusiasm for lavish stage settings and musical productions saw a spate of glass perfume bottles molded in the form of theatrical masks or harlequin clowns. Changes in fashion, such as the love of the smartly dressed Art Deco woman for pearls, were translated into bottles with pearlized or jewel-like finishes. A fine example of this was Le Collier Miraculeux by Parfums de Marcy in 1927, which consisted of thirteen graduated pearl-shaped bottles arranged in their box like a necklace.

Lalique was not the only designer and manufacturer of commercial scent bottles in the Art Deco period. The design and decorating firm of Julien Viard (1883–1938) was responsible for some of the most innovative creations to emerge from the perfume houses of Isabey, Lubin, Volnay, Gabilla, and Gueldy. Working in association with a range of different glassworks, the firm was particularly acknowledged for the superior quality of its figurative bottles, most likely reflecting the earlier training of Viard as a sculptor. The architect and decorative arts designer Louis Süe, as well as designing interiors for the couture houses of Piver, Patou, and d'Orsay, also designed perfume presentations for these firms. The furniture designer Jean-Michel Frank collaborated on bottle designs for the leading couturière Elsa Schiaparelli in the mid-1930s. Likewise Lalique faced competition for the production of glass scent bottles in the form of Cristalleries de Baccarat who, having produced traditional bottles for the leading perfume

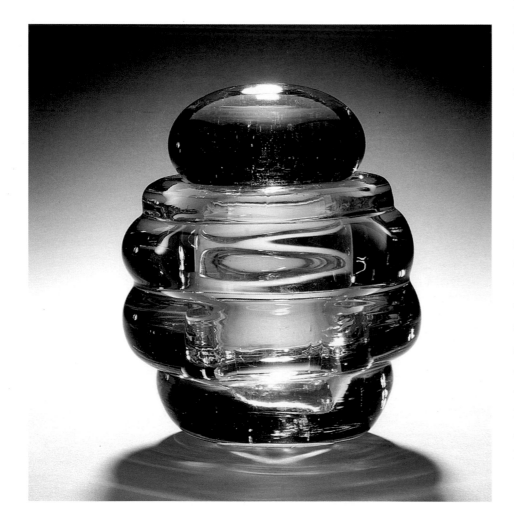

left: *André Thuret, a covered glass vase, circa 1930*

companies of the nineteenth century, had the majority of the more prominent perfume houses of the Art Deco period as their clients at one time or another. Also deserving a mention for their glass bottles were Verreries Brosse, Dépinoix & Fils, Lefebue & Cie., and Leune.

In the 1930s as the effect of the depression was felt, scent bottle designs tended to be less lavish and opulent and more in keeping with the functional streamlined forms of the Bauhaus school in Germany. The clean, linear lines of the American skyline and the simple, geometric shapes of modern machinery now provided the stimulus. There was greater emphasis on the designers to be more cost effective and less exclusive; this was especially true in America.

Equalling the importance of René Lalique's glass in the Art Deco period is the work of Maurice Marinot (1882–1960). However, instead of exploiting the industrial technology of the period for artistic expression, he followed the more established path of the traditional studio glassworker. Far removed from the mass-production techniques of Lalique, Marinot is known for his unique pieces that were individually hand-worked in the enclosed confines of his studio. Marinot escaped a career in his father's hat shop through his natural ability and passion for drawing. He attended the Ecole des Beaux-Arts in Paris between 1901 and 1905, at the end of which time he submitted a painting to the Salon d'Automne. Marinot's painting happened to be exhibited in the same room as the works of the Fauvists and thus started an association with this colorful group of artists that saw his work displayed alongside theirs at the Salon d'Automne and the Salon des Indépendants on a regular basis until 1913.

However, even as he was exhibiting his paintings, the real focus of Marinot's creative energy had shifted since 1911. That was the year in which he visited the glassworks of his friends, the brothers Eugène and Gabriel Viard. He was instantly

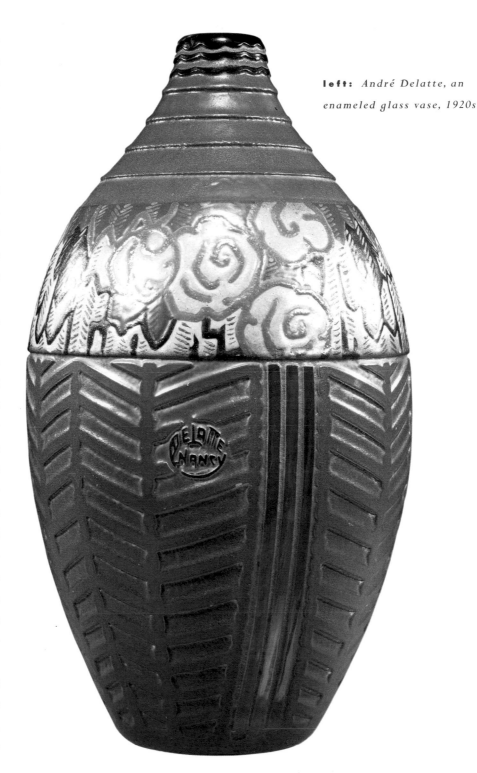

left: *André Delatte, an enameled glass vase, 1920s*

fascinated by the glass, with all its multiple qualities and, aided by the Viard brothers, set about learning the fundamental techniques of glassmaking. Initially Marinot designed models for vases and bottles that the glassworks executed. He would later personally enamel these pieces with stylized flowers, nudes, birds, and masks in bright, vibrant colors reminiscent of the palette of Les Fauves. In fact, a number of these were exhibited alongside his paintings at the Salon des Indépendants and the Salon d'Automne from 1911 to 1913.

Returning from the War in 1919, Marinot took up his work with fresh vigor. His use of external enamel decoration was soon replaced by experiments to find ways to integrate the decoration within the glass. By 1922 he had begun to blow his own glass vessels, frequently strongly sculptural in form, where the inherent qualities and faults of the glass mass itself created the decorative effect. He trapped small air bubbles, streaks and whirls of color and dusty tints of pale yellow or gray between layers of clear glass; the thickly walled vessels usually had smooth surfaces to contrast with the textured interiors. Likewise vases and bottles with small globular stoppers were repeatedly bathed with hydrofluoric acid to deeply etch away striking abstract motifs. From about 1927 Marinot started working the glass in the furnace, directly modeling or shaping the vessels, often applying molten glass to create strong sculptural forms. Shapes tend to be simple ovoid, cylindrical, or spherical gourd in form.

right: *Daum, an acid-etched table lamp, 1930s*

Like Lalique, Marinot enjoyed great critical success at the 1925 Paris Exhibition where he showed his glassware in the pavilions of the Ambassade Française, Musée d'Art Contemporain, and in Adrien Hébrard's shop on the Alexandre III bridge, the latter being his agent since 1913. The relatively small output of Marinot's work in no way corresponds with the considerable influence his glass exerted over his contemporaries; he broke with the accepted methods of treating glass, seeing it as a sculptural medium through which the glassmaker could find greater freedom and expression.

Two of Marinot's greatest followers were Henri Navarre (1885–1970) and André Thuret (1898–1965). Originally a sculptor and stained-glass artist, Navarre began experimenting with glass after 1924. He mainly produced glass that was worked in the kiln, thickly walled with internal decoration of swirling color, metallic inclusions, and interlayered effects. More than Marinot, he tended to favor the use of applications to adorn the surface of his vessels. Thuret, a glass technician for the Bagneux Glassworks, started his own experiments around the same time as Navarre. Although he created thickly walled vases and bottles, giving the clear glass internal bubbled decoration, his pieces tend to be more flowing in shape than Marinot's. Jean Sala and Georges Marcel Dumoulin were also influenced by Marinot to produce glass vessels with bubbled *intercalaire* decoration. Developing from Marinot's sculptural style, Aristide Colotte (1885–1959) produced powerful, abstract sculptural pieces that were carved, chiseled, acid-etched, or wheel-carved from large chunks of raw glass or crystal. In addition to making animal or figurative themes, he also made a number of religious sculptures, which often incorporated strong geometric motifs and forms.

As so often happens in the history of the decorative arts, the groundbreaking work of the small, individual artist or craftsman is absorbed and retranslated by the larger firms or factories, which, in an attempt to seem fashionable and progressive, respond to public taste and demand by producing versions of the original. Famed for their Art Nouveau cameo glass produced around the turn of the century, the Daum factory in Nancy reopened after the First World War in 1919. Keeping with the times, they started to produce a range of heavy, thickly walled vases in clear, transparent, or colored glass deeply etched with

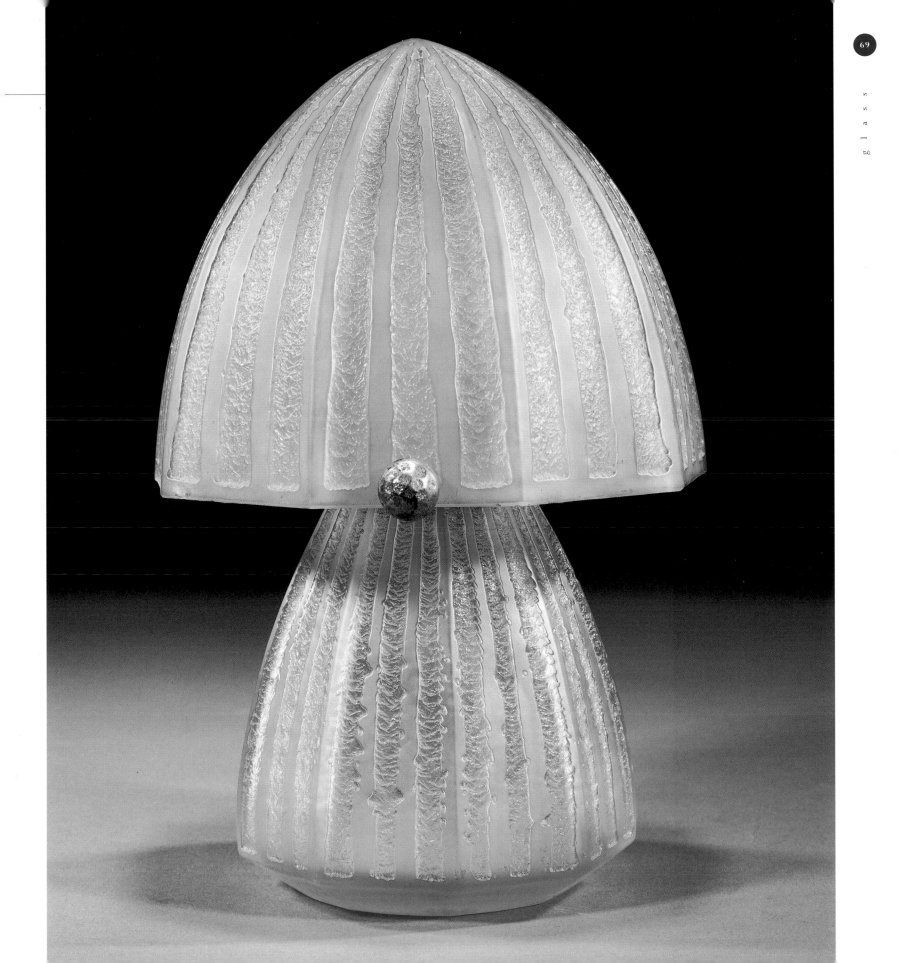

strong Art Deco geometric or floral motifs. Often the glass was blown into a bronze or wrought-iron armature made by Edgar Brandt or Majorelle, while other pieces were internally decorated with scattered gilt or silver foil inclusions. The firm favored gray, turquoise, amber, yellow, and aqua green colors.

below: *Daum, a selection of acid-etched glass vases, circa 1925*

By the 1930s Daum was using thinner-walled glass with shallower, etched decoration. They had also made a name for themselves with their range of glass lamps and lampshades, which although mass-produced retained the essence of studio-created pieces.

The Schneider glassworks, started by Charles and Ernest Schneider at Epinay-sur-Seine near Paris in 1913, was also influenced by Marinot's work and produced a range of vases

and bowls with acid-etched geometric patterns and colorful internally streaked and mottled opaque lamps, tazzas, and vases. They also made cameo glass with stylized designs incorporating floral, animal, plants, and insect motifs.

It would be easy to assume that the majority of noted Art Deco glass came only from France, but important developments were taking place throughout the rest of Europe. The Val-St-Lambert glassworks in Belgium produced a series of vases with Art Deco themes under the label Art Décoratif de Paris, mainly designed by Léon Ledru and Joseph Simon. Czechoslovakian glass in the Art Deco period was largely represented by the wide variety of molded glass perfume bottles produced throughout the country. Frequently based on French designs, for example by Baccarat, many of the bottles were relatively

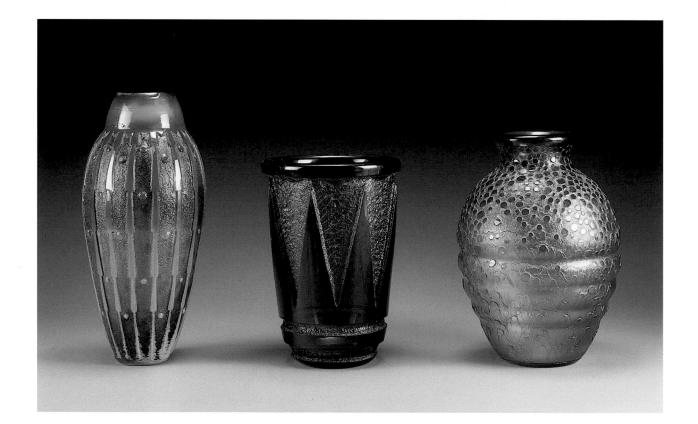

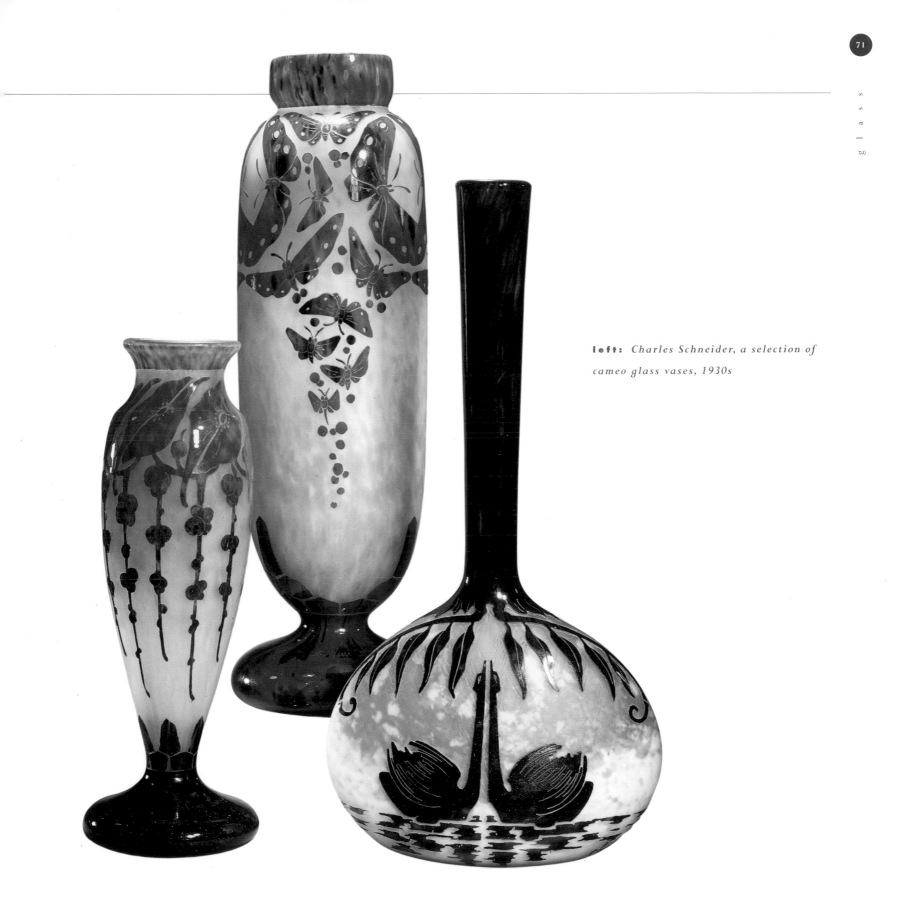

left: *Charles Schneider, a selection of cameo glass vases, 1930s*

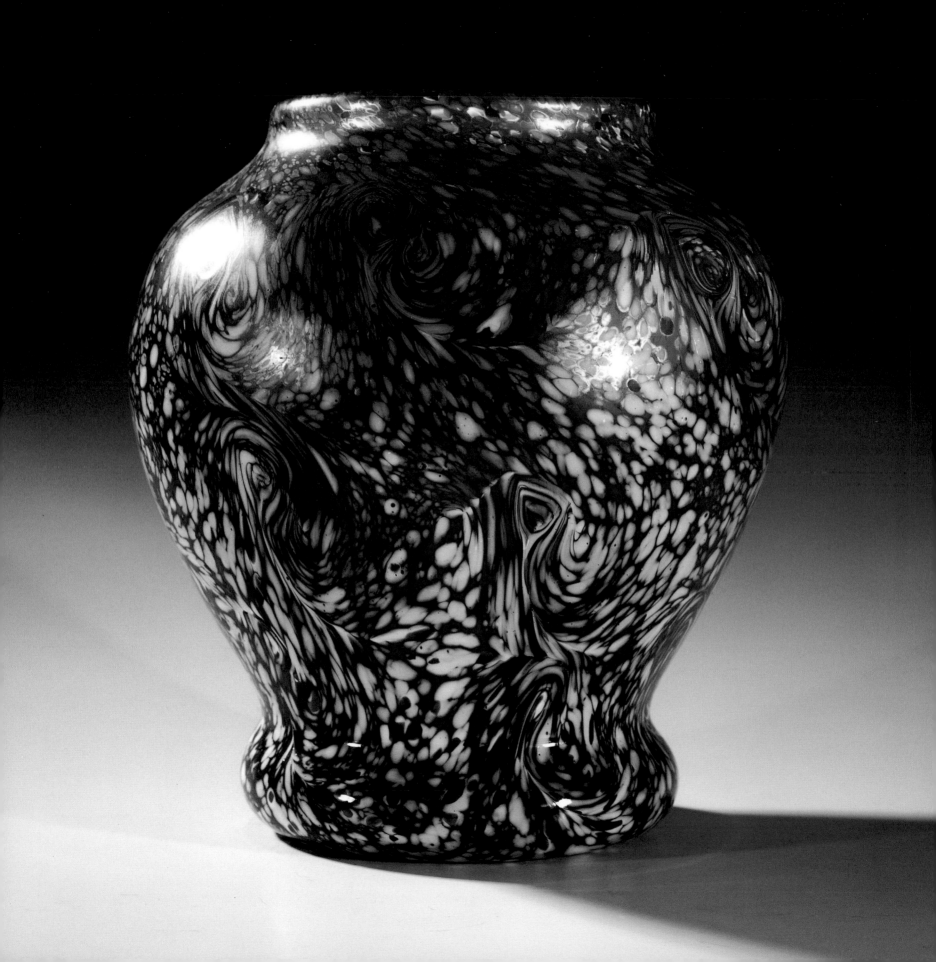

stylish with elaborate cut tiara (fan-shaped) stoppers and black enamel banding. Czechoslovakia was also responsible for a varied selection of liqueur services and decanters, usually in clear glass, decorated with black or colored enamel and engraved geometric designs.

In England the influence of Marinot's internally decorated glass was reflected in the Monart range which the Moncrieff Glassworks in Perth introduced after 1924. These light and relatively thinly walled glass vessels, which were characterized by their use of internal mottles, swirls, bubbles, stripes, or aventurine inclusions, were blown under the direction of the Spanish glassblower Salvador Ysart. Likewise the 1920s saw the Gray-Stan glassworks in London produce a selection of internally mottled and streaked art glass in rich color variations of green, yellow, red, and amber.

During the 1920s and 1930s many English glasshouses simply reverted to the long-established tradition of producing brilliant-cut glass. In order to break with established shapes and forms of decoration, many of the leading designers of the country, such as Eric Ravilious, Paul Nash, Dame Laura Knight, and Graham Sutherland were invited to submit glass designs for a Harrod's display in 1934. The firm of Stuart & Sons, in Stourbridge, was responsible for executing these designs. Likewise the Staffordshire glassworks of Stevens and Williams employed the talents of a leading designer, this time in the shape of the New Zealand architect Keith Murray (1892–1981) to add impetus to their repertoire. Working for the firm between 1932 and 1939, Murray designed a range of glass vases, bowls, decanters, and bottles (known as Brierley Crystal) where the emphasis was on simple, elegant forms with a minimal amount of fluted or engraved decoration. Clyne Farquharson (dates unknown), working for the glassworks of John Walsh Walsh of Birmingham and Stevens & Williams, also designed a series of clear glass vases and tableware typified by

their plain shapes with restrained cut decoration of stylized leaves and stems.

Many of the English glass designers, notably Keith Murray, had been influenced and inspired by the engraved glass that Scandinavia was producing in the 1920s and 1930s. This was particularly true of the Orrefors factory in Sweden. In conjunction with the production of simple utilitarian wares, the firm created a small design studio under the direction of Simon Gate (1883–1945) and Edvard Hald (b.1883) to introduce a new range of artistic glass. During the 1920s the firm produced a large quantity of finely engraved paneled glassware that relied heavily on neoclassical themes for inspiration, Gate in particular specializing in scenes of stylized Bacchanalian revelers

left: Monart, an internally decorated glass vase, 1930s

and athletes. However with the employment of Vicke Lindstrand in 1927 pieces adopted a stronger Art Deco feel and by the mid-1930s the glass had become heavier and thicker walled with fresh new themes of subaqua scenes.

Simultaneously, aided by the glassblower Knut Berkqvist, Gate and Hald developed a new technique that was called Graal glass (from the Swedish for Holy Grail). In this process a design was acid-etched into a vessel and then encased in a clear outer layer, the whole being polished to create a soft rounded effect. The early tinted floral designs soon gave way to more stylized patterns, such as naked female figures designed by Gate or abstract geometric motifs by Hald. A variation of this technique, called Ariel glass, was introduced in the early 1930s under the direction of Edvin Ohrstrom. One of the chief characteristics of this glass was its numerous encased air bubbles and, in collaboration with Lindstrand, Ohrstrom cleverly designed vases and bowls that made full use of this special effect, for example mermaids within a sea of bubbles.

Throughout the years Orrefors employed many fine designers and glassworkers: Gustav Abels, Edvard Stromberg,

Johann Selbing, Sven Palmquist, and also Nils Landberg. Orrefors' stand at the 1925 Paris Exhibition made a strong and favorable impression among their contemporaries, the superior quality and crispness of their engraving leading the way for future glassmakers.

Sweden was not the only Scandinavian country that made a contribution to the development of Art Deco glass. The Karhula-littala glassworks in Finland commissioned the leading architect and designer Alvar Aalto to design a range of modern glass, while the Holmegaard Glasvaerk in Copenhagen employed the talents of another architect-designer, Jacob E. Bang, to create a functional yet stylish line of glass tableware

below: *Eric Ravilious, a cut and etched glass vase, for Stuart Glass, circa 1934*

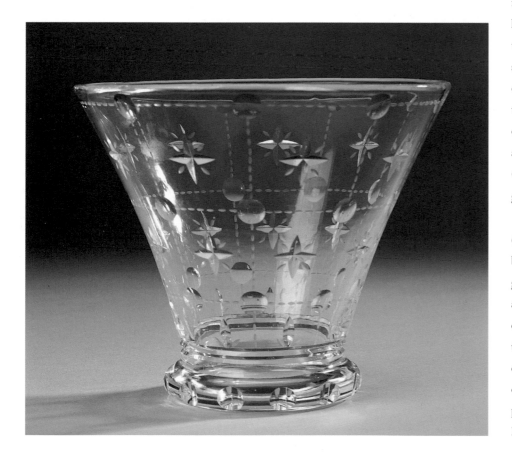

and vases. The Hadelands Glassverk in Norway produced a range of pieces with restrained engraved decoration. Elsewhere in Europe, the trend of drawing on the creativity of leading architects to design modern glass was continued at the Leerdam glassworks in Holland where Hendrik Berlage and K.P.C. de Bazel created a range of glass that was suitable for mass-production techniques. Important contributions to the firm's repertoire were made by Andries Dirk Copier, Cornelis de Lorm, and Chris Lanooy.

In the United States, the master Art Nouveau glassmaker and artist Louis Comfort Tiffany (1848–1933) had dominated the field of glass in the early part of the twentieth century. Comparable only to the works of René Lalique and Emile Gallé, in terms of its contribution to this sphere of the decorative arts, his work had acted as a beacon to those American glassworkers who were still caught up in the traditionalism and revivalist styles of nineteenth-century Europe. As the Art Deco style emerged in the 1920s and 1930s there was the possibility that the brightness of Tiffany's talent would overshadow the development of any new modern style. Fortunately firms such as the Steuben Glass Company, a division of the Corning Glassworks from 1918, led the way forward for the next generation of American glassmakers and designers.

Under the direction of the Englishman Frederick Carder (1863–1963), formerly employed at Stevens & Williams between 1881 and 1902, Steuben introduced a new range of glassware in the French high Art Deco style during the 1920s and early 30s. Carder was initially responsible for many of the designs himself, the majority of which were characterized by their alternate use of zigzags, stylized gazelles, and curved outlines. After Carder's departure from the firm in 1934, many of the most important pieces to emerge from Steuben in this period were due to the talents of Sidney Waugh and Walter Dorwin Teague. Both artists drew on a number of different

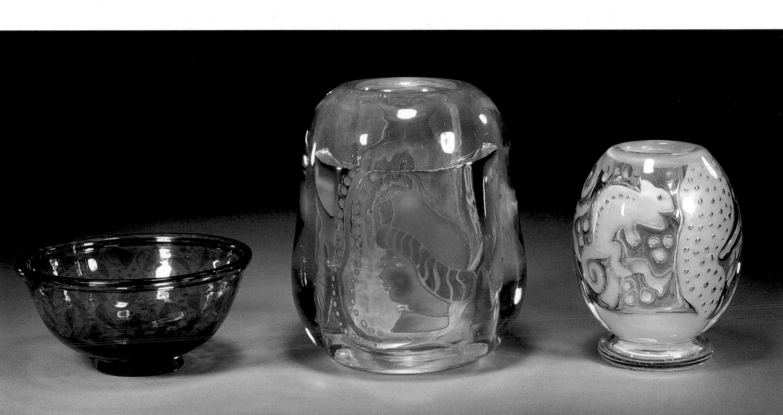

influences but the contemporary work of Scandinavian glassworks, in particular Orrefors, provided the greatest inspiration. Acting as chief associate designer for Steuben from 1933, Waugh created glass that incorporated designs of highly stylized animals and figures that, when finely engraved onto the clear crystal, created the illusion of bas-relief. Teague likewise employed engraved motifs and figures to decorate his simply shaped crystal wares.

The worldwide effect of the Depression led the majority of the American glass manufacturers to abandon the production of their exclusive designer pieces in favor of mass-produced press-molded ware. Eventually becoming known as Depression Glass, these pale or pastel-colored pieces relied more on their geometric shapes and outlines than on their decoration for effect. Always intended for the cheaper end of the market, this particular type of glass was important in its time for introducing the Art Deco style to a more mainstream audience.

There is no particular feature that characterizes the glass produced during the Art Deco period, but rather a number of different influences that intermingled to produce pieces that, though benefiting from the various achievements of the master Art Nouveau glassworkers, firmly identified themselves with the twentieth century. Artists like Lalique and Marinot drew both on the latest technological developments as well as the long-standing traditions and practices of the studio glassworker.

above: *Orrefors, a bowl and two vases, circa 1938 and 1951*

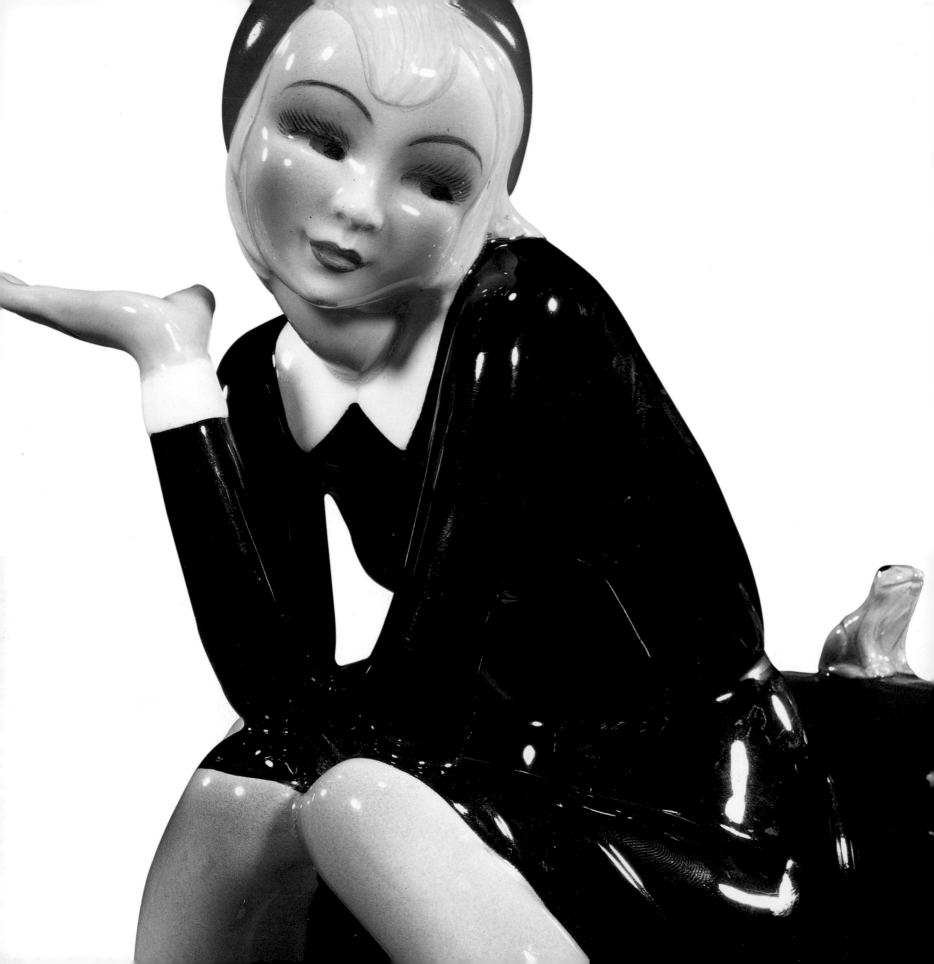

CERAMICS

chapter four

Like so many other areas of the decorative arts, the field of ceramics during the Art Deco period benefited from the numerous different artistic and cultural influences that were marking the period. The work of the leading potters of the Art Nouveau movement were heavily influenced by the simple shapes, yet intricate glazes, of the Oriental wares being introduced into Europe at the end of the nineteenth century. The ceramicists of the 1920s and 30s continued to rely on the art of Japan and China for inspiration, but rather than submerging themselves totally in this influence they also looked towards contemporary trends and fashions for fresh impetus. The arrival of Sergei Diaghilev's (1872–1929) Ballet Russe in Paris in

below: *Sèvres vase, by Jacques-Emile Ruhlmann, 1931*

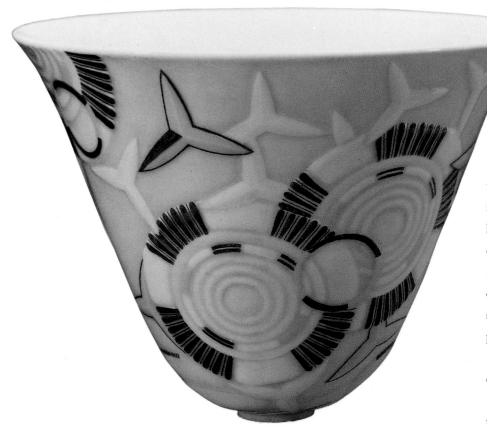

1909, with its exotic costumes and bold and bright stage sets sparked the production of ceramic wares painted in a dazzling array of vibrant colors. The increasingly fashionable tribal art of Africa, with its highly stylized masks and figures, heralded the introduction of geometrically shaped tableware, be it a vase, teapot, or dinner plate. Likewise the avant-garde painting movements of the period, most notably Cubism, had a profound effect on potters. Exhibiting at the 1925 Paris Exhibition, the Cubist work of Sonia Delauney (1885–1979) and Fernand Léger, characterized by their use of planes of strong color and the abstract juxtaposition of shapes, encouraged ceramics designers to radically rethink the traditional design process. The paintings, in particular the analytical Cubist designs of Pablo Picasso (1881–1973), taught designers to focus more on each individual object, with greater emphasis placed on the item's relationship within time and space. All of these influences, as in other spheres of the applied arts, were able to germinate internationally owing to the improved communication processes, especially printing, that were developing in the Art Deco period.

In France, many commercial ceramics factories embraced the newly emerging Art Deco style with enthusiasm. Ever since its establishment in 1738, the national porcelain factory Sèvres had long led the way in ceramic design in its country. Under the direction of Georges Lechevallier-Chevignard, in the 1920s and 30s, the firm adopted the policy of employing leading freelance designers and sculptors to supplement their creative pool. The success of the policy had already been seen in the Art Nouveau period, for example when the sculptor Agathon Léonard (b. 1841) had produced a series of biscuit porcelain figures, entitled the Scarf Dancers, for display in the firm's stand at the 1900 Paris International Exhibition. The Art Deco years saw the tradition continued at Sèvres as the sculptor Francis Pompon

reproduced his stylized bronzes, most notably his sleek polar bear, in the factory's high quality porcelain and the brothers Jan and Joêl Martel produced a craquelure glazed figure of a cat in 1929. Working as a consultant for the factory between 1934 and 1939, Jean Mayodon (1893–1967) introduced the influence of the Far East when he designed a series of vessels with metallic oxide glazes as the sole form of decoration. He was later to return to the Sèvres factory as its artistic director between 1941 and 1942. Also included among the repertoire of designers executing work for Sèvres in the Art Deco period were the painter Raoul Dufy (1877–1953), the designer Jacques-Emile Ruhlmann, and the poster artist Jean Dupas.

The 1925 Paris Exhibition was an important event for the Sèvres factory. Lechevallier-Chevignard, in association with Paul Léon and Henri Rapin, commissioned the architect Pierre Patout to design an impressive pavilion that would announce the firm's supremacy in the decorative arts. Contributing to the interior design were the glassmaker René Lalique, the sculptor Max Blondat, and the designer Edouard Benedictus.

The Sèvres factory was not the only commercially driven firm to adopt the modern decorative style. In Paris, many of the leading retailers of the day, always sensitive to their customers' tastes, began to sell ceramics reflecting the new artistic influences. Most important was the Atelier Primavera, which, being the ceramic department of the large departmental store Au Printemps, listed more than 13,000 different designs in its stock by the 1920s. Though many of these designs would have been traditional in shape and decoration, a large part of the list would have been dedicated to the increasingly fashionable Art Deco style. Much of the latter group was produced under the guidance of René Buthaud (1886–1987). Though originally trained as a painter, Buthaud later changed the direction of his talent towards ceramics, so that by 1918 he was a regular

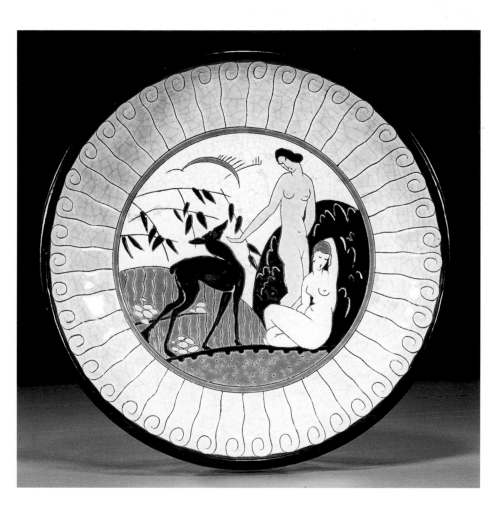

exhibitor of this medium in artistic circles and his work was recognizable in many places at the 1925 Paris Exhibition. Heavily influenced by tribal art, Buthaud commissioned local craftsmen to throw pots that were covered in high-fired monochrome and craquelure glazes. He developed a distinc-

above: *Longwy, a pottery charger, circa 1930*

tive glaze called *peau de serpent* that imitated the texture of snakeskin. His work for Atelier Primavera was characterized by its use of stylized African-inspired female figures.

The Lorraine-based ceramics firm of Longwy also contributed wares to Atelier Primavera's stock. Their pieces were

instantly recognizable for their use of a bright turquoise palette and craquelure glaze, both of which were in imitation of Oriental cloisonné work. Like Sèvres, Atelier Primavera had its own pavilion at the 1925 Paris Exhibition, which, designed by Sauvage and Wybo, was formed as a glass-capped pyramid.

The Parisian retailer Robj took a slightly more humorous approach to the Art Deco style. Producing a wide range of lamps, inkwells, and general domestic ware, the firm was particularly successful with its series of wine flasks alternatively modeled as professional workers—judges, soldiers, and vicars were depicted

right: Edmond Lachenal, a pottery vase, 1925

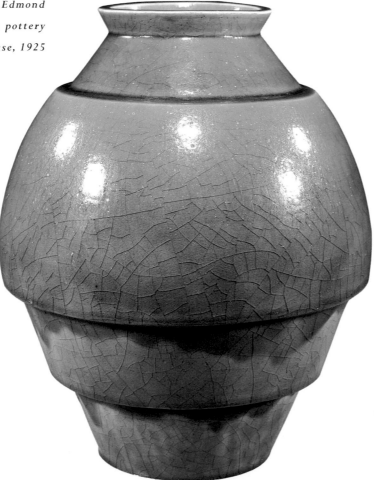

with bright rosy-cheeked complexions that were intended to reflect the flask's contents. Sponsoring an annual competition between 1927 and 1931, Robj invited contemporary artists to design wares, which would then be manufactured by the firm. Their series of figures modeled as a stylized jazz band, produced circa 1925, perfectly capture the frivolity of the period.

In contrast to the more commercially minded firms that produced Art Deco stylized wares in France during the 1920s and 30s there was also a growing number of studio potters who were more inspired by the desire to discover new and also to explore old glaze techniques and formulas in the pursuit of beauty. In France, as elsewhere in Europe, the pioneering studio potters of the early part of the twentieth century had been strongly influenced by the Japanese and Chinese wares that were being shown at national and international fairs and exhibitions at that time. Many of these potters made the decision to reject the low-grade mold-produced wares of the large ceramics factories and instead they concentrated their energy on the small-scale production of the studio, which allowed for experimentation and trial. Choosing hand-painted decoration, as seen on Oriental pots, in preference to mass printing, these Art Nouveau studio potters left a legacy that was later picked up by ceramic artists during the Art Deco years.

The ceramicist Auguste Delaherche (1857–1940) produced a range of simple vases, both in stoneware and porcelain, which provided the canvases for his experiments with glazes. In Boulogne-sur-Seine, Edmond Lachenal first attempted to perfect the ancient technique of flambé glazes before seeking to recreate the appearance of cloisonné enamel in his glazes. His work influenced that of his apprentice, Emile Decoeur (1876–1953), who, though initially producing floral-decorated wares

right: Goldscheider, a pottery figure by Josef Lorenzl, circa 1935

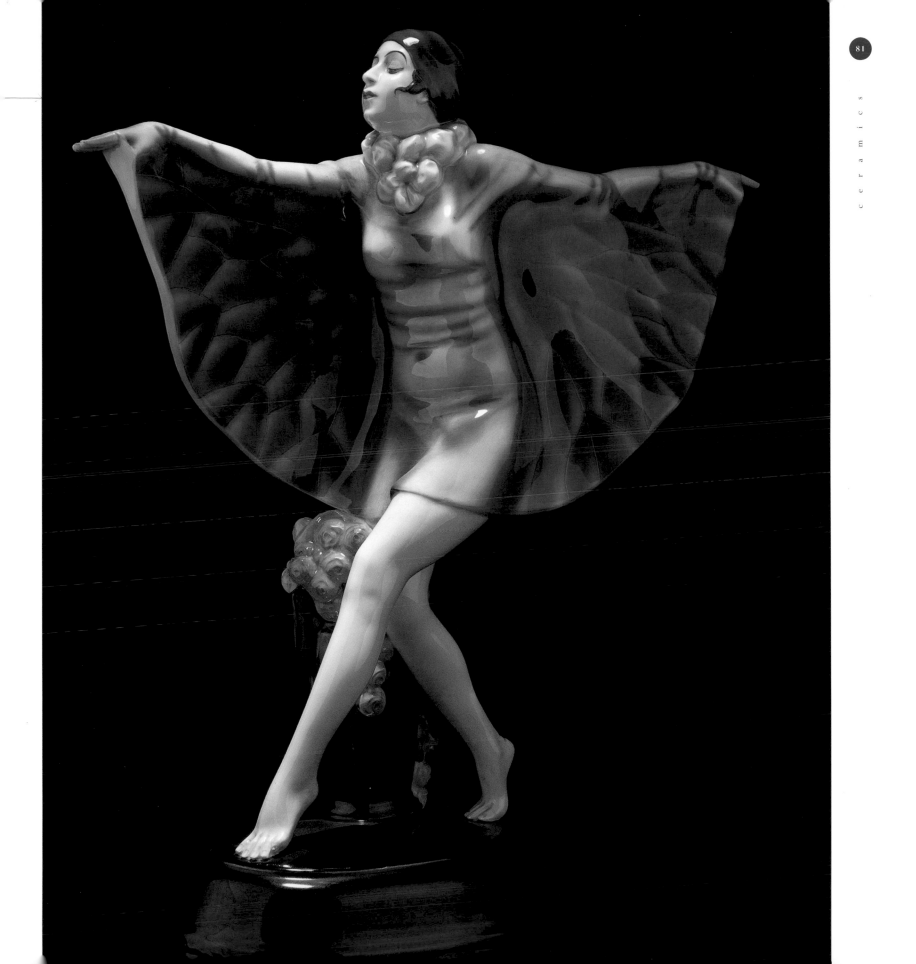

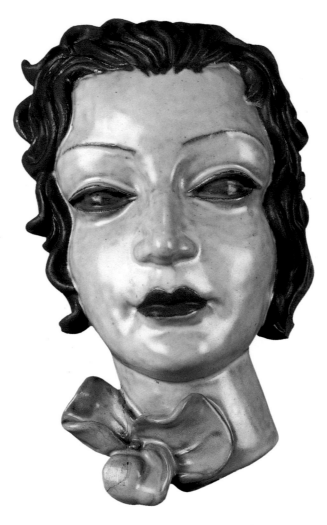

above: *Goldscheider, a terracotta
mask, circa 1930*

Emile Lenoble (1875–1940) introduced an element of decoration into his studio wares in the form of incised and painted motifs. Having worked with the influential Art Nouveau potter, Ernest Chaplet, in Choisy le Roi circa 1904, Lenoble later progressed to producing plainly glazed wares with a simple geometric motif or stylized floral design. These pieces were particularly popular with contemporary interior designers, such as Ruhlmann, who incorporated them into his overall design schemes. The increased interaction between the fine and decorative arts saw artists such as Henri Matisse, Odilon Redon, and André Derain employed by the potter André Metthey to decorate his ceramic wares. The sculptor Auguste Rodin encouraged potters including Séraphin Soudbinine to incorporate sculpture into their ceramic work.

In Belgium the leading ceramic designer of the Art Deco period was Charles Catteau (1880–1966). Joining the Boch Frères ceramic factory in 1906, a year later being promoted to its artistic decorator, he reintroduced the technique of throwing by hand, which replaced the low-quality mold-produced wares that until then marked the firm's output. Designing both the shape and decoration, Catteau's wares were characteristically monumental in scale and demonstrated the influence of African art in their use of exotic flora and fauna and stylized animals, such as elephants and gazelles, as decorative themes. However, the bright enamel finish of these pieces, boldly applied in shades of blue and green, also reflected the influence of traditional Japanese cloisonné wares. Catteau was awarded a Grand Prix for his work at the 1925 Paris Exhibition.

In Austria the leading ceramics manufacturer of Art Deco wares was the Goldscheider factory. Initially founded in 1885 to produce ceramic and stone reproductions of classical figures that were on display in local Viennese museums, the factory production by the 1920s was based around a series of stylized figures and wall masks designed by some of the most popular

before the First World War, later went to work in Paris where his oeuvre became more focused on the interplay between architectural form and monochrome glazes. The simple shapes of Decoeur's wares and the experimental nature of his glazes were a direct homage to Oriental pottery. Henri Simmen also studied under Lachenal and went on to produce Far Eastern–inspired ceramic pieces. He often worked in conjunction with his Japanese-born wife who produced many of the wooden stands and ivory covers for his wares.

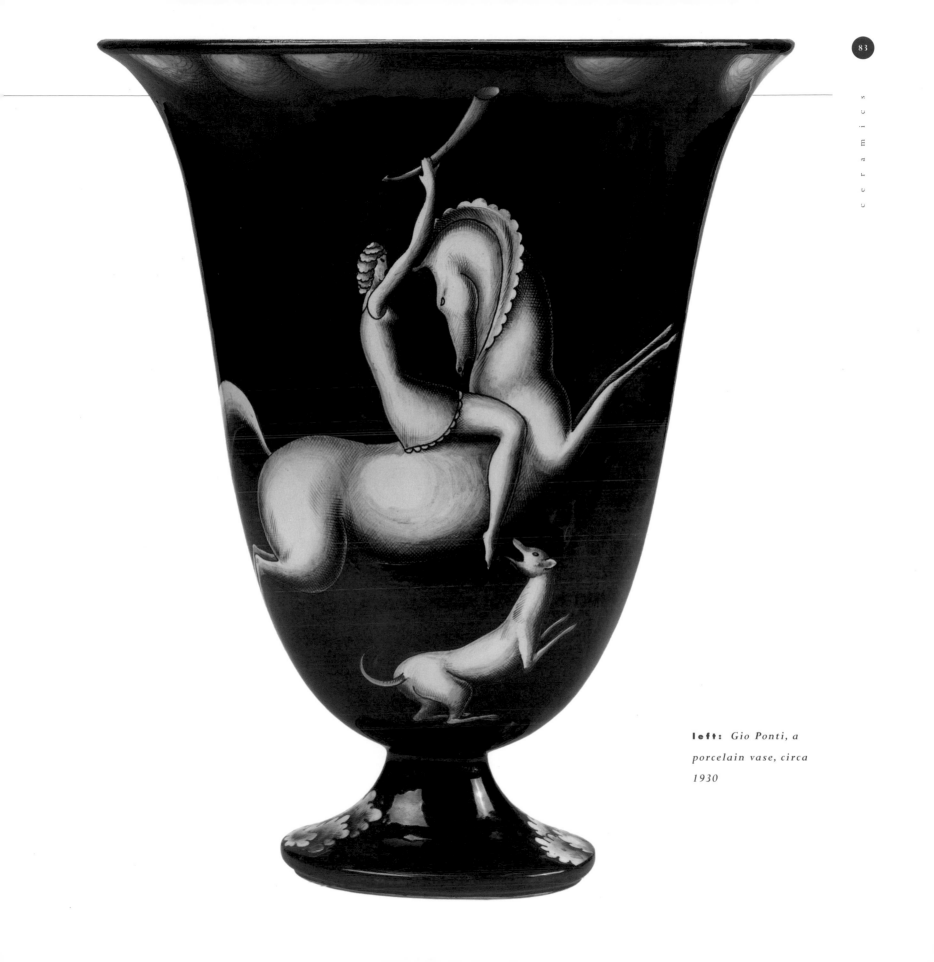

left: *Gio Ponti, a porcelain vase, circa 1930*

ceramics

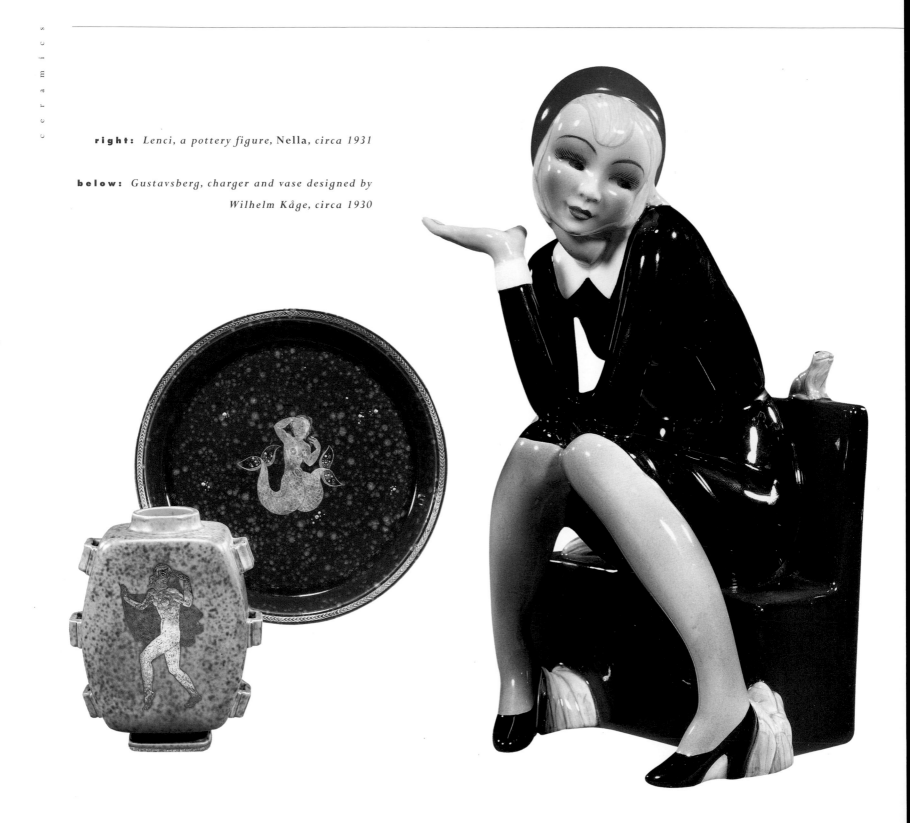

right: *Lenci, a pottery figure, Nella, circa 1931*

below: *Gustavsberg, charger and vase designed by Wilhelm Kåge, circa 1930*

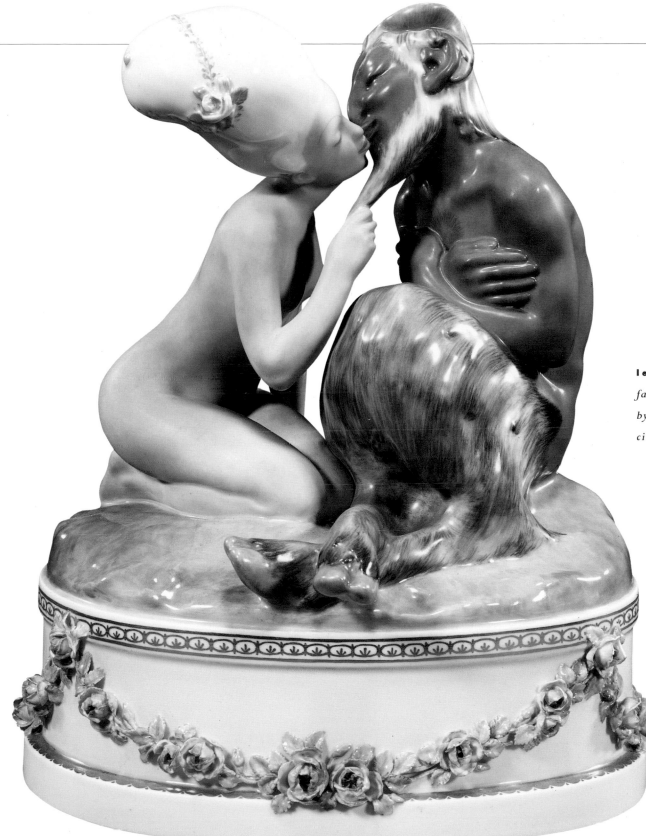

sculptors of the day. Under the guidance of Walter and Marcell Goldscheider, designs by the sculptors Bruno Zach and Josef Lorenzl were translated from bronze and ivory into ceramic. Brightly painted by hand, these mold-produced porcelain figures were retailed at a fraction of the price of the sumptuous bronze originals.

The figures were often modeled on contemporary dancers or performers, such as Josephine Baker, or were sometimes recognizable as being leading socialites. Working to Lorenzl's designs, Goldscheider also produced a series of earthenware wall masks, which had more in keeping with the studio pottery of the influential Austrian workshop, the Wiener Werkstätte, though they tended to be cruder in concept and far more abstract.

right: *Detail of a Clarice Cliff House and Bridge pattern plate, circa 1930*

These highly stylized faces were very much influenced by the African tribal masks that had been in vogue in Paris since 1910.

The German ceramics movement in the 1920s and 30s was intrinsically linked with the Bauhaus, the school founded in 1919 by Walter Gropius that based its format on the Arts and Crafts guilds of late-nineteenth-century Britain. However, this fast-moving artistic group had, by 1922, progressed from admiring the handmade craft ethos of those guilds to becomming one of radical new design. A brand new breed of designers, such as Marcel Breuer, were encouraged in the school's inspirational environment to use new materials and production techniques like tubular steel and bentwood. Handmade items were generally deemed costly and an inefficient use of resources. These concepts were reflected in the ceramics, which the school's artists, such as Margarete Friedlander-Wildenhain and Margarete Heymann-Lobenstein (b. 1899), produced. The latter created a teapot of conical form with a unique solid handle made up of two circular discs; the discs being echoed on the finial and the large flat disc foot. Available in monochrome glazes that emphasized its stylized

form, it proved unpopular with consumers, who found it awkward to use, irrespective of its revolutionary design. Upon the Bauhaus' move to Dessau in 1925 the ceramic department of the school was closed.

The response in Italy to the Art Deco style was different from that of the Northern European countries. The pottery firm of Richard Ginori produced a range of porcelain and earthenware vases and plates to the designs of Gio Ponti, which reflected the country's classical legacy. Urn-shaped vases and plates were painted and printed with stylized classical figures, the high quality of the hand painting being comparable in quality to that of the famed Sèvres factory in France. The Lenci factory, founded in Napoli by Enrico Scavini and Elena Scavini in 1919, initially produced children's dolls and wooden furniture before moving to the manufacture of ceramics in 1928. Drawing immediate critical acclaim, the production of ceramics at Lenci was based around a range of earthenware figures, wildly ranging from innocent Madonna-like figures to risqué scantily clad young women. Many of the figures conveyed a humorous feel; for example, a pair of bookends often consisted of a studious girl reading at one end, while the other end was modeled as the same girl kicking her legs in the air, the book discarded. Other more surreal figures included a nude girl riding a hippopotamus or a sea-creature, while figures of stylishly dressed young women standing beside miniature skyscrapers demonstrated an interest in contemporary architecture. The success of Lenci's more religious wall masks and figures and their large volume of sales allowed the firm the freedom to experiment with the more adventurous figures.

The firms of Royal Copenhagen and Bing & Grøndhal dominated the ceramic market in Denmark. Long-established for the superior quality of their work, the Royal Copenhagen factory's work in the 1920s was marked by its production of a series of porcelain figures. Frequently based on characters from

Hans Christian Anderson's fairytales or figures in national dress these figures received much critical acclaim at the time, a small Icelandic Girl (designed by Arno Malinowski (1899–1976), in fact was purchased by the Victoria and Albert Museum in London in 1934 for its collection. Other designers who contributed to Royal Copenhagen's success in the Art Deco period were Gerhard Henning (1880–1967) and Christian Thomson. The dominant Oriental influence on the decorative arts in the 1920s was reflected in the factory's production of plainly shaped wares with experimental glaze effects. The firm of Bing & Grøndhal continued its production of high-quality, though traditionally styled, wares until 1912, when, under the direction of Carl Peterson, it began to introduce a range of stoneware items drawing on contemporary trends. Designers including Knud Kyhn (1880–1969), worked for Royal Copenhagen and developed a series of heavy stylized

right: Clarice Cliff, an Appliqué Orange Lucerne Conical coffee set, 1931

figures and abstract vases in subtle mottled brown and green glazes, which were exhibited at the 1925 Paris Exhibition.

Wilhelm Kåge, the artistic director at the Gustavsberg porcelain works in Sweden, produced a series of highly finished wares under the label Argenta. Having joined the company in 1917, Kåge had immediately tried to introduce simple, functional designs, which, though cheaper to produce, would lack the crassness of some contemporary mass production. The Argenta range, which was first brought to the public's attention in 1930 at the Stockholmsutsallingen Exhibition of Art and Design, proved immediately popular and continued in production till the 1950s. Using mottled green glazes, these stoneware items were inset in silver with highly stylized nubile female figures, animals, and near abstract floral motifs. Kåge also designed the Praktika range of domestic ware in 1933, which, though benefiting

customers with its space-saving stacking abilities, proved commercially unpopular. The Gustavsberg factory exhibited in the Swedish pavilion at the 1925 Paris Exhibition alongside other native ceramic firms, namely the Rörstrand Porcelain factory and Upsala-Ekeby. The former achieved recognition for its services and objects in faience and porcelain designed by leading artists such as Nils Lundstrom, Edward Hald, and Karl Lindstrom.

The ceramic designs produced in Great Britain between 1929 and 1940 showed, of all the different spheres of the decorative arts, some of the strongest links with the European Art Deco style; these designs, however, also emphasized some of the differences. Though the country was represented at the 1925 Paris Exhibition, the critics and public did not warmly receive its pavilion. English ceramic factories responded by adopting a policy of using recognized designers and promoting new talent to design and advertise their wares. These designers, many of them women, were quick to understand the joie de vivre of the new modern age and quickly rose to positions of power and influence within their respective firms. Though the British economy of the interwar years was suffering from the side effects of the worldwide depression accentuated by the Wall Street crash of 1929, the standard of living for the majority of the country was growing to unprecedented levels. The spread of cinemas, radios, newspapers, and magazines (such as *Ideal Home*), saw fashion become intrinsically linked with lifestyles. The general public, tempted by the additional advertising that the increased forms of communication brought about, craved new design as never before. The ceramic manufacturers organized bold advertising campaigns and countrywide exhibits to promote their chief designers' work, so much so that in time many of these designers became national names in their own right.

Clarice Cliff (1899–1972) was one of the leading ceramic designers working in England in the Art Deco period. Her

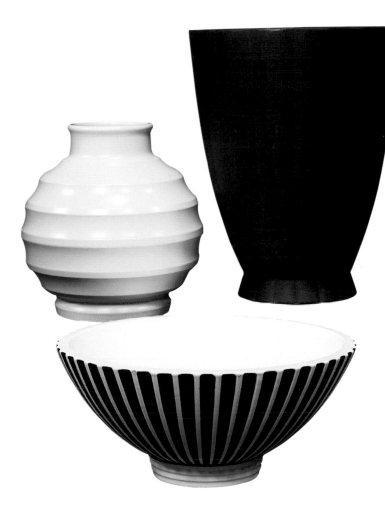

bold palette of oranges and yellows and range of distinctively shaped pottery wares lit up the grayness of the drab depression years. One of seven children and born in the long-established pottery region of Staffordshire, she joined the ceramics firm of A. J. Wilkinson as an apprentice lithographer in 1916. In 1922 she came to the attention of its owner, Colley Shorter, and was appointed as an apprentice modeler at his newly acquired Newport pottery on the edge of the Wilkinson factory. Possibly after having visited the 1925 Paris Exhibition, Cliff was asked by Shorter in 1927 to

above: *Keith Murry, two Wedgwood vases and a bowl by Norman Wilson, circa 1934*

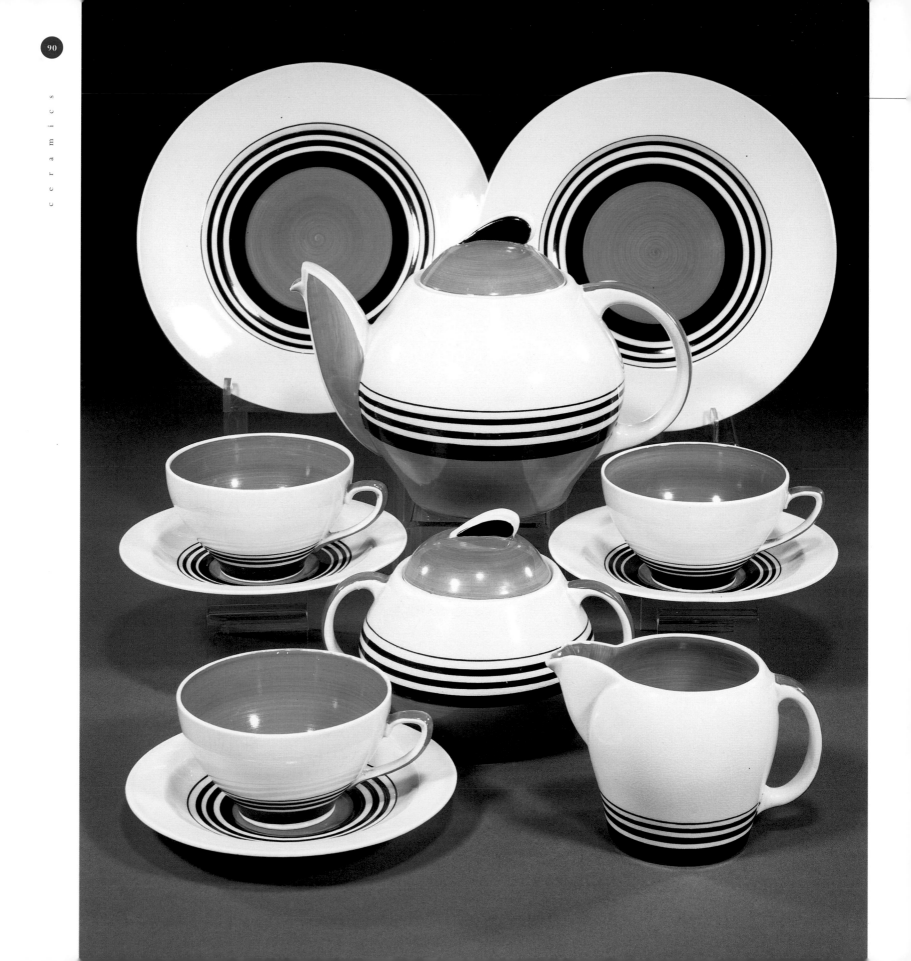

decorate a selection of the firm's old stock. She immediately decorated these traditionally shaped pieces with banded or geometric patterns in a variety of bright colors. Simply marked "Bizarre," these boldly decorated utilitarian wares were immediately popular in the retail outlets in which they were offered. Following on from this success, Cliff introduced the Crocus pattern in 1928, a simple design consisting of hand-painted flowers, which continued in production till after the Second World War. As Colley Shorter set about promoting the wares and the artist, the printed Bizarre back stamp became Bizarre by Clarice Cliff. Together with her team of paintresses, Cliff toured the country, setting up temporary displays in the large departmental stores, such as Waring & Gillow in London.

Clarice Cliff drew on a number of influences for her designs, from the works of the Austrian designer Josef Hoffmann and Margarete Heymann-Lobenstein at the Bauhaus to the French designer Edouard Bénédictus (1878–1930). The latter's vibrantly colored *pochoir* prints provided the inspiration for many of her color combinations and could be seen in both the Lucerne and Lugano designs of her Appliqué range, which she first introduced to the market in 1930. This range was characterized by its thickly enameled paints in bright, bold colors and the loosely painted designs that covered the entirety of the ceramic vessel. As the stylization and geometry of the Art Deco style gained general popularity, Cliff introduced the Conical range in 1929. The cone shape provided the basis for a range of items including a bowl resting on four square feet, a sugar sifter, and a vase with flange supports mounted on a foot. Her designs showed the influence of the French Art Deco designer, Desny, who had been responsible for a number of conical-shaped metal cocktail glasses. The Yo-Yo vase, which involved mounting an inverted cone on top of another cone to form a highly stylized

but basically impractical vase, illustrated the extent of her constant experimentation in this area.

Alongside Clarice Cliff, the potter Susie Cooper (1902–1995) was the other great name in the field of British Art Deco ceramics. Born in Burslem in 1902, Cooper started her career by working under Gordon Forsyth at the ceramics firm of A.E.Gray & Co. Ltd. She hoped this employment would lead her to a scholarship at the Royal College of Art in London where she planned to study fashion design. Working at Gray's between 1922 and 1929, she initially designed patterns that could be applied to the firm's traditionally shaped wares. These early designs, with their use of stylized animals, such as the gazelle, flowers, and geometric motifs, were already showing her understanding of the blossoming Art Deco style. Slowly gaining credence for her work, Cooper regularly exhibited at important national and international fairs and shows, such as

left: *Susie Cooper Pottery, Kestrel tea set, 1931*

the 1923 British Industries Fair. With the support of her brother-in-law and savings of £4000, she left Gray's in 1929 to set up on her own. By 1930 she had founded Susie Cooper Pottery where she was designing the shapes as well as the decorative patterns. The commercial success of her pottery led to expansion, remarkable in a time of recession, in 1931 when she bought the Crown Works in Burslem. Her designs were being advertised in magazines such as *Pottery Gazette* and *Glass Trade Review* as "Elegance combined with Utility. Artistry associated with commerce and practicality." Always demanding perfection from her decorators, Cooper introduced the Kestrel range of tea ware in 1932. The teapot was of ovoid form with a streamlined handle and spout that ran up the side of the body with a hooked lip; Modernist in style, the design was also highly practical.

Information on contemporary European ceramic design and new artistic theories was relayed to the British ceramics

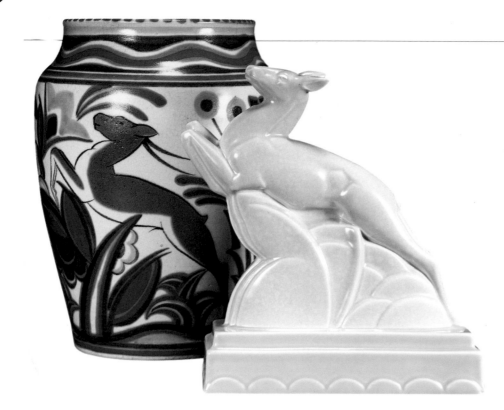

above: *Poole Pottery, a vase and bookend, 1935*

designer in the 1930s through a series of lectures in Stoke-on-Trent, the heart of the country's pottery industry. The architect and lecturer, Serge Chermayeff, came to England in 1910, and through artistic groups such as MARS (1933–1936) and lectures at Stoke-on-Trent, he preached the Modernist ethos. His belief was that the design, and not the decoration, was the most important part of an item. For example, Susie Cooper's Kestrel teapot would have been championed by Chermayeff as good design, but only when complemented by a simple graduated linear design and not when decorated with a fussy floral spray. Also leading the way forward for British Art Deco ceramic design was Gordon Forsyth (1879–1953). His visits to international fairs and exhibitions, such as the 1925 Paris Exhibition, exposed him to developments in the Continental ceramics field that he brought back to his students at the Stoke-on-Trent Art School. In his book *Twentieth Century Ceramics* Forsyth echoed many of the design principles of Chermayeff. Believing in the potential of the machine, he stated in the introduction of his book that "the ingenuity that made the machine can be turned to good account in the production, not only of unity, but of beauty." He illustrated the two different poles of tableware, writing "the purely functional, which has nothing to do with art, to the purely decorative, which has nothing to do with function," and that successful designs must aim for "maximum decorative purpose allied to maximum functional purpose." The ideas of both Chermayeff and Forsyth, were quickly absorbed by contemporary ceramicists and potteries, and were used as the basis for many pieces in the emerging Art Deco style.

The long-established English ceramics factory Wedgwood, Stoke-on-Trent, went through a period of tremendous change in the 1930s. Assembling a new team of eager, young designers, the firm explored the potential of modern production techniques, though this was tempered to a certain extent by the general commercial depression.

Leading the factory forward was Victor Skellern (1909–1966) who joined Wedgwood following the end of his schooling in 1923. Like Susie Cooper, he took time out to further his art education at the Burslem School of Art under Gordon Forsyth and in 1930 accepted a scholarship to study at the Royal College of Art in London under the artist Edward Bawden. On his return to Wedgwood, Skellern developed production methods, such as the use of lithography for decorative purposes, and began the policy of commissioning leading artists to produce designs for the firm's wares.

One of the most important of these designers, and a highly influential player in the development of British Art Deco ceramics, was Keith Murray. Born in New Zealand before emigrating with his family to England in 1906, his early training as an architect was terminated by the outbreak of the First World War. Following this, Murray's initial foray into the field

of design was his work for Marriot Powell at the Whitefriars glass factory in Wealdstone, London, and then the glassworks of Stevens & Williams at Brierley Hill in Staffordshire. Having been introduced to Felton Wreford, the manager of Wedgwood's London showroom, in 1932, and subsequent to a meeting with the factory's then owner, Josiah Wedgwood V, Murray began to submit ceramic designs for production. Following a formal contract in 1933 it was agreed that Murray would work for the firm for three months a year.

For both Stevens & Williams and Wedgwood, Murray produced a plethora of sketches to illustrate his designs. Many of these designs were equally suited to glass and ceramics and were produced in both media. Cool and architectural in style, based on simple angular or spherical forms, Murray's earthenware or basalt wares would be covered in a variety of monochrome glazes created by Norman Wilson. Obviously influenced by the stylized forms of the European Art Deco style, Murray's vases and bowls were frequently accentuated with simple decorative patterns of graduating grooves, which, incised into the wet clay, were produced by hand at the lathe. The contemporary look of his wares made them an immediate commercial success. Advertised in the form of hand drawings, the modern, clean shapes of Murray's designs skillfully reflected Wedgwood's long-established tradition of producing fine quality basalt ware.

As already mentioned Norman Wilson (1902–1988) played an important part in the development of new glazes at Wedgwood. Having joined the firm in 1927 as one of its first young artists, he was responsible for the introduction of a new copper color for the basalt range. Regularly exhibiting his work, such as in the Grafton Galleries exhibition in 1936, his constant experimentation with new glaze techniques bore close affinities with the work of Lachenal and Decoeur in France. The lithographic designs of Eric Ravilious (1903–1942), although

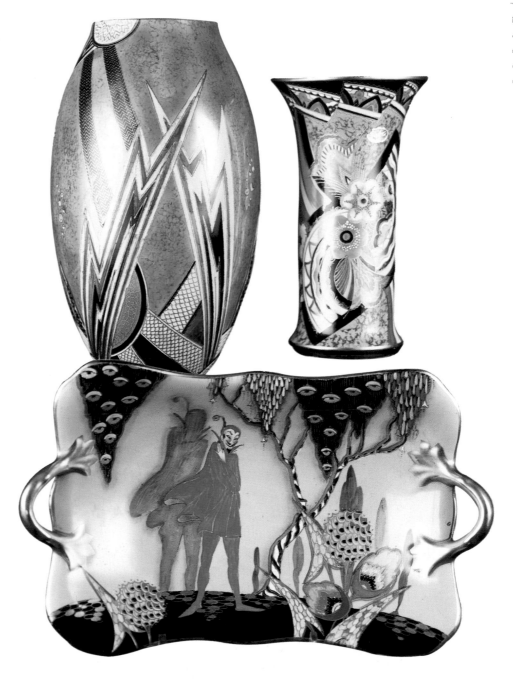

above: *Three Carlton Ware pottery items, circa 1935*

only really brought into production after his death in a flying accident in 1942, also contributed to Wedgwood's commercial success in the 1920s and 1930s. One of his first designs for Wedgwood was Edward VIII's coronation mug, which, though rejected after the prince's abdication, was later redeveloped for George VI's coronation in 1937. His Boat Race bowl and chalice of 1938, despite being traditional in shape, featured stylized lithograph vignettes that clearly demonstrated the influence of the Art Deco style, while his series of Travel tableware, designed in 1937, reflected the current vogue for transport and travel. The sculptor John Skeaping produced a series of animal sculptural designs, fourteen in all, for mass production by Wedgwood. Made in basalt or earthenware and covered in Norman Wilson's monochrome glazes, their similarities to the work of European animal sculptors, such as Jan and Joël Martel for the Sèvres factory, demonstrated the constant interaction between different countries and spheres of the decorative arts during the Art Deco period.

right: *A selection of 1939 New York World's Fair plates, 1939*

More so than elsewhere in Europe, the commercial potential of the new modern style was recognized by the smaller English potteries. The Shelley Pottery had built up a market for its porcelain tableware based on traditional shapes and patterns. However, this changed when its designer, Eric Slater, introduced the Vogue and Mode range in 1930. Conical in form, with a solid triangular handle, these shapes were transfer decorated with geometric and abstract designs. Placing advertisements in magazines such as *Good Housekeeping* as well as producing its own in-house magazine *The Shelley Standard* (bimonthly from 1927), the factory was at the forefront of the new innovative advertising campaigns that were sweeping the country in the 1930s. The Shelley Girl, a porcelain figure of a contemporarily dressed, fashionable young woman, sat proudly at the center of these ads. Though the Vogue tea set initially proved unpopular with the British public, its teapot handle being considered awkward and its shape allowing the tea to cool rapidly, it gained popularity after it was remarketed under the name Eve in 1932 and a hollow handle was introduced. Interestingly though, these modern wares were sold at a much lower price than the traditional pieces. In an attempt to merge the two, Shelley decorated modern-shaped items with conservative floral or landscape designs, as in the Tall Trees and Chinese Lantern designs aimed at the mass market.

Under the guidance of Truda Carter, the pottery firm of Carter, Stabler & Adams, at Poole in Dorset, developed within their earthenware range a group of items with Art Deco shapes and patterns. Keeping with the firm's tradition of hand-painted decoration and using a similar color palette, the geometric style of these pieces reflected the influence of French Art Deco textile and wallpaper designs. The classic Art Deco motif of a leaping springbok, much seen at the 1925 Paris Exhibition, was frequently incorporated, along with stylized birds, into the patterns of tightly packed flowers and foliage. Furthermore John Adams used it as the model for a three-dimensional lamp base as well as a pair of bookends. Adams was responsible for a number of experiments with glazes, a typical pursuit of many Art Deco ceramicists, and introduced a range of spray glazes in matt colors that he applied to the geometric shapes and simple raised decoration of the Picotee, Everest, and then Plane wares. Demonstrating the many different sources of inspiration that potters looked to in the 1920s and 30s, the designer Olive Bourne created a series of vases and plates for the pottery. These designs, depicting stylized maidens and flowers, were copied from watercolor pattern books and adapted to the curved or ribbed surfaces by a team of skilled paintresses, including Anne Hatchard and Ruth Pavely.

Unlike many of the British ceramic factories, the firm of Wiltshaw and Robinson chose to promote a specific range

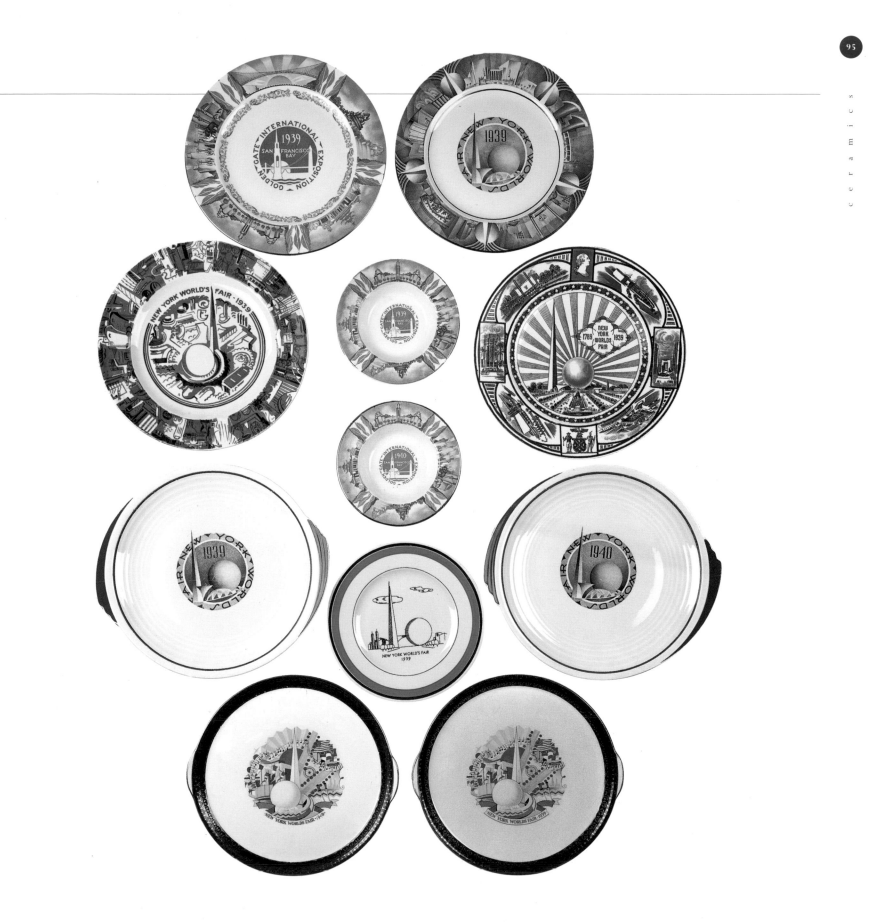

rather than a designer in the Art Deco years. Heavily inspired by the fashion for chinoiserie landscapes and motifs, as well as the recent discovery by Howard Carter of Tutankhamen's burial chamber in Egypt, the Carlton Ware range was characterized by its rich, lustrous surfaces and intricate enameled decoration. Bearing a stamped mark that was based on ancient hieroglyphics (in addition to its normal factory mark), the range was printed in gilt and highlighted in enamel with a variety of Egyptian-inspired motifs, from a funeral boat, to a charioteer or a vulture. Following the growing popularity of the European Art Deco style, the firm also went on to produce between 1930 and 1935 a number of pieces with strongly stylized floral or geometric patterns.

The Crown Devon ceramic works also produced luster-glaze wares during the 1930s. This development was probably largely due to the fact that the firm was joined by Wiltshaw and Robinson's design manager, Enoch Boulton, as well as their sales manager, George Baker, in 1930. In an attempt to improve sales during the national recession, the firm decided to increase the number of new designs and shapes that it displayed at the British Industries Fair. One of the most successful of these, and clearly reflecting the influence of the Oriental style during this period, was the Mattajade range. Deserving mention for her popular series of decorative figures of bathers, sailors, or fashionable ladies for Crown Devon was Kathleen Parsons. These pieces were competitively priced to

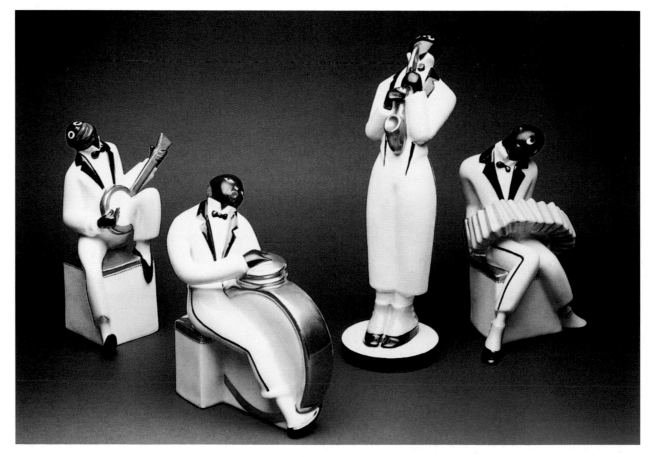

compete with the Continental figure groups that were produced during the Art Deco period.

The American ceramics industry, in the first two decades of the twentieth century, had undertaken a considerable amount of investment to enable new techniques, such as mold production and transfer-printed decoration, to be combined with the production process of the small studio pottery. Immigrant potters and visiting lecturers from Europe provided the impetus for new and modern design, while a display of key items from the 1925 Paris Exhibition at the New York Metropolitan Museum of Art in 1926 introduced American designers and craftsmen to the newly emerging Art Deco style. Two years later some of the United States' brightest ceramic designers were pitted against their European counterparts at the International Ceramic Exhibition in New York, an event that spurred them on to achieve higher standards of design. The explosion of construction work in America in the 1920s and 30s led to a rise in number of orders for ceramic architectural detailing including tiles and wall plaques.

Although only briefly producing work between 1921 and 1930, Cowan Pottery, in Rocky River Ohio, dominated the American field of ceramics. The firm made a range of angular domestic ware, alongside a series of figural pieces, which, though both cheap to produce and popular with customers, was brought to an early demise by the 1929 Wall Street crash and ensuing economic depression. Like the European ceramic firms, young designers were given the freedom at Cowan Pottery to develop new styles and ranges. Waylande Gregory (1905–1971), popular with both the artistic critics and the public, produced a varied and prolific amount of work that ranged from architectural detailing to decorative figures.

The Rookwood pottery company in Cincinnati, established by Maria Longworth Nichols in 1880, had been one of the leading ceramics works in America at the end of the nineteenth century.

Although this period marked the peak of its success, it was also noteworthy during the Art Deco years for its experimental glazes and production of simple geometric decorative designs.

Viktor Schreckengost had studied under the designer Michael Powolny (1871–1954) at the Wiener Keramik before moving to the United States. Combining his love of ceramic design with contemporary jazz music, Schreckengost fused both in his production of simply shaped wares decorated with semi-abstract jazz scenes under monochrome glazes. A masterpiece of American Art Deco ceramics, his Jazz punchbowl of 1931, with its

left: A Robj pottery jazz band, circa 1925

stylized players, bore close similarities to the work of Gio Ponti in Italy. This bowl, produced in a limited edition of 50 and retailed at $50, was an immediate success after the President's wife, Eleanor Roosevelt, bought two.

As seen, a wide variety of ceramics were produced in the 1920s and 30s, from the large-scale factories making mass-produced ware to the handmade individual pieces of the smaller studio. Often angular, with an emphasis on modern shapes inspired by industrial design, Art Deco ceramics simultaneously drew on the forms, glazes, and patterns of the Orient. Glaze techniques that had been perfected at the beginning of the twentieth century were applied by artists such as René Buthaud to monumental forms and fused with African and Cubist influenced designs. In England Keith Murray updated Wedgwood's traditional range of basalt ware, developing a line of sleek architectural designs. Clarice Cliff took inspiration from European designers and produced a distinctive range of boldly patterned wares painted in a distinctive bright palette. Both in America and Europe the humor and gaiety of the Art Deco period was incorporated into ceramic designs and heavily marketed to the public through the increased number of lifestyle magazines, newspapers, and exhibitions.

SILVER AND METALWORK

The traditional industry of the silversmith was slow to take up the design challenges thrown down by the new Art Deco style and much of its production in the early 1920s was conservative in style. The silver industry had only tentatively taken up the free-flowing lines of the Art Nouveau style and by 1925 had just begun to experiment with the more angular motifs and streamlined forms of the Art Deco style. The silversmiths' market was historically based around a specific range of products such as tea and coffee services, candlesticks, and cutlery, but this market expanded with the rise in popularity of smoking and drinking. Silver was the ideal medium for the rich to display their wealth. Sets of cocktail glasses and shakers and cigarette

below: *Jean Puiforçat, a silver and mahogany table lamp, circa 1926*

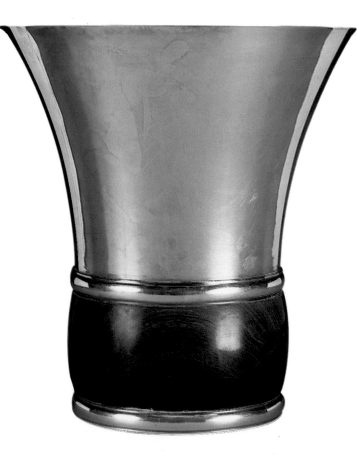

cases were ideal objects to develop the new angular and geometric style. The further development of electricity led to a rise in demand for the production of items such as lights and clocks at the expense of the mirrors and dressing-table sets that were popular during the Art Nouveau period. The late-nineteenth-century invention of electroplate, and its subsequent refinement, coupled with the new, versatile stainless steel, created possibilities of expanding existing markets with whole-scale mass production. Throughout this period large, established factories thrived with the development of mass production and dominated the silver market. However, smaller-scale artist studios were also successful, producing commissioned pieces that were often, due to their individual nature, more abstract and daring in design.

Jean Puiforçat (1897–1945), one of the most important metalware designers in France, learned the trade from his father. Trained as a sculptor, he developed the use of simple primary shapes that were stripped of decoration but accentuated with colored hard stone or clear rock crystal. He experimented with the cube form and then implemented a calculated curved line to the simple solid shapes to create movement. In a reaction to the hand-hammered finish of the Arts and Crafts and Wiener Werkstätte movement, where the nuts and bolts of production were often left visible, Puiforçat produced smooth, large, flat expanses of polished silver that concealed his production techniques. Shapes produced for simple coffee and teapots took on the thoroughly modern look shared with the railway engines, ocean liners, or streamlined cars of the period. Embellishment was refined to rock crystal, lapis lazuli, or Macassar ebony finials and handles. Although his designs were extremely Modernist in style, Puiforçat did not design for mass production, distinguishing his production from that of engineers and industrial designers of the period. Puiforçat's clients, like Ruhlmann's, were the rich who could afford to

commission individual designs produced by hand in the most expensive materials. Puiforçat exhibited at the Salon d'Automne in 1921, and at the 1925 Paris Exhibition he was requested to be a member of the prize-awarding jury and the admissions jury. His principles of design were apparent as early as 1924 when he produced a covered sugar basin that was a forerunner of the Art Deco items subsequently produced by the silver industry. The basin of solid silver is supported on four Macassar ebony stepped feet with a simple stepped finial in the same wood. The design highlights Puiforçat's understanding of the Modernist fundamental principle of function and form. His work was already established by the time of the 1925 Paris Exhibition and it was displayed at several sites including the French Embassy pavilion and the Grand Palais, and the interior designer Ruhlmann used three of his jardinières in his pavilion. Puiforçat went on to confirm his place in the ranks of the leading new Art Deco designers, regularly exhibiting with artist designers such as Le Corbusier and the glassmaker Jean Luce. In 1930 some of his tableware was exhibited at the Décor de la Table exhibition held at the Musée Galliera. This exhibition, with the cooperation of the major European silver houses, highlighted traditional and new uses for silver in the modern domestic environment.

The Christofle factory in Paris commissioned artists, including Gio Ponti and Paul Follot, to design silverware and the more commercial electroplated material that they had developed in the late nineteenth century. The firm marketed itself extensively across Europe, especially in London, and also in America. As well as using French designers it also employed Carl Christian Fjerdlingstad (1891–1968), whose designs were more in keeping with the Danish tradition of smooth,

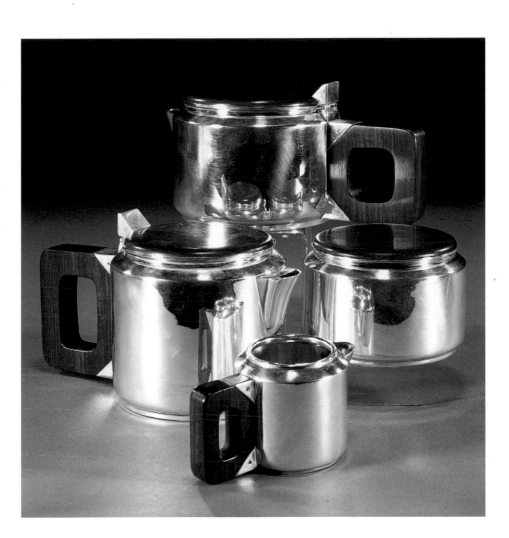

above right: *Jean Puiforçat, a silver and Macassar ebony tea set, 1926*

streamlined forms. At the 1925 Paris Exhibition Christofle shared a commercial pavilion with the Glassmaker Baccarat— the Maison Christofle-Baccarat pavilion was designed by Georges Chevalier (1894–1987).

The art of enameling silver, plate, and other metals was a traditional Western technique that had been revived by the British Arts and Crafts movement in the late nineteenth century. During the 1920s London, Paris, and Limoges all saw a renaissance in the various techniques of enameling, with several artists such as Camille Fauré (1872–1956) and Gérard

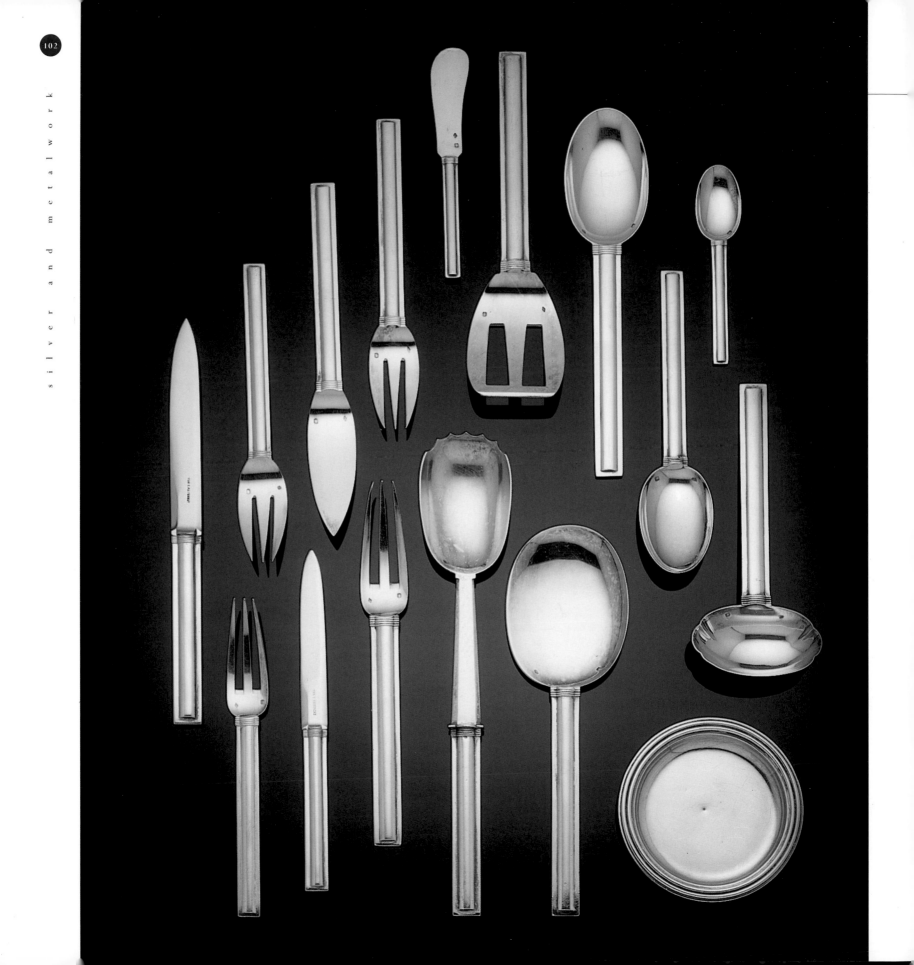

Sandoz specializing in the production of abstract enamels. The city of Limoges is steeped in the history of enameling, having been a center for the art since the Renaissance period. Camille Fauré was apprenticed in the city before setting up his own workshop to develop his own unique enamel style. He produced a series of bold geometric designs on vases and decorative objects that he displayed at his workshop and in Paris at the gallery Au Vase Etrusque. Although his work was similar in style to other contemporary artists, he worked the enamel in a different manner, applying it in layers that built up a translucent three-dimensional finish. Other artists, for example Jean Goulden, used the enamel as flat plains of color that relied more on the geometric shape of the object for the overall Art Deco form.

Gérard Sandoz, after training with his father in both jewelry and silver production, designed small boxes, cigarette cases, and jewelry, often with shagreen, lizard skin, or ivory inclusions. The work was highly Art Deco in style, incorporating both geometric and mechanical motifs into the design. Sandoz's

tête à tête tea services exhibited in the 1925 Paris Exhibition displayed his ability to produce smooth sleek design and also faceted modern shapes. Both sets included covered milk and sugar basins that, when photographed for publicity shots, were arranged to emphasize the symmetrical nature of design. Jean Tétard, in the same section, produced a tea service of more classical design with a traditional spout and handle, set with ivory finials. Sandoz brought an abrupt end to his influential career as a silversmith when, in 1930, he decided to stop producing silver and instead to turn his attentions to abstract painting and film-making.

A Greek Orthodox church situated on the secluded Mount Athos was the unlikely early training place and inspiration for Jean Goulden (1878–1947) to learn the art of enameling during the years of the First World War. When he relocated to Paris he learned champlevé enameling techniques from Jean Dunand, while studying medicine. Champlevé

left: *Jean Puiforçat, a Cannes French vermeil service, 1928*

below: *Ravinet D'Enfert, a pair of silver-plated and palmwood candlesticks, 1928*

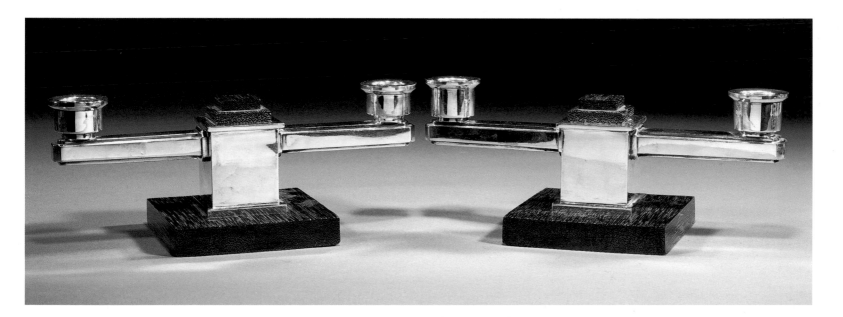

enameling involves the artist carving out niches in the metal object that can then be filled with the molten enamel. When the enamel is fired, it hardens, forming blocks of color. Goulden developed a range of copper, bronze, and precious metal objects, including clocks, candlesticks, and caskets, all of which were of highly geometric abstract form. Often the object was cast in a highly stylized angular shape and then highlighted with panels of different colored enamels. Goulden came from a rich family with an agricultural background that enabled him to buy and also commission work from his neighboring metalworkers, such as Dunand and other artists, working in the close artistic community of Paris. His private income enabled him to survive on individual commissions for his own work, which, with its angular architectural form and flat plains of color, were the ideal Art Deco accessory to any modern interior.

Goulden's strikingly Modernist clocks contrasted with the designs by major jewelers of the period who took their inspiration from the East. Louis François Cartier's interest in Egyptology led him to produce his first Egyptian designs for jewelry in 1852. By 1910 the company regularly produced designs in the Egyptian manner. Cartier's three grandsons expanded his sales around the world, opening showrooms in London and New York in 1909. The Louvre held a Franco-Egyptian exhibition in 1911 and interest increased when Howard Carter found the doorway to the lost tomb of Tutankhamen in 1922. In 1925 Cartier produced a sarcophagus vanity case and in 1939 Cartier designed and produced a lavish table clock in mother-of-pearl, coral, and diamonds. On the clock front was set an antique bronze portrait of a king. These lavish timepieces were made of the finest materials as special commissions, using the most skilled jewelers and craftsmen of the day. One of Cartier's most spectacular

right: *Christofle, a silver-plated metal vase, circa 1925*

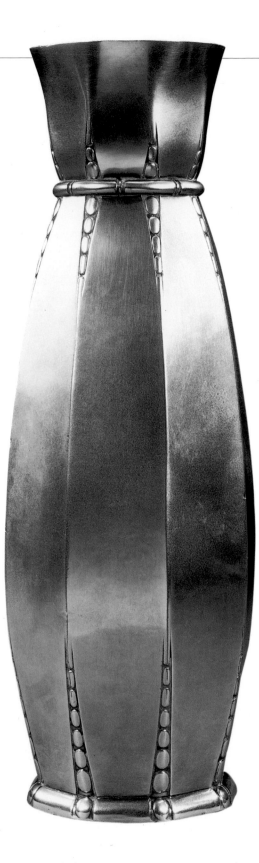

timepieces, inspired by Japan, was the Shinto Torri Gate clock, which was designed in 1927. This gravity clock was designed by Maurice Coüet with pillars of jade, opulently set with coral, which housed the concealed movement. As the clock was raised to the top of the portico the movement was set, the weight of the movement due to gravity providing the power via a series of gears as it fell. The lavish materials and original and exotic designs would have been ideally suited to an interior by Jacques-Emile Ruhlmann. Other jewelers produced a series of objects inspired by both the Orient and Egypt, often with a humorous angle, including a table clock by Juvenia modeled as a pagoda.

Jean Tétard (1902–1937) exhibited work for the first time at Décor de la Table in 1930, the exhibition that was organized by the French silver industry in an attempt to boost sales. Tétard's work was characterized by its strong, angular shapes and often draws comparison to the liners and motorcars of the day. Tétard rejected this appraisal of his work, attributing his style to an individual approach to redesigning everyday items without the traditional stigmas of historicism. He produced a range of simple designs highlighted with geometric motifs while working at his father's foundry, Maison Tétard. Many of the designs, although simple in form, were actually complicated constructions that displayed his mastery of the materials and production processes available at that time.

In addition to reviving the art of enameling, French artists introduced the Eastern art of lacquering to Europe, with the earlier mentioned Jean Dunand being the recognized master. The processes of decoration that he developed were equally suited to a small cigarette case or to the large murals commissioned for the ocean-going liners of the day. Although he was originally involved in producing bronze statues for the 1900 Paris Exhibition it was at the 1925 Paris Exhibition where his art truly flourished. Dunand exhibited in the French section a

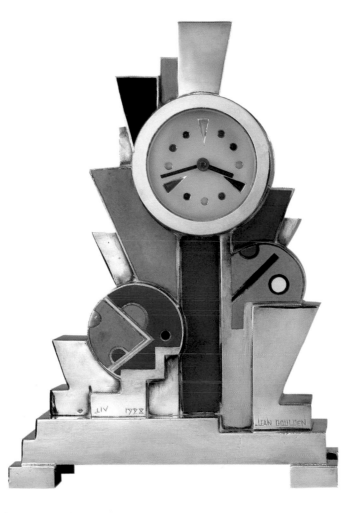

lacquer panel depicting two stylized females and a deer in a landscape that displayed the influence on him of the Cubist painters. The costumes and the foliate backdrop were shown as flat plains of geometric color, decorative at the expense of representational interpretation. He had previously exhibited at the Brussels International Exhibition designs in lacquer that he had been experimenting with since 1910. He learned the art of lacquering directly from the Japanese artist Seizo Sugawara, who arrived in Paris in 1900, in return for first teaching Sugawara to produce metalwork. Dunand also

above: *Jean Goulden, a silvered bronze and enamel clock, 1928*

right: *A Cartier jade*
clock designed by
Maurice Coüet, 1927

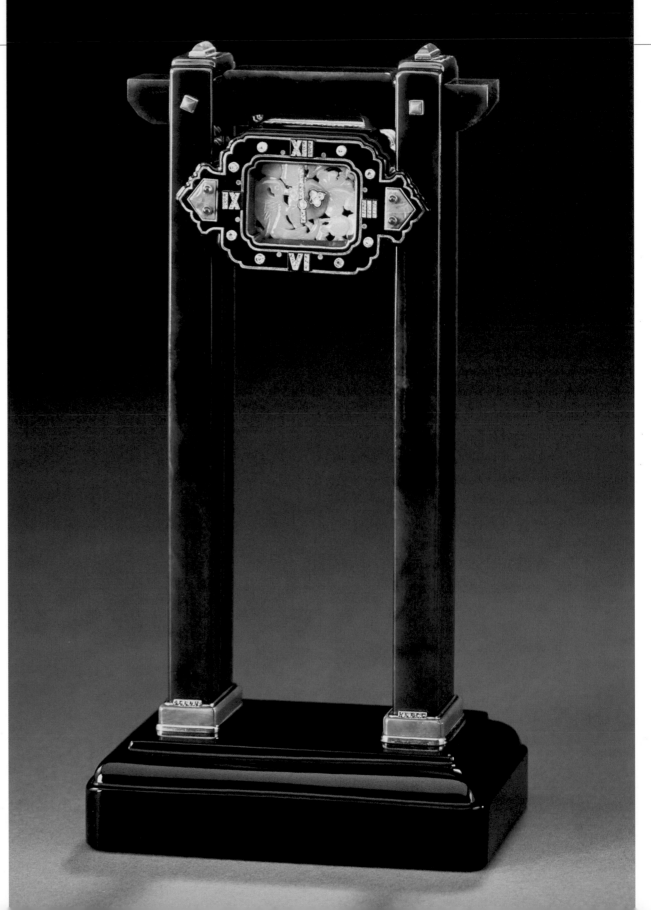

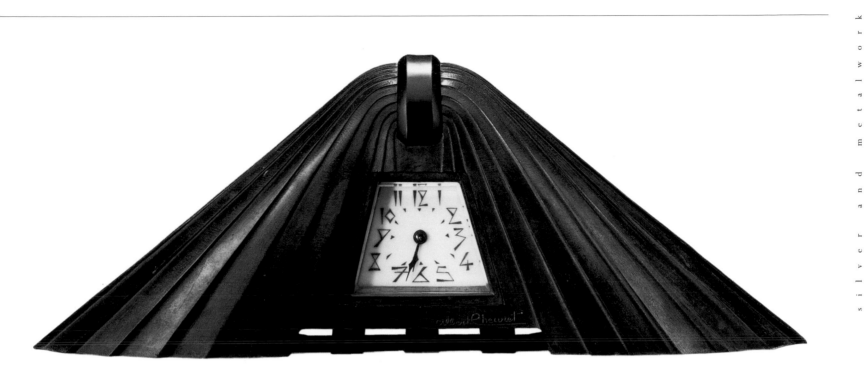

experimented with a series of bronze snake sculptures, almost exclusively cobras, either depicted coiled or rearing up in anticipation of attack. In 1913 he applied two cobras to the sides of a monumental classically shaped amphora made of copper and inlaid with silver. This vase was produced twelve years before the 1925 Paris Exhibition but incorporated the exotic materials and animal motif that would equally be developed by later Art Deco designers.

Dunand was busy experimenting with the art of *dinanderie*, a technique that produced a hand-hammered vase from a single sheet of copper or similar soft metal. Working from the center outwards the piece is hammered into shape with a wooden mallet, the finer detail being hammered with a metal mallet in the final stages. The construction led to the body being left as a thin skin of metal with the rim and peripheral outer edges being reinforced, having received less of a pounding from the hammer during the production process. Once the form was completed, decoration could be applied, metal oxides or reacting acids being painted onto the surface,

which could then be embossed. Dunand worked in collaboration with Jean Dupas, who designed a large curved panel, *The Epic of the Republic*, which was displayed at the 1939 New York World's Fair.

Claudius Linnossier (1893–1953) trained under Dunand before moving to Lyon in France, where he set up his own smithy and started the production of lacquered vases and plates for the retailing firm of Rouard. Linossier displayed at the 1925 Paris Exhibition a range of lacquered vases following the designs of Dunand, some of which were inlaid with fine eggshell decoration. Other artists who experimented with lacquer, inlaying metals, and oxides on metal were Louis Süe and Luc Lanel (1894–1966), the latter producing designs for Christofle. Raymond Templier (1891–1961), having studied at the Ecole des Beaux Art in Paris before joining his father's jewelers, produced a range of small decorative objects in a combination of luxurious materials including eggshell, lacquer, and precious metals.

above: *An Albert Cheuret bronze and onyx mantle clock, circa 1925*

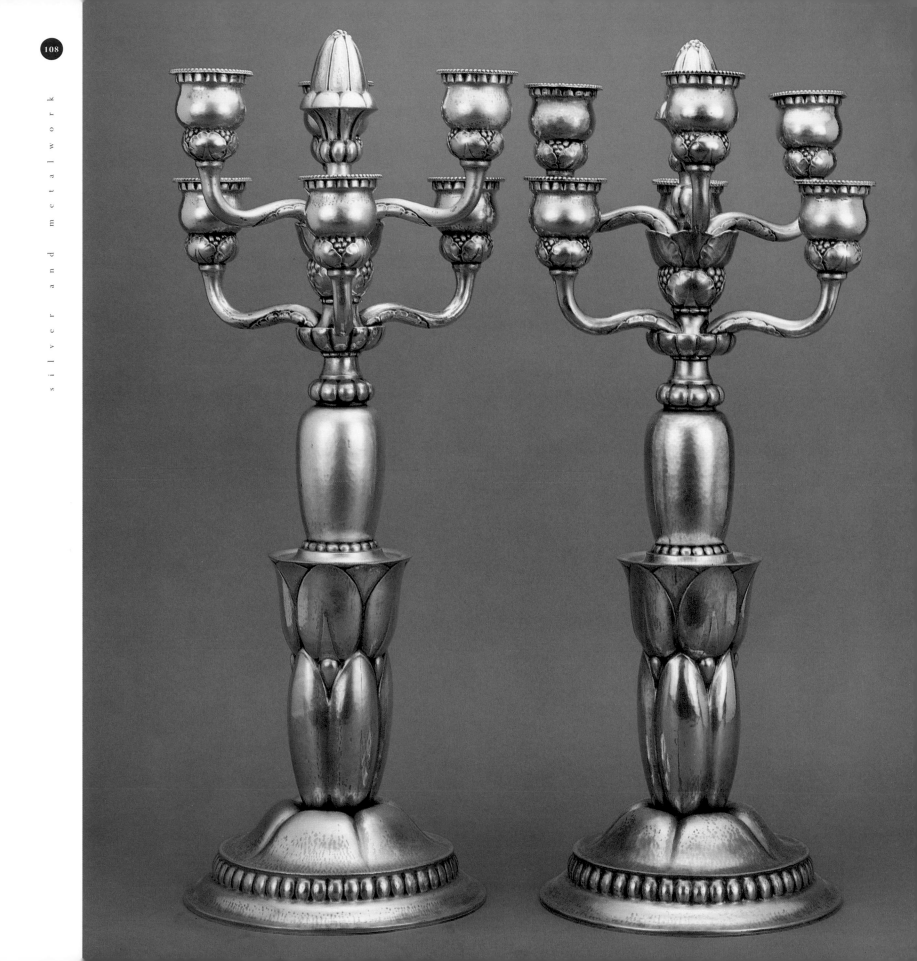

Unlike the techniques associated with wrought-iron working and enameling, the lacquer revival predominantly stayed on mainland Europe, not reaching Britain or America. Eileen Gray was the one artist working in Britain who did choose to develop her designs in this "new" material. She studied at the Slade School of Art in London in 1898 where she practiced drawing while learning the art of lacquering in her spare time at a furniture restorer. Upon moving to Paris in 1902 and after meeting and studying with Seizo Sugawara (who arrived in Paris 1900), her career took off. She worked closely with Sugawara from 1911 to 1921, although her designing stopped and she returned to England during the First World War. Before the war she had already received several commissions including orders for lacquer panels as well as furniture designs. On a smaller scale Reco Capey (1895–1961) produced a series of lacquered boxwood figures, including the sculpted Princess Badroulbodour and some lacquered panels in 1926. His work was praised in *The Studio* for its craftsmanship, with several pieces illustrated next to an article devoted to the art of Jean Dunand.

The leading Danish silversmith Georg Jensen (1866–1935) dominated the production of silverware in Northern Europe from the turn of the century until the outbreak of World War Two. After a long period of apprenticeship, travel, and freelance design, he opened a workshop in Copenhagen in 1904 that initially sold commercial jewelry set with semiprecious stones. After opening another workshop in Berlin, Jensen opened branches in Paris in 1919 and in London and New York in 1920. As well as producing a large range of flatware and domestic ware, the company also produced a range of decorative candlesticks and jewelry. Conscious of changing tastes as the fashion for cocktails swept across Europe and America, the firm quickly produced a range of cocktail shakers to satisfy demand, with cigarette cases following for smokers.

Jensen employed a number of freelance designers in order to create new shapes and patterns to be produced in silver and in 1906 he began collaborating with Johan Rohde (1856–1935). In 1913 Rohde, an architect, painter, and designer, became the permanent designer at the silversmiths and quickly set about creating the simple Acorn pattern range of flatware in 1915. Rohde was instrumental in introducing the first simple streamlined designs of the Art Deco style into the firm's repertoire, although often these designs were too avant-garde for immediate production (an ewer designed in 1920 was only put into production in 1925). Jensen also employed his brother-in-law Harald Nielsen (1892–1977) at the company from 1909. Nielsen produced a range of simple, streamlined shapes that incorporated stylized fish, fruit, and animals formed as finials or handles as well as a range of items in a simple classical style, with fluted stems and columns. These simple

left: *A pair of Georg Jensen silver candelabra, 1930*

yet elegant designs are the antithesis of the more powerful designs of Tétard or Puiforçat, but share the ideals of luxury and quality manufacture present in Cartier's clocks and objets d'art. Nielsen introduced the "modern" style with his Pyramid pattern flatware service designed in 1926 and when Jensen died in 1935 Nielsen took over the role of the leading designer at the firm. Jensen importantly credited the designers by allowing them to sign their work, either by monogram or with a full signature on each individual piece.

Second only to Georg Jensen's company, in Denmark, A. Michelsen produced silver caskets and boxes in the smooth modern line of the Art Deco style. The company, founded by Anton Michelsen in 1841, was the only Danish silversmith invited to display at the 1900 Paris Exhibition. Michelsen in the 1920s employed the artist Kay Fisker to design various bonbonnières and other small covered vessels for production in silver. Fisker also produced a candelabra, designed with four

drop arms and a central sconce, mounted on a simple stepped base, which was exhibited in 1925. The firm's designs in the 1920s developed the streamlined classical approach of its flatware, at the expense of a more angular industrial approach popular elsewhere in Northern Europe. However in the 1930s it developed a range of stainless steel designs at the expense of its more exclusive silver designs.

The German silver and metal industries of the twenties and thirties were severely affected by the economic recession, internal depression, and rapid inflation within their country. There was a desperate shortage of commissions. Many companies and workshops, such as Karl Ernst Osthaus' Hagener Silberschmiede, originally set up in 1910, closed during the turmoil of the First World War. The most commercial of the German

companies, Württembergische Metallwaren Fabrik (WMF), however, survived due to its continued production of low-cost plated ware that was based on the designs of the earlier Art Nouveau style, which remained popular with customers. Production was only brought up to date in the thirties with the introduction of the Ikora range of metalware. Ikora offered a more geometric style of design, often including verdigris and enameling techniques for decoration and the use of inlaid metal in a similar fashion to the ceramic ware produced by the Swedish pottery Gustavsberg in their Argenta range. The subject matter varied from simple floral and geometric abstract motifs to the more stylized female figures that were popular with both painters and sculptors of the Art Deco period.

The strongest design influence in Germany was based around the artist community of the Bauhaus. Set up by Walter

right: *Adie Brothers, silver, and Bakelite tea set designed by Harold Stabler, 1935*

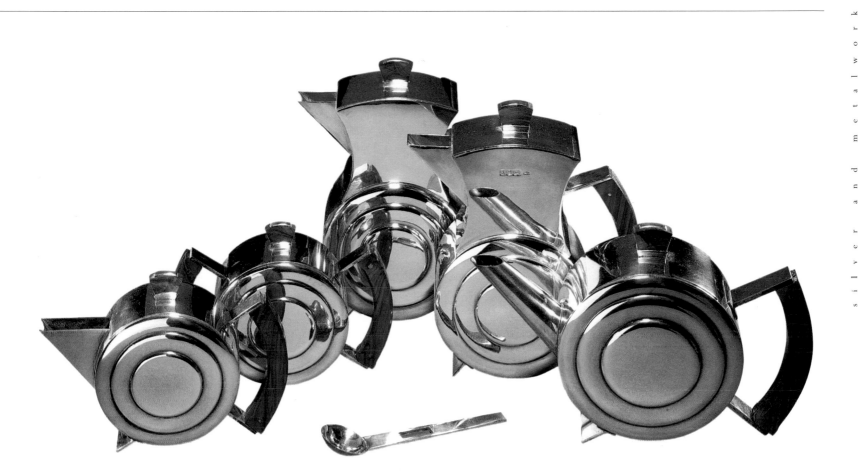

Gropius in 1919, the Bauhaus was founded on the ideals of the British Arts and Crafts movement. Gropius was joined by Christian Dell (1893–1974), who joined as technical supervisor in 1922, and by Wilhelm Wagenfeld in 1923. Wagenfeld had previously studied the techniques of silversmithing in Hanau in 1919. The style created at the Bauhaus was based on industrial design, either by hand or for machine production, and eventually led to the Modernist movement. Christian Dell's silver jug, designed at the Bauhaus in 1922, incorporates a spherical body and conical neck with integrated spout and ebony handle. Marianne Brandt's (1893–1983) cocktail shaker of 1930 developed from this design to be perfectly spherical in form with a small offset neck and a sweeping handle that accentuates the body. Although these bold masculine shapes are comparable in appearance to those designed by Jean Puiforçat, his belief in a luxurious hand-finished object was the opposite of the Bauhaus' industrial design brief.

In Brussels Marcel Wolfers (1886–1976); the son of the Art Nouveau jeweler Philippe Wolfers (1858–1929), designed angular tea services that often incorporated the swollen ovoid form. The sphere was one of the five shapes, along with the cube, cone, cylinder, and pyramid, that were championed in the influential text New Objectivity, to be produced by machinery. These shapes were influential to the Dutch De Stijl movement and the theories of Piet Mondrian, which in turn became a main source of inspiration for the

above: *A Henry George Murphy silver tea set, 1934*

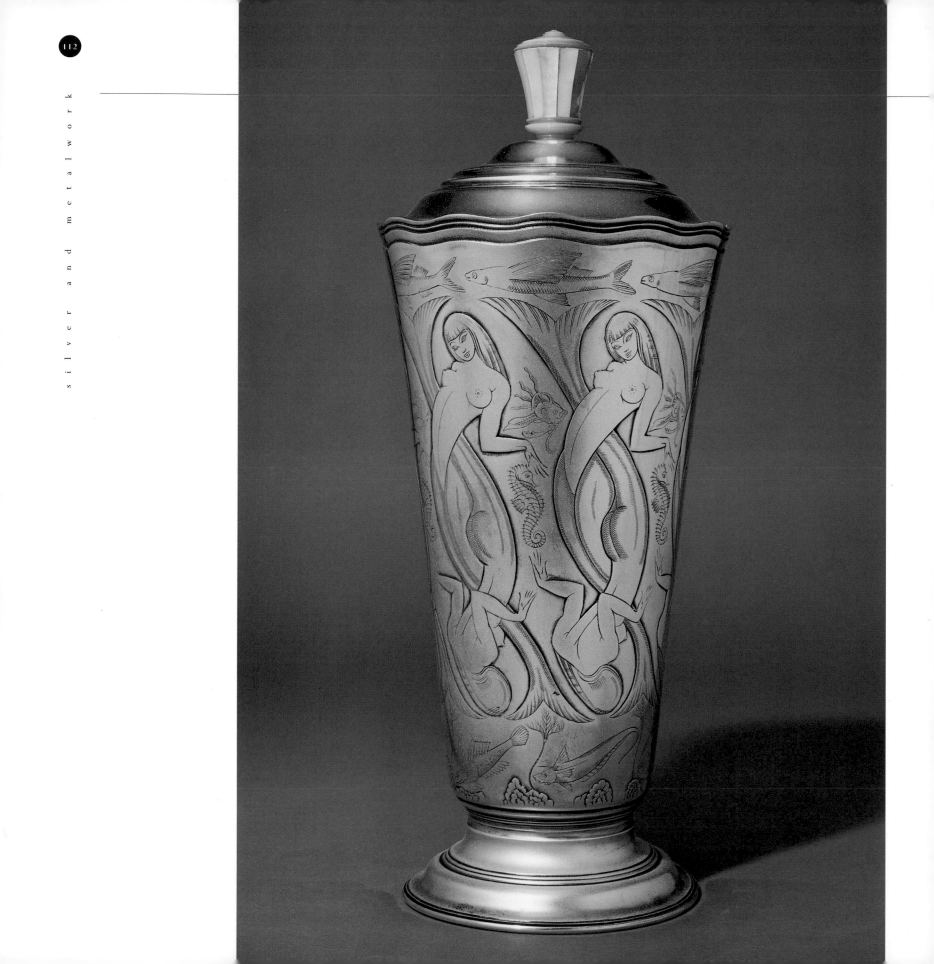

Art Deco designers. Wolfer's Giaconda service, designed in 1925, was a symmetrical, faceted form decorated with ivory handles. In contrast Delheid Frères, also in Brussels, produced tea and coffee services in a more modern, smooth line.

In England the field of silver design in the 1930s was dominated by two artists, Harold Stabler and Henry George Murphy, both inspired by the British Arts and Crafts movement. English silversmiths had enjoyed a renaissance during the late nineteenth century with artist-craftsmen such as C.R. Ashbee and Alexander Fisher reviving the traditions of hand-produced high-quality silver and enamel decoration. These pioneers had different views on design but importantly both helped to set up the craft industry infrastructure in which the Art Deco designers could later prosper. Coupled with the emergence of new materials such as stainless steel, invented by Frith Vickers in Sheffield in 1913, a new design criterion and practice were established that bore links with the more opulent and geometric designs found on the continent.

Harold Stabler (1872–1945) studied at the Kendal Art School before joining the Keswick School of Art as director in 1898. He was included in the executive team set up to organize and vet silver designs for the 1925 Paris Exhibition. His designs for the exhibition included cloisonné enamel brooches depicting exotic animals and mythical creatures that contrasted with Jean Goulden's style of enameling. Stabler's most important contribution to the British Art Deco style occurred when he helped found the Design and Industries Association in 1915, which aimed to marry correct design with manufacturing efficiency. The machine was now to be accepted as an aid to production. At the Adie Brothers silversmiths in Birmingham, Harold Stabler designed an angular tea service in 1935. The design incorporated the basic rectangular shape that allowed an economic use of space, and was originally meant to sit on a fitted rectangular tray. Available in silver with ivory and wood handles

as a four-piece set, it could also be produced in an electroplated version more suited to wholesale production at a cheaper price. This general reduction in production cost led to the introduction of Art Deco–shaped pieces to the general public.

The Birmingham based company of Napper and Davenport produced the revolutionary Cube Teapot design in 1922. This design was patented by Robert Johnson in 1916, and by incorporating both the spout (which only just existed past a lip) and the handle into the overall cube form of the pot, it had the twin advantages of both economy of storage and resistance to damage. The design, easily mass-produced, was developed in electroplated versions by Cube Teapots Ltd, Leicester, and also in ceramic and pottery versions by many different potteries throughout the 1930s, Cunard in fact ordered 30,000 ceramic

left: A Wakeley and Wheeler silver cup and cover by Richard Yorke Gleadowe, 1938

Cube teapots for the Queen Mary liner's maiden voyage in 1936.

Many English silversmiths of the period continued to design and work in the guild, school, or workshop tradition, which led to small-scale Modernist design and the continuation of traditional historical designs. Charles Boynton (1885–1958) set up his own company in 1933 in an attempt to break away from the latter. Although he produced several geometric designs for tea and coffee services, Boynton also designed a range of more classically inspired designs that utilized the Art Deco motif of ivory handles, hard stone finials, and slender bands of foliage, while continuing the hand-hammered craftsman finish.

Henry George Murphy (1884–1939) studied at the Central School of Arts and Crafts in London and traveled to Berlin before opening his Falcon workshop in London in 1913. Murphy's work reflected his call for machine-made items that display the machine influence. However, as he was unable to find a commercial company that was willing to produce his designs, he often produced them himself. Murphy employed

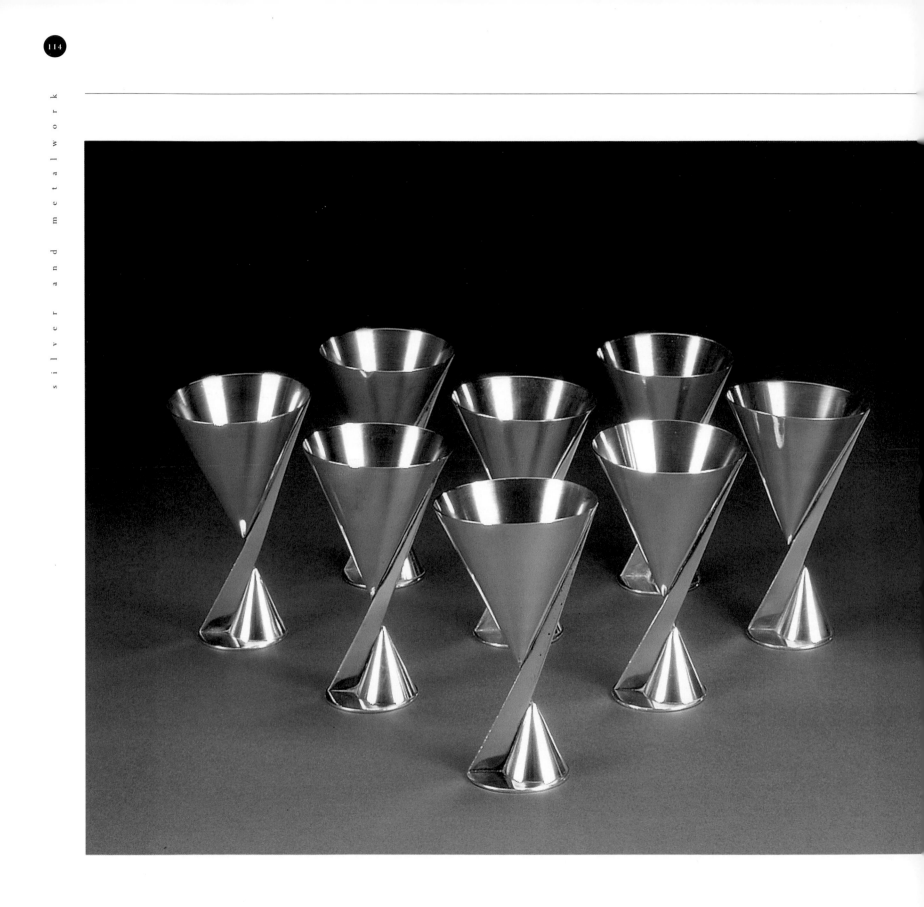

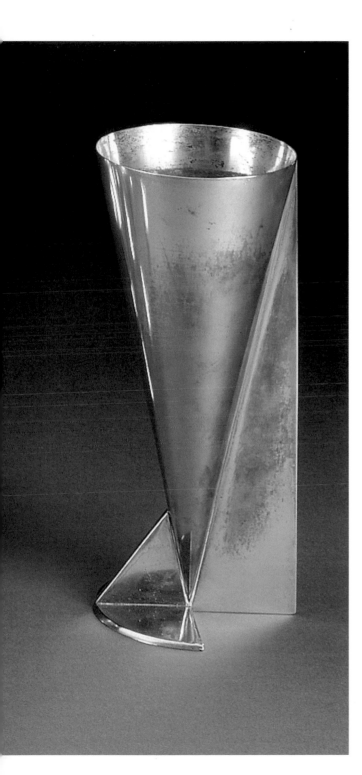

artists-craftsmen at his workshop to produce the design by hand as if it had been produced by machine. Designs were simple, based on the circle or square shape with a minimal decorative motif, such as a swirl, and embellished with a hardwood or ivory handle or finial. In contrast to the silver designs of the Arts and Crafts movement, simple designs could also be applied by engraving. In 1933 Murphy exhibited a silver and kingwood three-piece tea service in Milan that was also reproduced in *The Studio* of the same year. The tea service was designed to be die stamped in two parts and assembled by a technique that would reduce the cost of production and thus the final retail price. Although the design won an award in

left: *Maison Desny, a silver-plated cocktail set, circa 1925*

Milan the set did not enter wholesale mass production. Murphy's hand-produced Art Deco designs, although originally intended to be machine produced, were finished using the same techniques as Puiforçat in France.

Other factories like Mappin and Webb utilized freelance designers such as Keith Murray to produce designs that were suitable for mass production. Murray, more famous for designing ceramics for Wedgwood or glass for Stevens and Williams, produced designs for cocktail shakers and tea sets in the Modernist style. At the height of his success Murray had a one-man show held in London at the Medici Gallery, which displayed his designs in ceramics, glass, and silver. The prestigious location and the use of the artist rather than the product as the fundamental link, meant the industrial designer had come of age. His designs were equally well suited to glass, silver, and ceramics, resulting in several designs being executed in all three media. The simple use of banded decoration, or a ribbed or fluted body could be transferred from a monochrome black basalt vase to a polished silver vessel. Wakely and Wheeler employed Richard Yorke Gleadowe (1888–1944) to create utilitarian and decorative designs. Gleadowe, Slade professor at

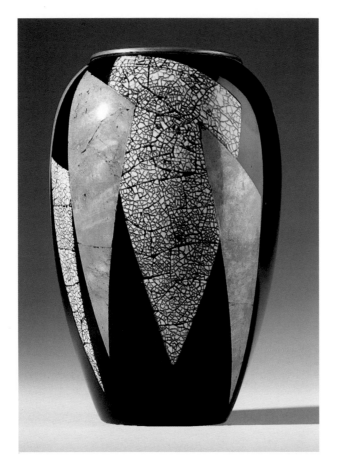

Companies such as the Gorham Manufacturing Co. were looking for modern European designers to update their products and boost sales, and hence accepted immigrant workers from Europe, including Scandinavia, from whom they could assimilate the new styles and ideas. The Danish silversmith Erik Magnussen settled in America in 1925 after leaving Copenhagen, where he trained under Georg Jensen. He was employed by Gorham as artistic director until 1929, where he produced a varied range of designs that went from the classical covered vases and bowls with fish or animal finial to geometric pieces heavily inspired by Jensen to his more abstract, Cubist-influenced the Lights and Shadows of Manhattan coffee service. While the classical bowls and coupe with gadrooned decoration relied on a simple hard-stone, ivory, or modeled finial for decoration, the Manhattan coffee set was made of mixed metals. Consisting of silver angular planes, variously finished with gold plate, oxidized, or polished to accentuate the form, it modernized Gorham's tradition of mixed-metal production, linking it to the Skyscraper architectural phenomenon. The link with the architectural towers received derision from some critics who saw this tall faceted shape as wholly unsuitable for the design of tableware, but to other designers it was inspirational. Cocktail shakers as well as plated tea and coffee services all followed based on the latest addition to the city's skylines.

Norman Bel Geddes (1893–1958) received his training in theater design, working as a stage designer at the Metropolitan Opera before changing careers and developing industrial designs. He carried out a range of different projects that included stoves, radio sets, cars, and windows, bringing to them an air of the theatrical. His highly streamlined shapes and futuristic eye-catching forms were ideal for the cocktail sets and shakers being marketed to the nouveau riche in America. His modern cocktail set with a tall fluted cylindrical shaker and

Oxford, also designed for H.G. Murphy and Edward Barnard & Sons in London and received important commissions, including the Stalingrad Sword given by George VI to the citizens of Stalingrad in 1943.

American silver designers reacted slowly to the new modern movement, even when designs for Christofle and Puiforçat from the 1925 Paris Exhibition were toured in the United States in 1926. The work, in fact, appeared too modern to them. Metalwork designers were more able to associate their work with the Wiener Werkstätte and assimilated Scandinavian Art Nouveau designs that were exhibited at the American

above: *A Jean Dunand lacquer vase, circa 1925*

pedestal glasses produced for the Revere Brass and Copper Company was taken one step further when he produced a cocktail set of two shakers and twelve glasses to be stored on a freestanding, rotating Ferris wheel.

Other traditional companies such as Tiffany and the Silver Company added a modern range to their output in an attempt to increase sales. Gene Theobald at the Silver Company, inspired by the architectural forms of Puiforçat, developed a range of tea and coffee services presented on a fitted tray. These were angular in form and decoration was minimized to a stepped foot and the functional wooden or Bakelite handle or finial. Tiffany delayed its introduction of a Modernist style until the 1930s with special designs for its centenary and then the 1939 New York World's Fair in the same year. These designs—which were a fusion of the European designs, the flaring conical form of Desny's cocktail set with more classical shapes of Puiforçat—ushered in the modern and quickly overtook the traditional ranges displayed in the House of Jewels at the fair.

The major silversmiths in Europe and America were slow to react to the possibilities of both new designs and modern materials at the start of the Art Deco period, but spurred on by the machine age, they produced a coherent modern style in keeping with the other contemporary decorative arts. The period saw a wide variety of products created, from the cheap and mass-produced Cube teapots made in England to the exclusive silver and rock crystal designs of Jean Puiforçat. However, the two extremes were linked by a modern design based on geometric forms and industrial shapes, with a rejection of the historical designs of the nineteenth century. Throughout the period, new techniques were developed for both small- and large-scale production that reflected the bright and decorative spirit of the era.

right: *A Jean Dunand monumental vase, 1913*

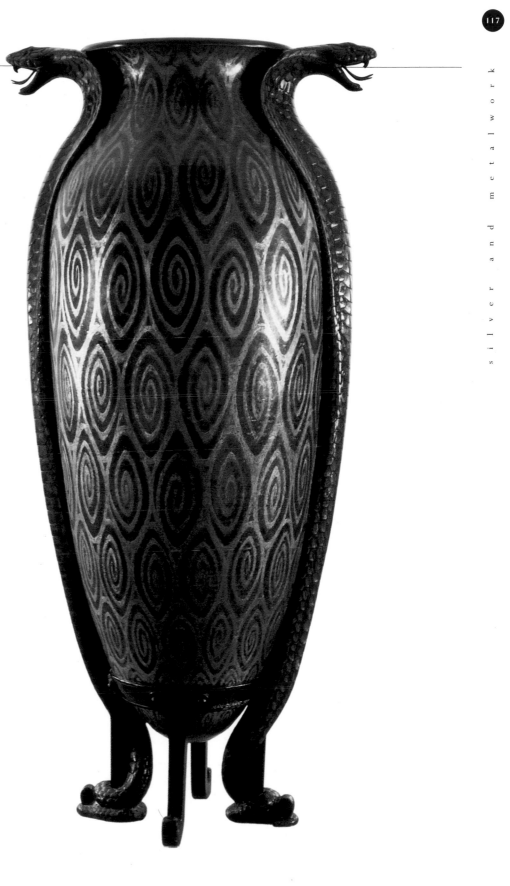

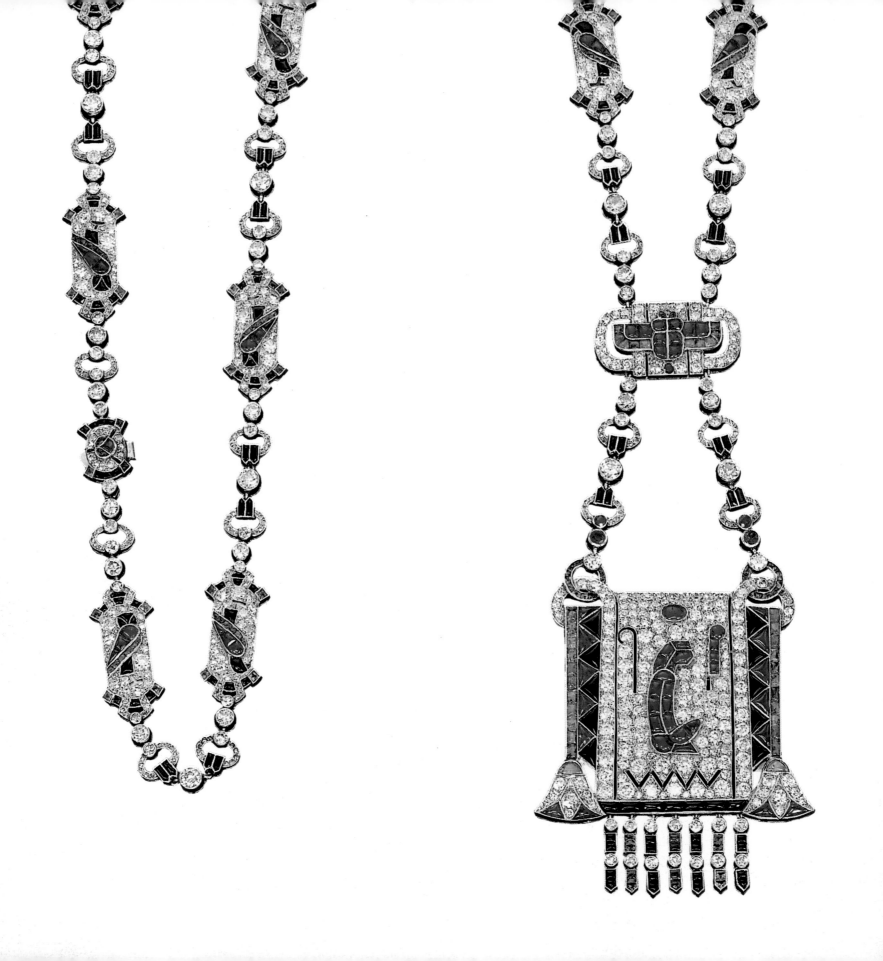

JEWELRY

chapter six

The Art Deco period saw the liberation of jewelers from the traditional range of stones, metals, and techniques available to them in the nineteenth century. Much of the credit for this liberation was in fact due to the revolutionary work of the Art Nouveau jewelers at the turn of the century. Pioneers such as René Lalique, Philippe Wolfers, and Georges Fouquet demonstrated through their exquisite pieces of jewelry that the true merit of a piece could only be based on the quality of its design and form rather than its price. Many innovative materials, such as horn, tortoiseshell, and ivory were introduced into the traditional palette of the jeweler. This concept was readily accepted by the next generation of jewelers who, having absorbed these ideas and being simultaneously influenced by the growing popularity of Orientalism and Egyptianism, began to incorporate jade, coral, lacquer, and enamel into their designs with increased regularity.

below: *An Art Deco pavé-set diamond and emerald brooch, circa 1928*

An important technical development that facilitated the slender creations of the Art Deco jewelers was the increased availability of platinum. Originally discovered in South America in the mid-eighteenth century, it was found to be a highly flexible yet resilient alternative to gold or silver. Unlike the materials of the previous century, with which the stones would be set into clearly visible mounts, platinum was strong and allowed the Art Deco jewelers to design pieces with increasingly delicate-looking settings. Silver-gray in color, platinum was also favored, most especially with the more innovative jewelers of the period, for the sharp contrast that it created when placed alongside diamonds or black enamel.

In the Art Nouveau period the diamond had lost favor with the more avant-garde jewelers. It was considered to have dominated the world of jewelry for far too long, and among the young jewelers of that period there was a concerted effort to bring it down from its elevated position in the hierarchy of

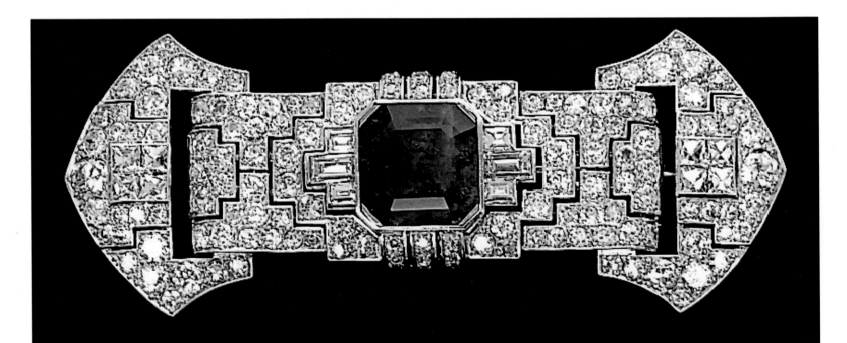

precious stones. However, the general popularity of the diamond, though dulled, never really lost its shine. In the early 1900s the more established jewelry houses, such as Boucheron, Chaumet, Coulon & Cie, and La Maison Aucoc in Paris, had remained loyal to the use of the diamond—though admittedly placing the stones in increasingly realistic floral settings to cater to the current vogue for naturalism.

The 1920s saw the diamond make a comeback, but like an ageing movie star, it relied on a dramatic makeover to recapture the hearts of its public. Instead of using the traditional cuts of the nineteenth century, namely rose and brilliant-cut, jewelers took advantage of the latest technical developments in gem cutting to introduce a wide variety of new cuts. Square, trapeze, table, navette, and baguette were just some of the cuts that the Art Deco jeweler employed to realize the growing trend for geometric arrangements, the baguette being the most popular. Often the jewelers would use a dazzling combination of these different cuts to emphasize and contrast the different tones and colors of the stones. The crispness of the diamond was also perfectly suited to offset the increased number of colored stones, for example emeralds and lapis lazuli, which had begun to enter the jeweler's palette. In the late 1920s there was a marked trend for pure diamond pieces, probably an allergic reaction to the mass of colorful creations of the preceding years.

Glass was a material that enjoyed the popularity of jewelers in the Art Deco period. The surge of interest in its decorative qualities was due to the lingering effect of its success in the Art Nouveau years where it had blossomed under the light of talented artists such as Emile Gallé and Louis Comfort Tiffany. Many of the chief protagonists of the glass from that period continued to explore its potential in the 1920s and 1930s.

The development of *pâte de verre* by glassmakers such as Alméric Walter and Joseph-Gabriel Argy-Rousseau was carried forward from the 1900s into the Art Deco period. Side by side

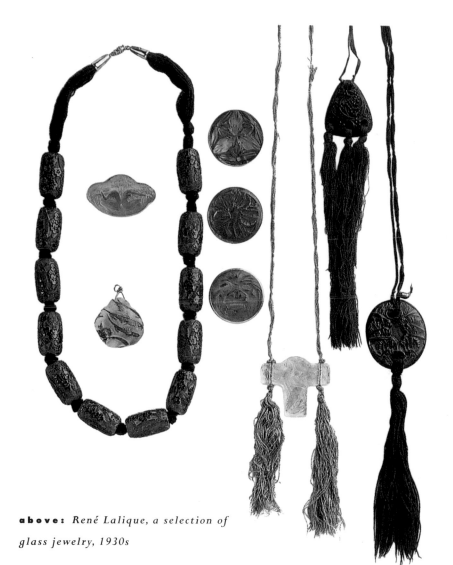

above: *René Lalique, a selection of glass jewelry, 1930s*

with their vases, plaques, and small statuettes, they produced delicate pieces of jewelry. These semitranslucent pendants and brooches were decorated with flowers, plants, and small insects, which as the Art Deco style gained in general popularity, became increasingly geometric and stylized in appearance.

René Lalique was no stranger to the world of jewelry. In fact, it had been largely due to the brilliance of his Art Nouveau jewelry at the turn of the century that jewelers after him had been able to throw off the shackles of traditionalism

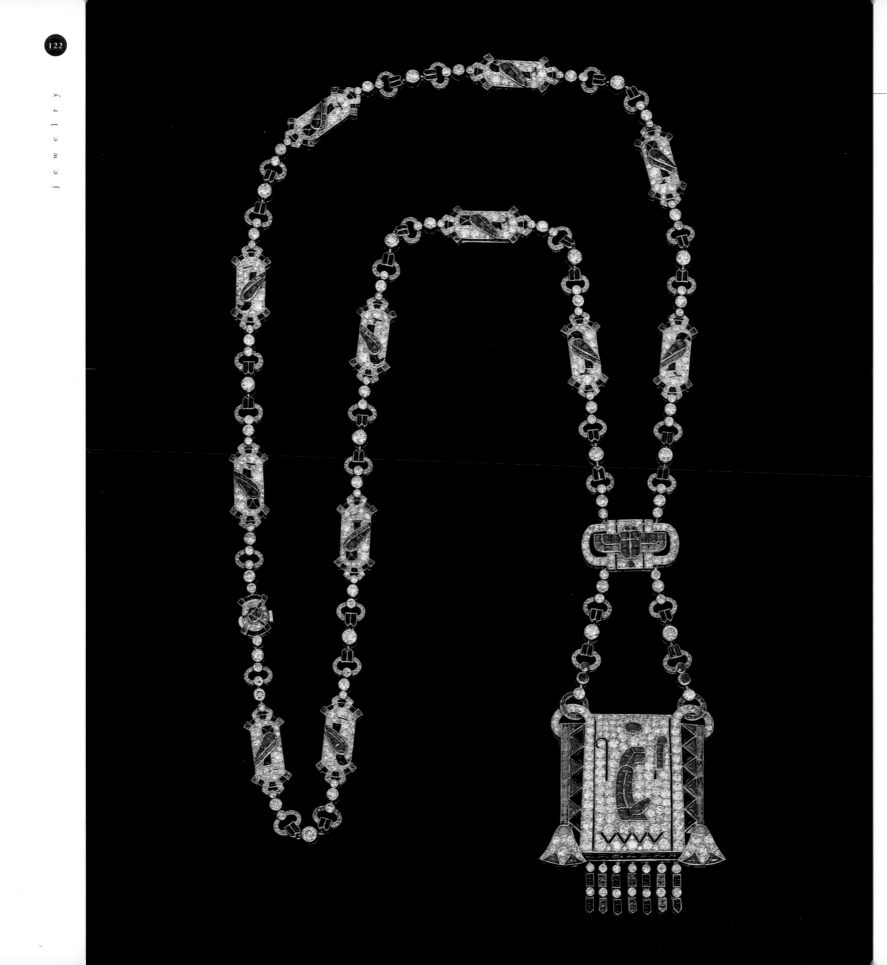

and revivalism. As already mentioned, Lalique broke with the established notion prevalent in the 1900s that the intrinsic value of a piece was to be considered above its form and composition. To this end he introduced a wide variety of non-precious materials such as bone, wood, horn, and enamel into his fantastic designs.

Although after the First World War Lalique concentrated on the production of glass, he continued to design jewelry, though now in this favored medium. Using the latest press-molding and mass-production techniques at his factory at Wingen-Sur-Moder, he made a wide variety of brooches, bracelets, necklaces, pendants, rings, and hatpins. Drawing on the same decorative vocabulary, which had inspired his other glass designs, namely birds, insects, flowers, the female form, and geometric motifs, Lalique produced jewelry in either clear glass or colors such as electric blue, green, amber, and black. To increase the decorative effect he would often employ a brown or blue stain to highlight the relief-molded decoration or add a colored metallic foil to the back of brooches to create a rich reflective effect. Pendants were suspended on long silk cords with tasseled ends.

The incredible developments that took place in the field of jewelry in the Art Deco period would not have been possible without the dramatic social changes that affected the way that women, after the First World War, perceived themselves. While their husbands, fathers, and sons had bravely fought in the trenches, women had played their part in the war effort by working in ammunition factories, ploughing fields, and running family businesses. The practicalities of working under such conditions released women from the constricting corsets, long skirts, and heavy bustles of the early part of the twentieth century to clothes that allowed them much greater freedom and movement.

left: *Van Cleef & Arpels, a ruby, emerald, and diamond sautoir, 1924*

This liberation of dress, coupled with the general joie de vivre and the sense of recklessness that swept across Europe after 1918, saw women refuse to readopt their traditional passive roles. They felt that they had earned the right to dance till dawn, drink cocktails, smoke cigarettes, and drive fast cars. Leading couturiers such as Paul Poiret and fashion magazines such as *Tatler*, *Vogue,* and *La Gazette du Bon Ton*, responded to the demand for greater comfort and ease of movement by producing increasingly streamlined dresses,

below: *Two ruby- and diamond-set bracelets, French, circa 1932*

which in looser, lightweight materials, were devoid of the excessive ornamentation of Victorian times. Artists and craftsmen rejected the whiplash curve of the Art Nouveau period in the early decades of the twentieth century in favor of geometric, angular forms. Fashion followed the same path by replacing

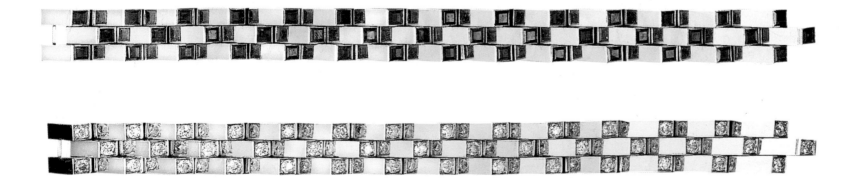

the previously adored curves of the nineteenth-century woman with a slimmer, longer silhouette in the 1920s and 1930s.

Each change in fashion was carefully digested by the jewelry industry. As the shapes of dresses were altered so jewelers began to produce or increase the production of jewelry that would complement these changes. The growing popularity of rows of pearls or strings of carved beads, such as jade, agate, or coral, stemmed from the increasingly low neck and back lines of contemporary dresses. Pendants on long chains were designed with tasseled ends to accentuate the overall stream-lined effect.

below: *René Boivin, a diamond cocktail ring, circa 1935*

The rising of hemlines in the 1920s was matched by the disappearance of sleeves that saw arms and wrists start to enjoy the hitherto unknown attention of jewelers. They were adorned with bracelets either in the form of bangles, worn singularly, or in graduated clusters, or designed as flat, broad bands, again worn on their own or in conjunction with others.

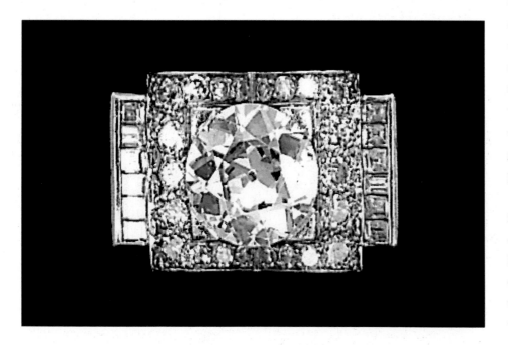

The materials that Art Deco jewelers employed for these bracelets encompassed the entire breadth of precious and semi-precious available at that time, elephant hair and ivory being particularly noteworthy for illustrating the current vogue for African art and culture. At the end of the 1930s there developed a taste for chunky bracelets, referred to as "tank track," which were typified by their large metallic surfaces and machine-made appearance. The Art Deco period also saw a revival in the popularity of charm bracelets. Usually of heavy form, the gem-set charms were often specifically designed for one bracelet as opposed to the traditional random collecting of charms. Following down from the wrists, the hand was decorated with large rings of geometric or Oriental-inspired form. As the 1920s progressed, rings became increasingly solid and heavy, with less emphasis on the actual gemstones, and more on the decorative effect.

In keeping with the desire for ease of movement and simplicity, women cut their hair into sleek, short bobs, which they covered with smooth cloche hats or adorned with slender, flat clips. Completing the "garçonne" look, the newly exposed ears and necks were decorated with pendant earrings. These were often of exaggerated length to match the stomach-reaching necklaces. Again the repertoire of materials used for earrings was as wide as the range of decorative sources. The introduction of ear clips in the early 1930s, as opposed to pierced drops, gave jewelers the opportunity to design heavier, geometric pieces with fan-shaped, circular, or square motifs.

A particular feature of jewelry in the Art Deco period was its versatility. Whether arising as a result of the frugality and constrictions of the war years or the increased speed of social life in the years following, certain pieces of jewelry were designed to be interchangeable. Pairs of clips were clasped together to form brooches or separated to create pendants, while brooches were randomly employed to decorate hats,

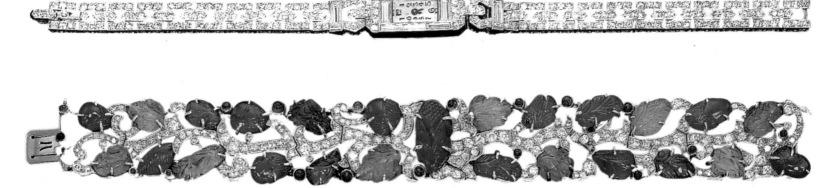

lapels, waistbands, or shoulders. The wristwatch likewise moved away from being simply an instrument of timekeeping to a highly prized item of adornment. Numerous firms produced slender, diamond-studded wristwatches that, in their extravagant designs and opulent settings, were more like bracelets than functional objects.

France, in particular Paris, was without a doubt the focal point for the development of Art Deco jewelry in the 1920s and 1930s. Here the leading jewelry houses embraced the latest artistic trends and fashions and led their clients forward into the new style.

By the 1920s La Maison Fouquet was already well established within Parisian jewelry circles for breaking with tradition and embracing the new. Georges Fouquet (1862–1957) had created sublime pieces in the Art Nouveau years that were revolutionary in their time for the inclusion of semiprecious stones and metals. As the Art Deco style developed he led the firm forward by designing pieces with the newly popular geometric motifs of circles, rectangles, and linear banding. Another characteristic of the firm's jewelry in this period was its use of precious and semiprecious materials and stones in striking color contrasts, such as diamonds, black enamel, jade, and coral. Georges' son, Jean, joined the firm in 1919, and in association with designers such as Eric Bagge and André Leveillé, continued the family tradition of breaking new ground by introducing increasingly abstract pieces of jewelry with strong geometric outlines and the use of original new materials. Jean's work bore close affinities to the more avant-garde style of jewelry that was beginning to appear at that time in Paris alongside the work of the traditional *hautes joailliers*.

top: *A lady's diamond wristwatch, French, circa 1930*

The House of Cartier was one of the leading jewelry firms in Paris during the Art Deco period. Founded in 1847 by Louis-François Cartier it eventually passed to his three grandsons who, over the years, built up an international reputation with branches in New York and London by the early 1920s. Traditionally catering to the luxurious tastes of the upper classes in the late nineteenth century, Cartier warmly embraced the new breed of nouveau riche that emerged after the First World War. Drawing on the latest decorative influ-

above: *Cartier, a diamond- and gem-set bracelet, circa 1928*

ences and reflecting the current trend for combining precious and semiprecious stones and materials, they became renowned for the superior quality of their jewelry and *objets de vertu*. Though the firm had been producing pieces with Egyptian motifs since about 1910, after Howard Carter's discovery of the

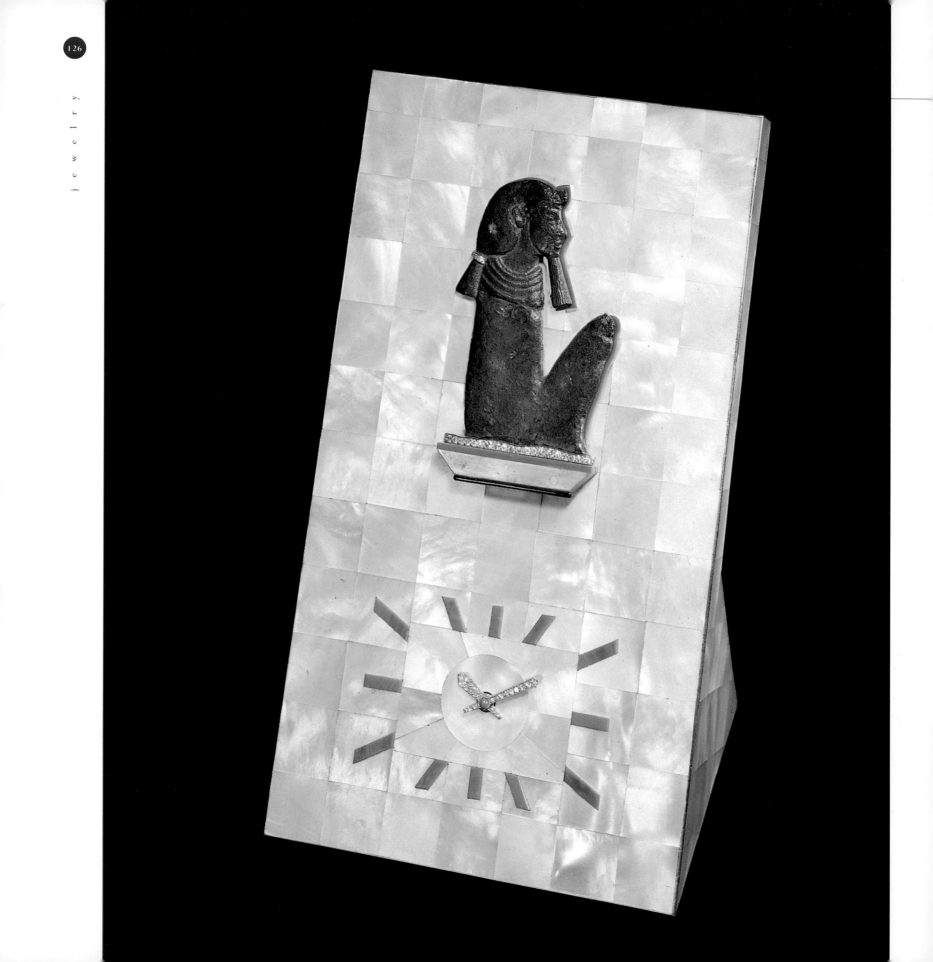

tomb of Tutankhamen in 1922 and the ensuing Egyptomania that swept through Europe, Cartier created a variety of exquisite jewels with motifs inspired by this theme. Sphinxes, stylized hieroglyphics, winged female figures, falcons, and lotus flowers regularly featured in their jewelry, as did the color combination of green (emerald), red (ruby), blue (sapphire), black (onyx), and white (diamond). Louis-François Cartier was so enthused by the art of Egypt that he occasionally incorporated antique pieces into contemporary works.

Cartier likewise found inspiration in the 1920s vogue for Orientalism. Since the mid-nineteenth century the influence of the Far East had been recognized for its contribution to the development of European decorative arts. However, the opening of Sergei Diaghilev's Ballet Russe in 1909, with its exotic chinoiserie costumes and stage settings, sparked a flurry of renewed interest in the art of this distant culture. Leading jewelry houses such as Cartier responded by increasing the use of materials such as jade, coral, pearls, enamel, and lacquer while at the same time drawing on Chinese and Japanese forms and motifs such as dragons, chinoiserie landscapes, and pagodas. Cartier was particularly successful with its range of desk and carriage clocks with exquisite settings and mounts that they frequently designed in the form of Japanese temple porticoes. Wealthy clients treasured these clocks more for their opulence than for their time-keeping abilities. In association with the clockmakers Maison Verger, Cartier developed the "mystery" clock, which was remarkable for creating the illusion that the dials of the face operated independently of any movement.

The jewelers of the Art Deco period did not limit their creativity to jewelry. The 1920s and 1930s, or the Age of Elegance as the period was sometimes known, was

left: *Cartier, a mother-of-pearl, coral, bronze, and diamond table clock, 1939*

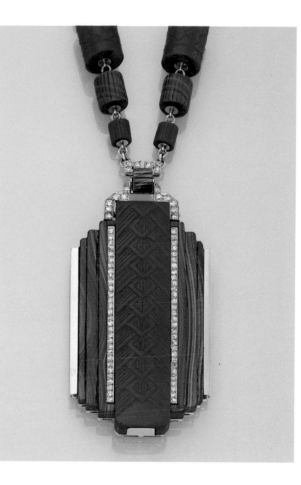

left: *Van Cleef & Arpels, a malachite, lapis lazuli, and diamond pendant sautoir, circa 1930*

marked by the increased production of luxurious accessories. It became socially acceptable for a woman to retouch her make-up in public and powder compacts, handbags, mirrors, and lipstick holders, as well as cigarette cases and lighters, began to enjoy the attention of the leading jewelry houses. Adorned with precious and semiprecious stones and employing exotic decorative techniques such as lacquering and enameling, these small items acted as the perfect vehicles through which the jeweler could demonstrate his skill and talent. Jewelers were also employed to decorate the clasps of handbags and purses in precious and semiprecious stones.

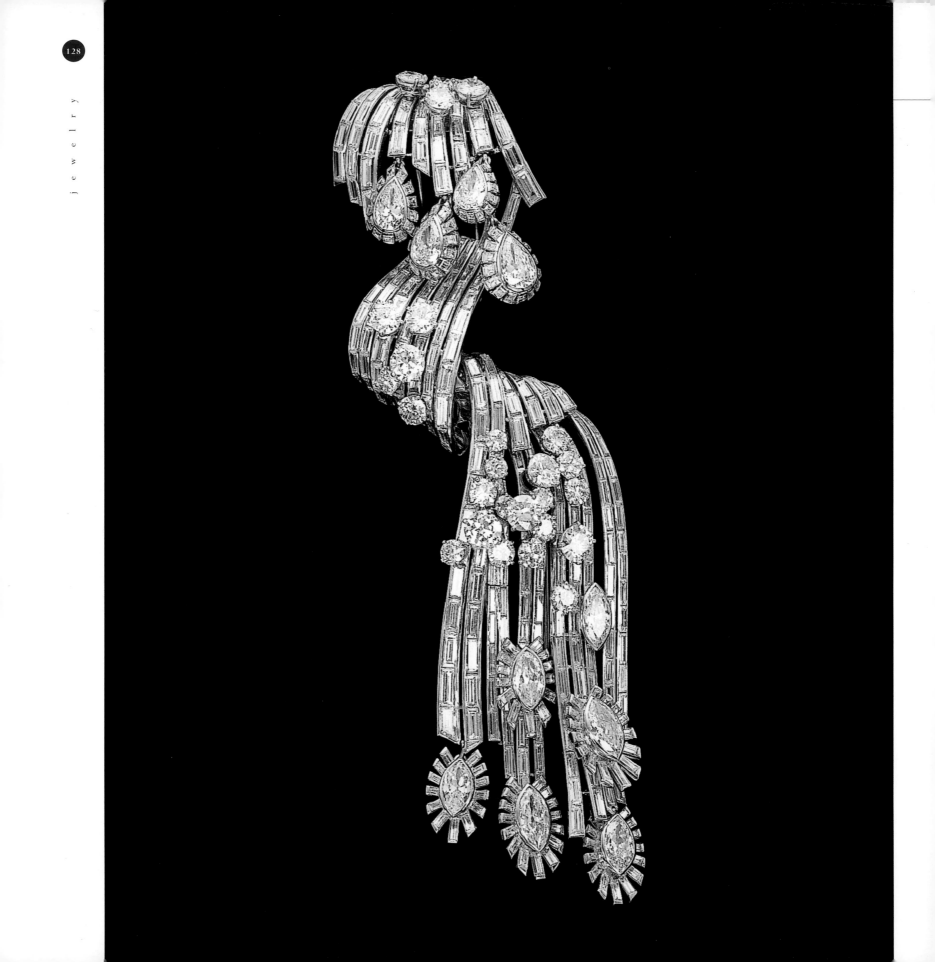

The Parisian firm of Van Cleef & Arpels, like Cartier and so many other Art Deco jewelry firms, also specialized in the production of small opulent accessories. The firm is particularly credited with the introduction of the minaudière, a form of vanity case, which would eventually become synonymous with the Art Deco period. First created in 1930, the minaudière was apparently named after Louis Arpels, one of the firm's directors, saw his wife simper (*minauder*) into a mirror. Containing a compartmentalized interior, the minaudière served as a multi-functional form of handbag, vanity case, and purse. Patented by Arpels in 1933, it was produced in a variety of geometric shapes: cylindrical, flat rectangular, or circular.

The House of Mauboussin had been established in Paris since 1827. It was a regular contributor to the various international exhibitions in the early decades of the twentieth century and, under the control of Georges Mauboussin in the 1920s, it adopted the Art Deco style with vigor. The firm's early jewelry was identified by its use of strongly colored hardstones but these gradually gave way to pieces set purely with brilliant diamonds, in keeping with the vogue for pure "white" jewelry that predominated in the late 1920s.

The Maison Boucheron was a long-standing aristocrat within the Parisian jewelry industry who successfully managed the transition from Art Nouveau to Art Deco. In the mid-1920s the firm was particularly known for producing clips, brooches, pendants, and small hand cases where the central decorative motif was a stylized arrangement of flowers in a vase, most usually in a colorful combination of precious and semiprecious gemstones such as coral, carnelian, malachite, and diamond. Such designs reflected the popularity with Parisian jewelers of the period for importing from India and

left: *House of Mauboussin, a diamond cascade double-clip brooch, 1939*

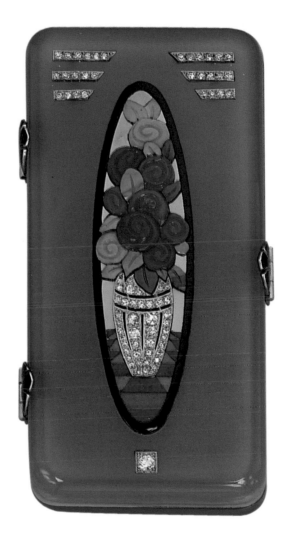

left: *Maison Boucheron, an agate, diamond, and enamel case, circa 1925*

Madagascar precarved emeralds, rubies, and sapphires in the shapes of leaves, berries, and flowers. These were easy to arrange into stylized bouquets of flowers or trailing vines, either contained within the design of the piece or forming its entirety, such as in a bracelet. The increased incorporation of color into jewelry design in the 1920s also illustrated the strong influence that the bold, striking color palette of the Fauvist artists and the vivid set designs of the Ballet Russe were having on the decorative arts at this time. The firms of LaCloche Frères, Van Cleef & Arpels, and Cartier were likewise

known to have produced Tutti-Frutti jewelry, as these colorful combinations came to be generally nicknamed.

Also deserving mention for their Art Deco jewelry in the 1920s and 1930s were the Parisian firms of Chaumet, Janeisch, Dusausoy, Mellerio, Vever, Linzeler-Marchak, and Boivin. The Madrid-based firm of LaCloche Frères earned a reputation for the superior quality of their enamel and gemstone accessories such as evening bags, powder compacts, and vanity cases, as much as for their jewelry.

right: LaCloche Frères, a diamond, black and red lacquer lapel watch, circa 1926

The firm was particularly inspired by the craze for Orientalism and, as well as incorporating motifs such as pagodas, cherry blossom, and Japanese landscape panels into their designs, they also produced many fine pieces in red lacquer, often with raised black flower heads and vine detail. A variation of this was their lacquer panels inset with colored mother-of-pearl in a technique referred to as *lacque burgauté*. Also in Paris at this time practicing a form of this inlay was the Russian Vladimir Makovsky (1884–1966). He is credited with the production of many exquisite compacts and accessories, which he decorated with chinoiserie-inspired plaques.

Working side by side with the larger established French jewelry firms, there emerged a group of jewelry designers in the late 1920s who are today referred to as artists-jewelers. They were largely distinguished by their abandonment of the representational motifs of the traditional *hautes joailliers* in favor of pieces where the emphasis was on the interplay between abstract and geometric shapes and the color contrasts of various stones and materials, whether precious or semi-precious. They drew their inspiration from contemporary

avant-garde artistic movements such as Cubism, Futurism, Constructivism, Suprematism, and Neo-Plasticism. The leading lights of this group were Raymond Templier, Gérard Sandoz, Jean Desprès (1889–1980), Paul-Emile Brandt, and the already mentioned Jean Fouquet.

Many of these young jewelers had the advantage of being born into established family jewelry firms. Such was the case for Raymond Templier. His grandfather had founded the Parisian firm in 1848, from whence it had descended to his son Paul who went on to establish himself as a distinguished designer in the Art Nouveau style. Raymond joined the firm in 1919, coincidentally the same year that Jean Fouquet began his career at La Maison Fouquet. Templier's oeuvre included a wide variety of brooches, pins, pendants, bracelets, and earrings, much of which, after 1929, were done in collaboration with the designer Marcel Pecheron. Templier's work was typified by its strong geometric forms frequently incorporating elongated or streamlined outlines. He favored the use of the newly popular platinum, diamonds, white gold, black enamel, and lacquer, which he placed in simple, yet strikingly effective contrasting arrangements of black and white, line, and circle or polished and matt surfaces. Occasionally Templier introduced such materials as coral, aquamarine, and hematite, though always in restrained proportions.

Jean Desprès designed jewelry that, like the work of all the artists-jewelers, reflected the influence of the machine. The success of the aeroplane, train, industrial factories, and the motor car in the 1920s had all sparked an international surge of interest in industrial design and the potential of mechanical machines. Similar to Templier, Desprès used contrasting

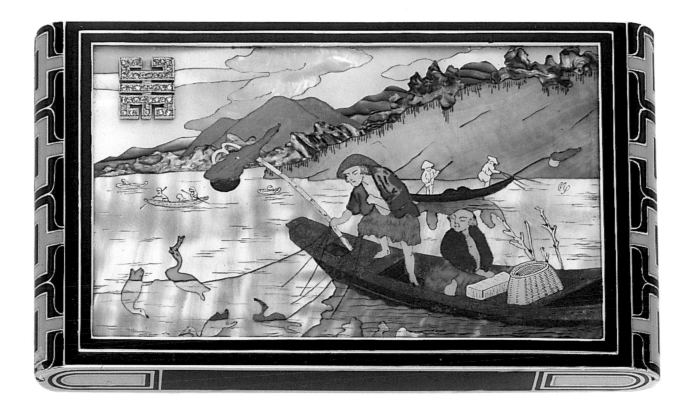

materials such as ivory, lacquer, silver, and crystal to design pieces that focused on the juxtaposition between geometric shapes or smooth and roughly finished surfaces. His thickly walled bracelets and large, solid rings also reflected the current vogue for African masks and the widespread influence of the Cubist movement.

Gérard Sandoz (b. 1902) was yet another jewelry designer who came from an established family firm of jewelers. He used his background to springboard a career that was typified by its use of a decorative grammar, which was yet again derived from the machine. Sandoz, however, was particularly noteworthy for the superior quality of the innovative new techniques that he incorporated into his work, chief examples being lacquer, niello, and eggshell. Niello work, whereby a thin layer of lacquer is inlaid into a silvered surface,

as well as *coquille d'oeuf* (crushed eggshell) were ideal for creating the sharp contrasts of color and texture that underpinned all the geometric designs of the artists-jewelers. In association with these materials Sandoz employed a wide variety of semiprecious hardstones such as onyx, rock crystal, aquamarine, citrine, and hematite. As well as jewelry he designed a varied selection of cigarette cases, lighters, and boxes, the flat surfaces of these fashionable accessories acting as perfect canvases for his designs.

above: *Vladimir Makovsky, a mother-of-pearl, hardstone and enamel compact, circa 1928*

Paul-Emile Brandt, not to be confused with the metalworker Edgar Brandt, also earned a name within Parisian high society in the 1920s and 1930s for his superior quality accessories. In conjunction with his jewelry he designed a varied selection of luxury items, such as boxes, cigarette cases,

and compacts that, like Sandoz, not only provided the medium through which he could develop his geometric design theories, but also allowed him to fully display his mastery of lacquering techniques. Brandt was particularly fond of crackled eggshell, which he placed in opposing irregular geometric shapes in black enamel or colored lacquer. Another favored material was black onyx, which he contrasted with platinum or inset with pearls in linear arrangements and designs.

Although today probably better known for his metalwork vases and lacquer screens and panels, Jean Dunand also included jewelry among his repertoire of work, much of which is recognizable for his characteristic use of red or black lacquer. Designing earrings, brooches, bracelets, and necklaces, Dunand used lacquer in collaboration with polished or hammered metal surfaces, silver being particularly popular.

above: *Black, Starr & Frost, an enamel, diamond, rock crystal, and ruby brooch, circa 1925*

In Germany, the city of Pforzheim, on the outskirts of the Black Forest, had long been recognized as a leading center for the production of jewelry. Established back in the eighteenth century, its jewelry industry had made a name for itself, both at home and abroad, for the high standard of mechanization and technical skills of its jewelers. The large manufacturing firm of Theodor Fahrner (1868–1928) in Pforzheim had been one of the first in Germany to produce good-quality, inexpensive

Art Nouveau jewelry on a large scale in the early 1900s. As the popularity of the Art Deco style took hold in the following decades, Fahrner continued the tradition of producing affordable jewelry based on the latest fashions. Retailed in England through Liberty & Co. and Murrle Bennet in the United States, or sold through cataloges, these pieces combined a variety of semiprecious stones, such as malachite, amazonite, and green chalcedony, with low-grade gold or silver settings. Strong color contrasts of blue and green or black and coral were frequent in the firm's designs. Though the quality of the firm's work was not that of the leading Paris jewelry houses, it was important for introducing avant-garde into mainstream commercial production.

However, what really took the Art Deco style to the masses in the 1920s and 1930s was the tremendous growth in the production of costume jewelry. In the eighteenth and nineteenth centuries the intent behind the manufacture of costume jewelry had been merely to recreate the gem-set work of the leading jewelry houses. Designs had usually been directly inspired by the prize-winning pieces on display at international exhibitions and salons. The only degree of innovation was how cleverly the colored glass or steel mounts could imitate the precious stones and metals of the traditional *haute joaillier*. In the Art Deco period, however, the creators of costume jewelry became internationally recognized for the originality of their designs.

Coco Chanel, the Parisian haute couture designer, was one of the first to see the potential of costume jewelry. Through an inherent sense of style and panache, she began to laden her clothes with flamboyant pieces of jewelry that were noted for their combined qualities of fun and luxury. Intended to last only as long as the season's fashion, costume jewelry became popular among the smart set of high society. The availability of relatively inexpensive new materials, such as chrome, Bakelite

(a form of plastic), and synthetic stones, meant that designers could be a lot more extravagant in their designs. Simultaneously advances in printed communication resulted in the publication of numerous fashion magazines, and the universal appeal of the movies meant that the ordinary woman of the 1920s and 1930s was more aware of the latest trends in fashion than her grandmother could ever have been. The Art Deco years saw the latest avant-garde designs being translated into affordable costume jewelry. As well as Chanel, the costume jewelry of the Italian designer Elsa Schiaparelli, the American firm of Trifari (founded by Gustavo Trifari, Leo Krussman, and Carl Fischel in the early 1920s), and Auguste Bonaz are all known for their superior quality.

In Scandinavia, the production of Art Deco jewelry was largely confined to the work of the Danish goldsmith and silversmith Georg Jensen. Having trained under the direction of the metalworker Mogens Ballin, Jensen opened his first shop in Copenhagen in 1904, selling jewelry and silverware with simple, rounded forms and restrained naturalistic ornamentation. Incorporating amber, tortoiseshell, or moonstone, he designed jewelry in the early decades of the twentieth century that was characterized by its use of stylized fruit, floral, or animal motifs, with curved fluid contours. The simple, refined quality of Jensen's jewelry proved easily adaptable to the stylization and abstraction of the Art Deco style and many of his designs in the 1920s and 1930s were simply variations on a previous theme. Also producing Art Deco–style jewelry in the interwar years were Evald Nielsen and Carl Christian Fjerdlingstad.

While American architects and furniture designers took great steps forwards in the Art Deco years, the country's jewelers found it hard to let go of the past. Though the presence of fashion magazines such as *Vogue* and the constant influx of European craftsmen in the 1920s and 1930s made American jewelers aware the European styles, jewelers were restricted by the traditional tastes of their clientele from fully adopting the new style. Achieving wealth and status in the New World, these clients found security and confidence in gem-set pieces based on nineteenth-century European originals. Some American firms, such as Black, Starr & Frost, Tiffany & Co., J.E. Caldwell & Co., and Marcus & Co. did produce some stylized Art Deco pieces, though always with an underlying sense of restraint.

The jewelry of the Art Deco, in its opulence and extravagance, matched the sense of joie de vivre and freedom that women enjoyed after the First World War. The bold, geometric designs, inspired by the cultures of distant and ancient countries, were the perfect adornment to wrist, neck, and ears of the socially liberated woman. More so than in other fields of the decorative arts, the new techniques and materials, such as platinum, were fully exploited by jewelers in the 1920s and 30s to create fresh, new designs, totally free from the historicism and revivalism of the past century.

Adored by women at the time, the jewelry of this period has never lost its appeal and is still today eagerly sought after and cherished by collectors and connoisseurs.

below: *Raymond Templier, a diamond, black enamel and platinum brooch, circa 1935*

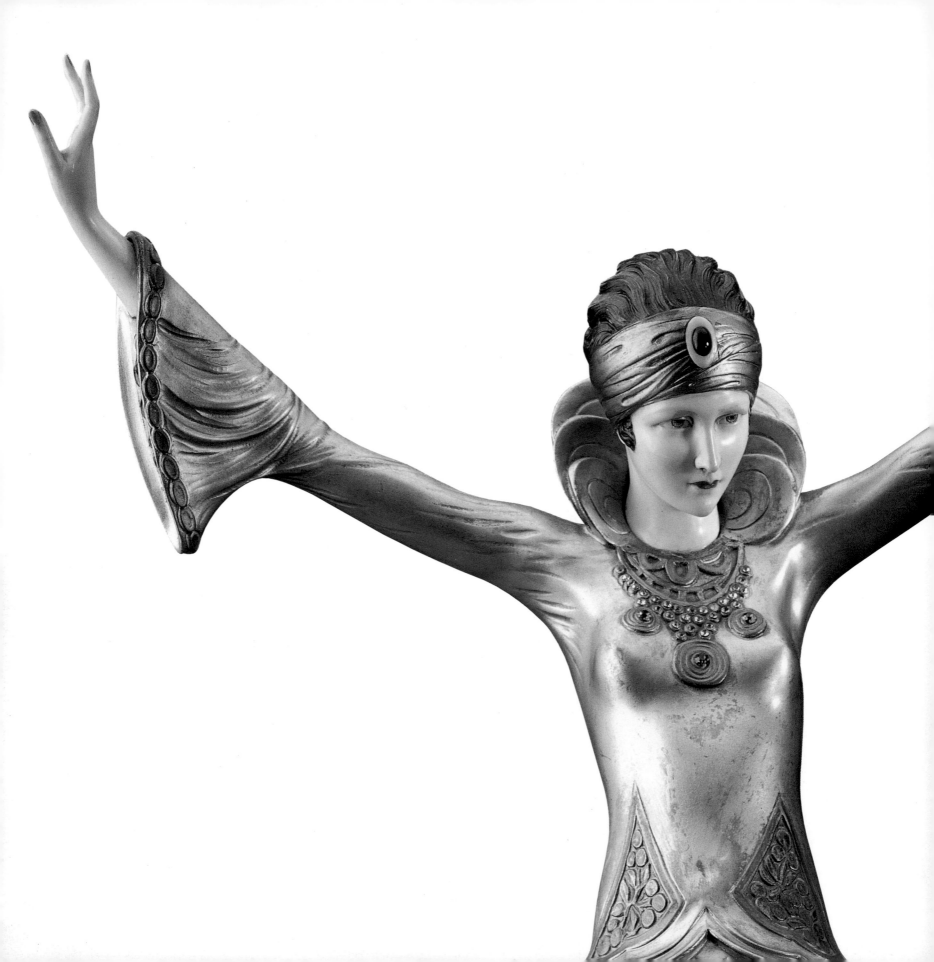

SCULPTURE

chapter seven

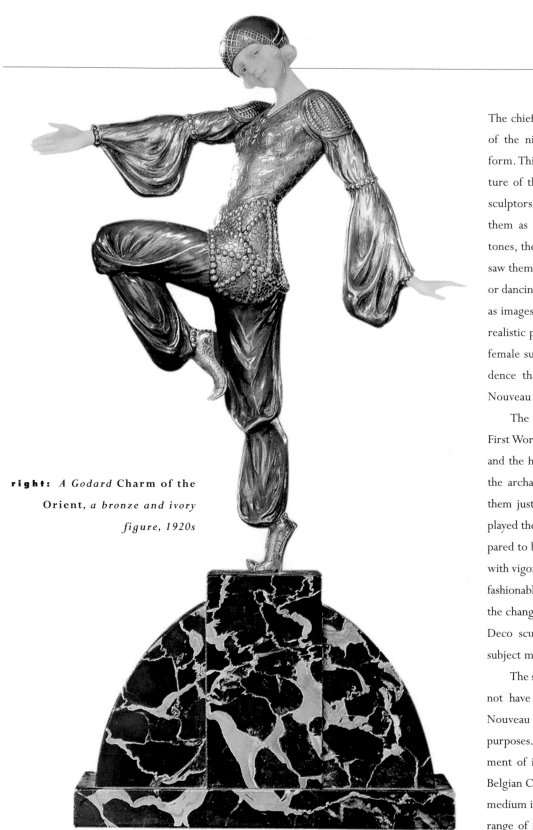

right: *A Godard* **Charm of the Orient**, *a bronze and ivory figure, 1920s*

The chief characteristic of Art Nouveau sculpture at the turn of the nineteenth century was its adoration of the female form. This theme was carried forward in the Art Deco sculpture of the 1920s and 1930s, but whereas the Art Nouveau sculptors had placed their women on pedestals, often seeing them as symbolic, mythical creatures with spiritual undertones, the Art Deco sculptors portrayed their subjects as they saw them in everyday life—playing tennis, smoking cigarettes, or dancing in a wild fashion. Women were no longer presented as images from a dream but they were shown participating in realistic pursuits. The fact that sculptors began to model their female subjects dressed in the latest fashions was further evidence that they had left the idealistic fantasies of the Art Nouveau period behind them.

The emancipation of women that came about after the First World War freed them, not only from the stifling corsets and the hobble skirts of the nineteenth century but also from the archaic restraints of "good" society that up till then saw them just as decorative, albeit useful objects. Having actively played their part in the war effort, women were no longer prepared to be treated as second-class citizens. They embraced life with vigor and threw themselves wholeheartedly into the newly fashionable recreational and sporting activities. Responsive to the changing tastes and the demands of their audience, the Art Deco sculptors adopted the new decorative vocabulary and subject matter with enthusiasm.

The success and development of Art Deco sculpture would not have been possible without the already established Art Nouveau tradition of using alternate materials for artistic purposes. A prime example of this was the increased employment of ivory in sculpture. Following the opening up of the Belgian Congo in the late 1890s there had been an influx of this medium into Europe, which had resulted in the production of a range of small bronze and ivory sculptures. Furthermore the

pantograph, invented by Achille Collas in the mid-nineteenth century, which allowed for the small-scale reproduction of large sculptural pieces, was further developed in the early twentieth century to enable sculptors to carve ivory with the same degree of accuracy and detail on repeated editions. Referred to as chryselephantine, these figures were made up of separate sections: the arms, the hands, the feet, and the head usually being of finely carved ivory while the base and torso were cast from bronze. Cleverly fitting together so as to create the illusion that these figures were made entirely of ivory beneath a bronze costume, these pieces were enhanced by the application of several colored lacquers (a technique referred to as cold-painting), or the delicate tinting of the ivory lips and cheeks or the gilding or silvering of the stylized bronze form.

The development of Art Deco sculpture and the sheer volume of work produced within this category in the 1920s and 1930s owed much to the growing number of foundries and editing firms throughout Europe. In the nineteenth century the majority of new sculpture had been large-scale monumental pieces, which, exhibited at the salons and international exhibitions, was executed primarily with the hope of winning a government or public commission. The founder-editors had catered to the tastes of the growing middle class by producing reduced models of the prize- or award-winning pieces for display in the home. After the First World War there was a marked decline in the production of such large decorative pieces for the salons. In order to meet the demand for small-scale figures, many

editing firms and foundries directly approached the leading sculptors of the day and commissioned them to produce models, which they could produce, in a variety of mediums and sizes. Throughout their careers most sculptors would work with a wide selection of different firms.

The variety of influences that the Art Deco sculptor could allow to direct his work was vast. One of the most obvious, however, not just in the field of sculpture, but also in other spheres of the decorative arts, was dance. This was particularly true of sculpture in France. The success of Léon Bakst's exotic costumes for the Ballet Russe, most especially his scrumptious designs for *Schérézade* (1910) sparked a spate of small bronze and ivory figures of dancers dressed in elaborate costumes that were inspired by the Orient.

left: *Amedeo Gennarelli,* **The Carrier Pigeon,** *a silvered bronze figure, 1920s*

A good example of this style was the work of the Belgian-born Claire-Jeanne-Roberte Colinet (active 1910–40). Having studied under the Art Nouveau sculptor Jef Lambeaux, one of the earliest exponents of chryselephantine, before moving to Paris, she was a regular contributor at the salon of the Société des Artistes Français and later the Salon des Indépendents. Though Colinet did produce some biblical and historically inspired figures such as Joan of Arc, she is best known for her bronze and ivory figures of exotic female dancers. Wearing elaborate costumes that were derived from national variations, such as the Hindu dancer and the Ankara (Turkey) dancer, these gilt and cold-painted figures were recognizable by their flowing and detailed costumes, which created a sense of

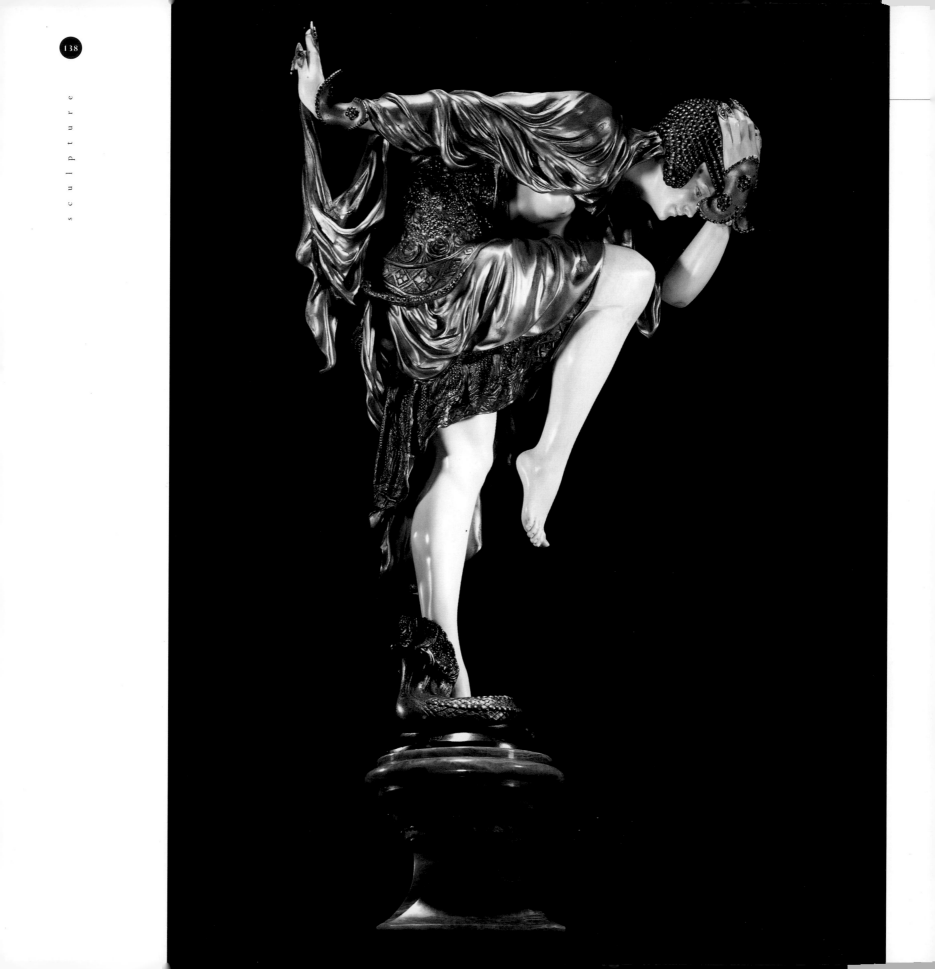

movement to the dramatic poses of the dancers. The majority of the bases were either in onyx or marble, sometimes with the addition of a small bas-relief plaque with motifs, which reflected the overall theme of the figure.

The best-known Art Deco sculptor working in Paris in the 1920s and 1930s was undoubtedly Demetre Chiparus (1888–1950). Like Colinet he left his native country, Romania, for the bright lights and shining dance halls of Paris. The stage was his greatest inspiration, either in the form of exotic dancers taken from the Ballet Russe or chorus lines of girls from the increasingly popular cabaret shows. Alternatively in bronze or chryselephantine, or occasionally in spelter and ivorine, all of his figures displayed the same high quality of detailing, carving, and casting. Many of his figures, either in the form of single dancers, dancing troupes, or couples, although never directly replicating specific dancers or costumes from the shows, bore such close similarities to be nearly identifiable. Leading performers of the day, such as the renowned Vaslav Nijinsky, the popular dancing duo The Dolly Sisters, or the exuberant Tiller Girls chorus line, all provided inspiration. The constant flow of dancers from the Far East, Hungary, and India into Paris in the early part of the twentieth century, all with lavish costumes and dance routines, created a swirling melting pot of influences from which artists like Chiparus could drink. For example the pleated skirt, seen in many of his small figures, most likely resulted from the interweaving of Russian and Indian-inspired costumes.

The firm of Edmond Etling, which was based in Paris, edited the majority of Chiparus' work. Some of his later pieces were executed by the foundry of Les Neveux de

J. Lehmann (LN & JL) and Editions Reveyrolis, as well as the Parisian branch of the Austrian firm of Goldscheider. Chiparus had a penchant for elaborate bases made of mottled onyx or marble, often employing different colored panels to create a nearly architectural shape.

The invention of the incandescent filament bulb in 1879 by Thomas Alva Edison had been instrumental in the development of Art Nouveau sculpture at the turn of the twentieth century. The Palace of Electricity at the 1900 International Exhibition in Paris, with its façade of thousands of electric bulbs, was a phenomenon to the thousands of visitors who came to the exhibition. Art Nouveau sculptors responded to the incredible technical development by producing a profusion of femme-fleur figural lamps, which in their cleverly thought out designs had blurred the line between decoration and function. During the Art Deco years of the 1920s and 30s sculptors continued this practice by producing a wide variety of figural lamps. Typical of this period was a nude female

below: Demetre Chiparus, Fan Dancer, a gilt and patinated bronze and ivory figure, 1920s

left: Claire-Jeanne-Roberte Colinet, Ankara Dancer, a gilt and cold-painted bronze and ivory figure, 1920s

below: *Demetre Chiparus,* Les Girls, *a bronze and ivory figure group, 1920s*

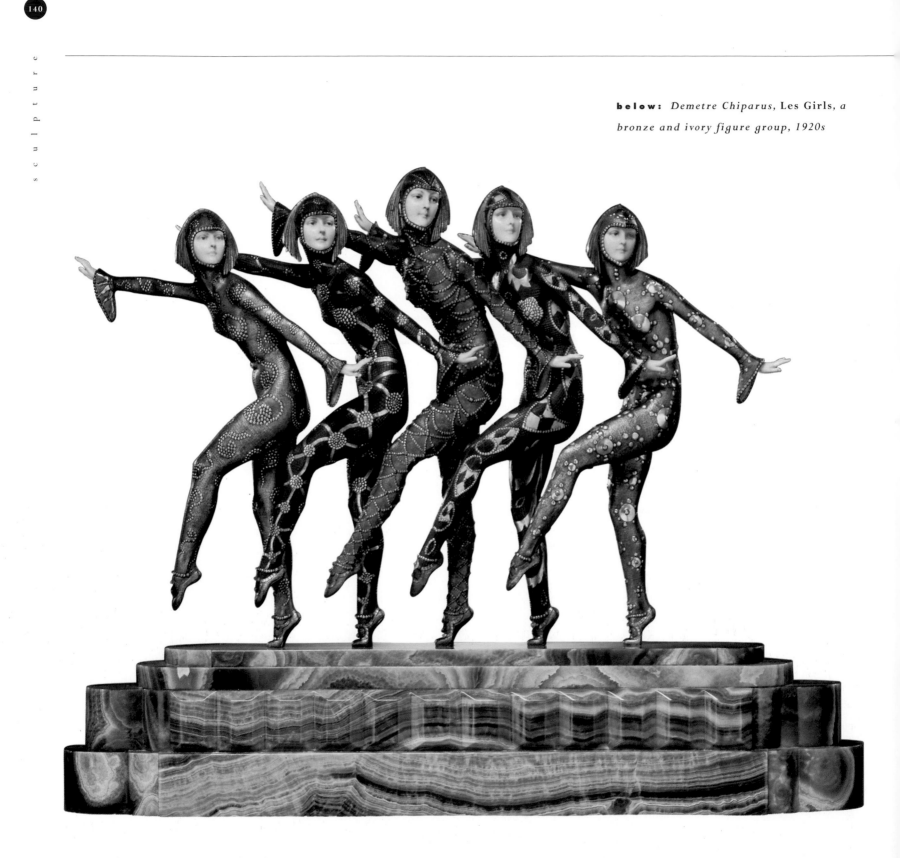

dancer poised on one leg holding aloft a spherical craquelure glass shade with an interior light socket. Produced in bronze or the cheaper spelter, these lamps were soon a regular feature of the Art Deco home.

Likewise the Art Nouveau movement had advocated that artists and designers should embrace all areas of the decorative arts and not just confine their talents to one specific field. Sculptors, as already seen, were freed from the staid tradition of working only to one-off commissions from wealthy patrons or from the state, and the fin de siècle period saw a profusion of leading sculptors designing all types of ornaments and everyday objects, including inkwells, pin-trays, clock-cases, boxes, and dishes. Though the Art Deco sculptor in the following decades did not produce quite the same extensive range of items, the practice of designing figures to compliment functional objects was closely followed. For example many sculptors in the 1920s and 30s modeled figures to be placed alongside clocks. These ranged in quality from fine cold-painted bronze and ivory figures that stood on small green onyx cases to crudely modeled gilt or silvered spelter figures standing on large, heavy cases; the latter often consisting of a plaster body on which thin bands of onyx were merely applied. Bookends provided another opportunity to create clever and original designs; gazelles leaping from one bookend to the other, comical clowns giving the appearance of pushing the books together, or small children peeping over the tops of the books, were just some amongst a vast range of ingenious designs that a number of the Art Deco sculptors produced during this period.

The sculptor Pierre Le Faguays (b. 1892) produced a number of figural lamps. He adopted a stylized approach for his work, which reflected the growing popularity for geometric and angular forms following the success of the Cubist movement. His figures tended to be of elongated outline with exaggerated poses but marked by a lack of movement. Working mainly in bronze, either gilded or patinated, and intermittently with ivory, marble, ceramics,

left: *Pierre Le Faguays,* **Odalinesque,** *a patinated bronze figure, 1920s*

and wood, Le Faguays also produced figures of strong mythological or allegorical women. These tended to be less stylized than his other figures and had more in common with similar themed pieces by Chiparus. Much of his work was edited by Goldscheider and at the 1925 Paris Exhibition he displayed his sculpture under that firm's La Stèle line of goods.

Marcel-André Bouraine (active between 1918 and 1935) likewise adopted a stylized decorative vocabulary for his bronze and chryselephantine sculpture. Focusing on the female form, he depicted her in a variety of guises such as a dancer or harlequin clown, but most noticeably as a striking female mythological archer or powerful, muscular Amazonian warrior. Bouraine's figures in the last two categories illustrate the marked trend in the Art Deco period for images and figures of strong, athletic women. This was possibly a response to the growing popularity of outdoor pursuits or perhaps reflected the newly emerging powerful position of women in everyday society. Working mainly in conjunction with the firm of Etling, Bouraine also produced a number of designs in the 1930s in *pâte de verre*

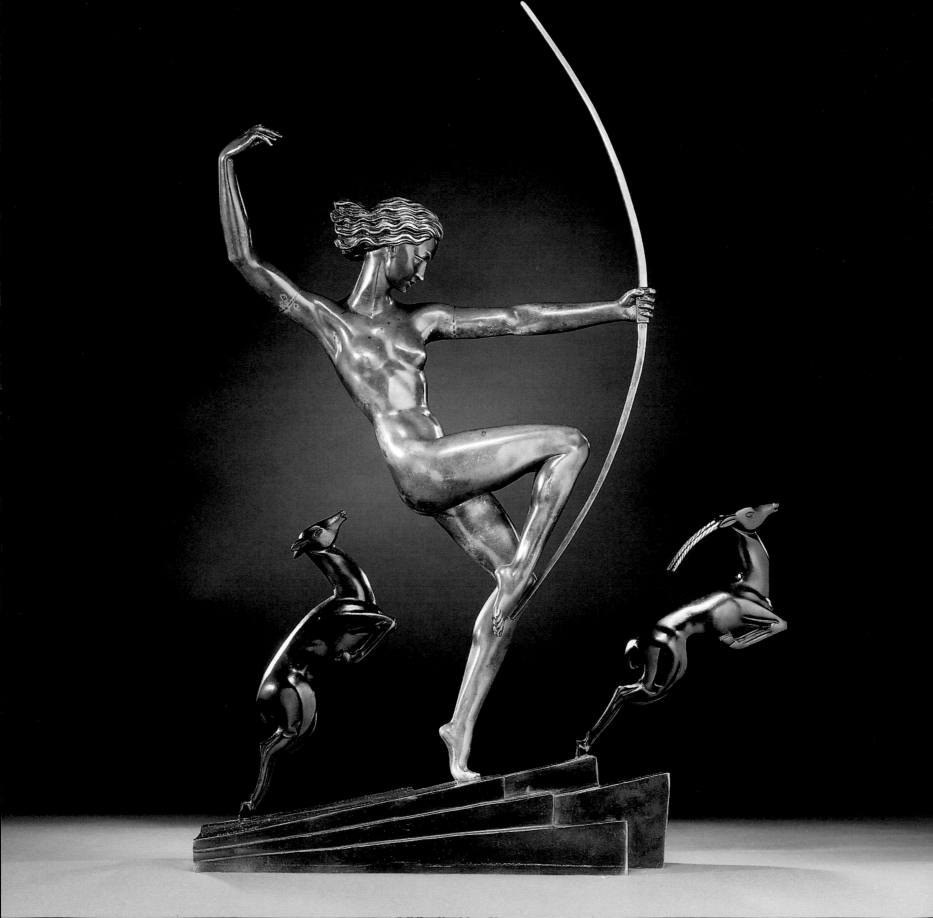

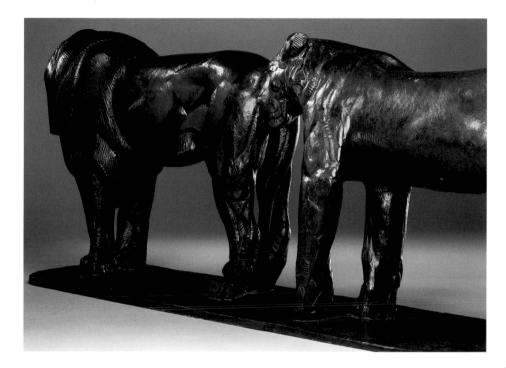

left: *Marcel-André Bouraine*, Diana the Huntress, *a bronze group, 1920s*

right: *Maurice Guiraud-Rivière*, The Comet, *a gilt and cold-painted bronze figure, 1920s*

glass that were executed by the glassworker Joseph-Gabriel Argy-Rousseau. Coincidentally another Parisian sculptor, Jean Bernard Descomps (1872–1948) designed some models for the other great exponent of *pâte de verre* glass, Alméric Walter.

The list of sculptors working in Paris in the Art Deco period is large, but deserving special mention for their work are Sybille May, Aurore Onu, Paul Silvestre, René-Auguste Rozet, Solange Bertrand, Amedco Gennarelli, Maurice Guiraud-Rivière, and Georges Lavroff. All of these artists represented the more commercial end of sculpture in Art Deco France. Their figures were intended to be reproduced in, though often limited, further editions. However, running parallel to this more mainstream work was a small band of sculptors attempting to find full artistic expression through the creation of one-off unique pieces. Drawing more from contemporary painting movements, such as Cubism and the influence of African art than that of dance, sport, and fashion, these avant-garde sculptors were producing highly innovative work during the 1920s and 1930s.

The sculptor and painter Jean Lambert-Rucki (1888–1967) was most especially known for his carved and painted wooden figures of highly stylized form and outline. Born in Poland but settling in Paris to pursue his career as a sculptor, Lambert-Rucki was heavily influenced by the geometry and stylization of the Cubist movement. Often collaborating on projects with the master lacquerist Jean Dunand, he frequently employed this technique to decorate his sculpture; the application of mirrored

glass or silvering being other methods included in his repertoire. The Cubist influence was also clearly visible in the work of Joseph Csaky (1888–1971), another immigrant sculptor to Paris. Originating from Budapest in Hungary, he arrived in Paris in 1908 and went on to exhibit with the Cubists at the Salon d'Automne and the Salon des Indépendants in 1911. Csaky's sculpture managed to incorporate the stylized geometry of this avant-garde artistic movement while never allowing it to fall into the overabstraction of other Cubist artists working at this time. Gustav Miklos (1888–1967) was, like Csaky, a Hungarian-born sculptor who settled in Paris in the early part of the twentieth century. Like many of the avant-garde artists working in Paris in the 1920s he came under the spell of Cubism. He began to produce work typified by its stylized forms and geometric representation. Miklos also drew on the art of Africa and the influence of tribal masks and carvings are visible in his figurative pieces. Also working in other areas of the decorative arts, namely jewelry, carpets, and metalware, Miklos collaborated with some of the leading exponents of the Art Deco style such as Jacques Doucet, F.L. Schmied, and Jean Dunand.

Also producing Art Deco–inspired sculpture in the 1920s and 1930s in France were Raymond Duchamp-Villon, Alexander Archipenko, Jan and Joël Martel, Constantin Brancusi, Jean Gabriel Chauvin, and Amedeo Modigliani. However, the nature of much of the work of these sculptors bears closer affinities to the contemporary avant-garde artistic movements than the high Art Deco style per se.

The surge of interest in far-flung cultures, most especially that of Africa, in the 1920s and 1930s, and the growing appetite for elegance and exoticism, saw the

left: *Jan and Joël Martel, a composition figure, 1920s*

introduction of new sleek animals into the traditional repertoire of the *animalier* sculptor. Gazelles, panthers, and borzoi were particularly popular, though polar bears, pelicans, seagulls, and dolphins enjoyed their share of the limelight in the interwar years.

By 1910 the Italian sculptor Rembrandt Bugatti (1885–1916), son of the leading Art Nouveau furniture designer Carlo and the brother of Ettore, the automobile designer, had already broken away from the highly naturalistic approach of the nineteenth-century *animaliers*. Working in bronze, he treated his subjects, mainly exotic wildlife, in an almost impressionistic manner. Employing rough, uneven surfaces with irregular texture (finger marks often still visible), he showed other sculptors how to convey the spirit and character of an animal without having to rely on realistic presentation.

Art Deco sculptors, such as François Pompon (1855–1933) and Edouard Marcel Sandoz (1881–1971) reinterpreted this lesson by producing highly stylized figures, which, though devoid of detail, still managed to evoke the essence of the animal. Pompon is particularly known for his streamlined model of a polar bear in white stone, which, like the majority of his bronzes, has a smooth polished surface. Sandoz created models of birds, fish, or wild animals in bronze, ceramic, or marble. Max Le Verrier, Marcel Prost, and Alexandre Kéléty all produced animal models in this highly stylized manner in conjunction with their more standard Art Deco figures of dancers and female forms.

The work of German and Austrian sculptors illustrated the other great influence on artists in the Art Deco years—namely outdoor athletic pursuits. Sports such as tennis, swimming, and golf encouraged a new type of beauty, a new look that was characterized by athletic young women with slender, muscular frames, short bobbed hair and an air of energy and vibrancy. Although German sculptors did include dancing females in

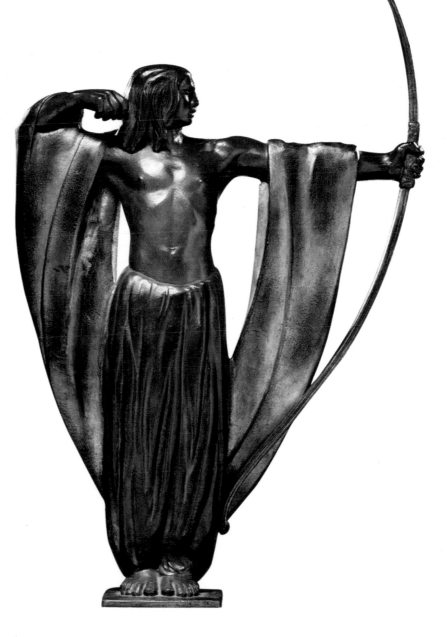

below: *Alexandre Kéléty, a patinated bronze figure, 1920s*

their repertoire, it was the new sporting stars of the day, such as the Olympic ice skater Sonia Henie and the tennis player Suzanne Lenglen who provided the greatest inspiration. The German bronze and ivory figures of dancers in the 1930s tended to have more in common with the acrobatic, slightly androgynous look of the African-inspired dancer Josephine Baker than the exotic appearance and elaborately costumed dancers of the Ballet Russe. The interwar years were marked by an increased interest in fitness and health, exemplified by the type of woman who, exuding fresh air and athleticism, was dressed in simple but fashionable tubular dresses.

The leading sculptor in Germany in the 1920s was Ferdinand Preiss (1882–1943). Born in Erbach on the Oderwald, a region of Germany that had long been established as a center for ivory carving, he later moved to Berlin. It was here that Preiss founded a small ivory workshop with Arthur Kassler in 1906, the firm being known as Preiss & Kassler. They later took over the firm of Rosenthal & Maeder in 1929.

Preiss was renowned for the superior quality of his ivory carving, which may in part have been due to his earlier training in Erbach, but owed much to his determination to produce anatomically correct figures with naturalistic faces and expressions. The majority of his early designs for ivory were of small classical female nudes, usually standing still with long flowing costumes. After the reopening of the workshops in 1919, following the end of the First World War, Preiss moved on to the production of small-scale bronze and ivory figures of children, dancers, and sportswomen. Employing more than ten workers by the mid-1920s, including Ludwig Walther and Walter Kassler, this company produced pieces that varied from figures playing tennis, throwing a javelin, swinging a golf club, fishing, and swimming to archers and dancers. The last-mentioned were often depicted dramatically poised with flaming torches, hoops, and glass balls. Several of Preiss' dancing figures represented the well-known performers such as Ada May, who was a member of C.B. Cochran's dancing troupe, or else were based on performers such as Georgia Graves, whose athletic dancer routines incorporating balls and steel hoops impressed both dance critics and audiences alike. The majority of Preiss' bases were formed from green onyx, although bands of black or brown were often added for further decorative effect.

Working in a style very similar to that of Preiss was the Berlin sculptor Professor Otto Poertzel (1876–1963). His bronze and ivory figures display the same high quality of

left: *Marcel Prost, a patinated bronze figure, 1920s*

carving and use of acrobatic young women, so much so in some pieces that it was often believed that Poertzel and Preiss were the same artist. However, it is now accepted that Poertzel merely provided designs for Preiss & Kassler and Rosenthal & Maeder (before the two companies merged).

Poertzel was not the only artist known to have produced models for the PK workshops; others include Rudolf Belling, Richard W. Lange, and Paul Philippe. The last-mentioned created a number of bronze and ivory figures based on the Spanish dancers, that were to be seen in the cabarets and the theaters throughout 1920s Europe. Poised on tiptoe, holding aloft a tambourine, fan, or parrot, often dressed in harem pants and short bolero jackets, they all wore the same short haircut of the day, as did his female dancers of stylized, angular form in colorful cold-painted costumes. Philippe also produced work for the Goldscheider foundry in Vienna and Les Neveux de J. Lehmann in Paris.

The female dancers of the German Gustav Schmidt-Cassel's (b.1867) chryselephantine sculpture wore lavish costumes that, in their excessive coloring and detailing, bore close similarities to the work of French sculptors such as Chiparus and Colinet. Modeled in dramatic, often physically impossible poses, many of Schmidt-Cassel's figures have an almost futuristic look. Some of these figures are known to have been executed by Preiss & Kassler and Rosenthal & Maeder. The sculptor Gerdago also produced bronze and ivory figures of exotic dancers with elaborately detailed and patterned costumes, several of which were edited by the firm of Arthur Rubinstein in Vienna.

Roland Paris (b. 1894), though born and having studied in Vienna, moved to Berlin to pursue a career as a sculptor and graphic artist. He created humorous, sometimes bordering on the satirical, bronze and ivory figures. Figures such as jesters and female dancers were modeled in a highly stylized manner

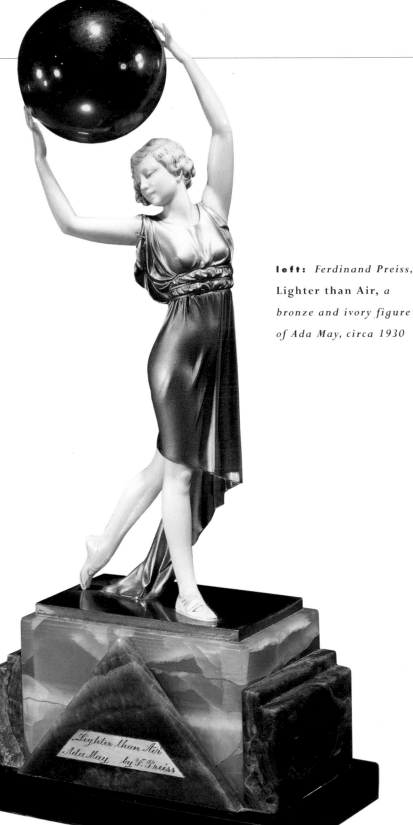

left: *Ferdinand Preiss,* **Lighter than Air,** *a bronze and ivory figure of Ada May, circa 1930*

with exaggerated facial expressions. In association with the Berlin foundry of Ernst Kraas he also designed figural bookends, clocks, and lamps.

Vienna in Austria was another city that developed an international reputation for the production of fine-quality Art Deco bronze and ivory figures. One of the most distinct of the artists working there in the 1920s and 1930s was Bruno Zach (dates unknown). Working mainly in bronze, Zach created female subjects, most often cold-painted or gilded, that presented another facet of life in the Age of Jazz. Whereas Preiss depicted wholesome girls engaged in athletic pursuits in the open fresh air, Zach's women introduced the seedier side of life in Europe's nightclubs. Standing assertively, often naked except for gartered stockings and high heels, loose camisoles, or casually worn fur coats, his women were boldly erotic. Smoking cigarettes, dressed in leather suits, or menacingly holding riding crops or whips, they were unabashedly provocative. An air of dominance and total confidence oozes out of all Zach's figures. He also produced models of ice skaters, tobogganists, and ballet dancers. The majority of his works were edited by the firm of Argentor, Broma Companie, or S. Altmann & Co. The sculptor Dorothea Charol (b. 1895) also produced a number of bronze and ivory figures in the same erotic vein but, though employing similar high heels and stockings to Zach's women, her work never quite achieved the same degree of provocativeness.

Also working in Vienna during the Art Deco period was Josef Lorenzl (dates unknown). Like Zach and other leading sculptors he based his work on the female form but he developed a totally different style of his own. His women are highly stylized with extraordinarily long limbs, small breasts, and simplified facial expressions. Usually naked, though occasionally wearing short tunic dresses, they are modeled poised on one leg with the other kicked high in the air, head

right: *Otto Poertzel,* **The Aristocrats,** *a bronze and ivory group, 1930s*

thrown back and arms outspread. The majority of Lorenzl's bronze figures were either gilded or silvered—though the costumes and scarves were frequently cold-painted in shades of green or blue or brightly painted in colored enamels with floral designs. He favored the use of tall paneled or cylindrical bases in green onyx. The leading Austrian firm of Friedrich Goldscheider was responsible for the execution of most of Lorenzl's bronze and chryselephantine figures, often producing the same model in a variety of sizes as well as in alternative mediums like plaster and ceramic. The Austrian sculptor Stephan Dakon also had his work, which bore close similarities to that of Lorenzl, edited by Goldscheider.

The Austrian sculptor, Franz Xavier Bergmann (1861–1936) produced many original designs as well as edited the models of other Art Deco sculptors. These tended to be primarily of Arabian subjects, such as carpet sellers, pot sellers, or donkey traders, or simply figures of men at prayer. Many of his larger pieces, such as a stylized mosque or oasis scene with palm trees, concealed a small decorative electric light. His models of slave traders with their naked female merchandise proved extremely successful. All of Bergmann's pieces, which were often marked with the anagram Nam Greb, displayed a particularly high standard of attention to the colorful enamel detailing and realistic casting.

Another Viennese sculptor, Carl Kauba (1865–1922), also specialized in small naturalistic bronzes of Middle Eastern inspiration. He was fond of creating female nude subjects that he would frequently conceal beneath a removable tent or a spring-mechanized cloak. Kauba, however, is probably best known for his bronze figures of cowboys and Indian braves. He would model his subjects on contemporary illustrations and photographs of the American Wild West. Alternatively shown galloping on horseback, shooting guns, or taking aim with their arrows, his figures are remarkable for

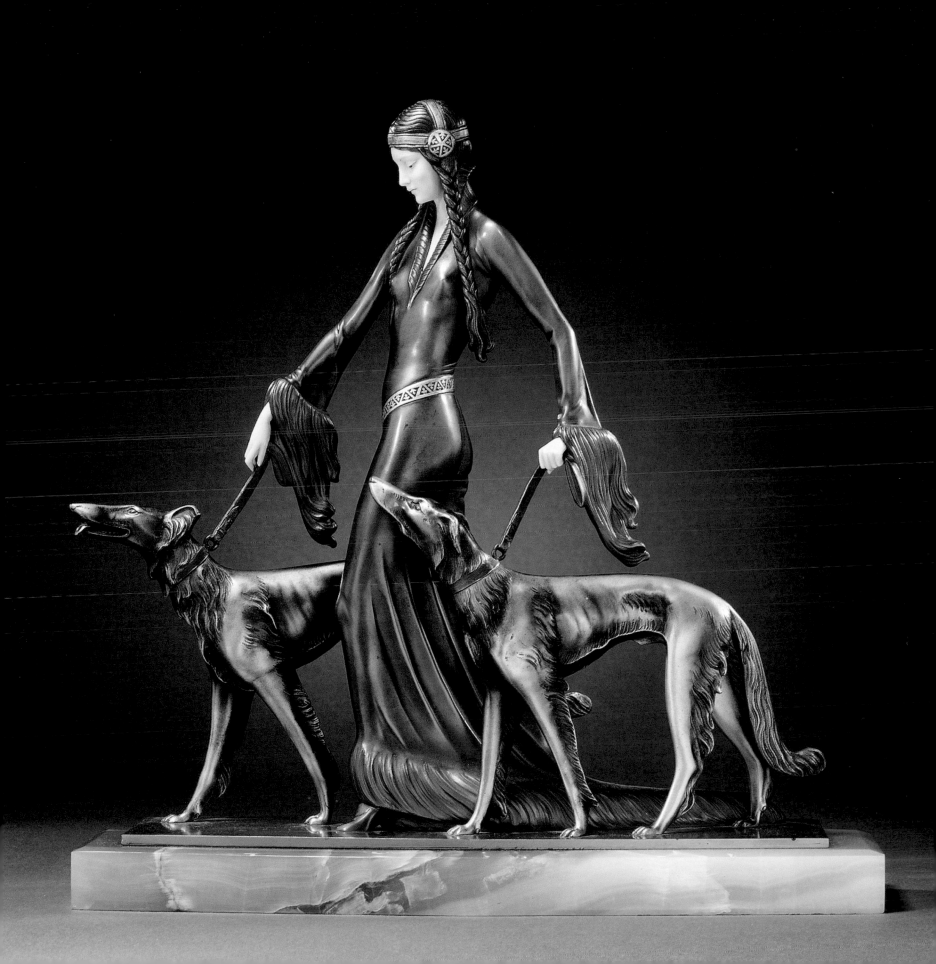

their fine cold-painted enameled decoration and naturalistically rendered forms. Unsurprisingly, much of Kauba's work was executed by Bergmann's foundry.

Across the oceans in America, series-produced chryselephantine figures did not enjoy the same degree of success as they did back home in Europe. For the most part American Art Deco sculpture in the 1920s and 1930s was represented by the large number of independent sculptors and artists who tended to work within the parameters of contemporary avant-garde artistic movements such as Cubism, Futurism, and Constructivism. While the figures of most European Art Deco sculptors mirrored everyday trends such as fashion, sport, and dance, in America sculptors seemed to take a much more academic and serious approach to their work. American public taste in the early 1920s was still relatively conservative, preferring the traditional classically inspired forms that were popular back in nineteenth-century continental Europe. However, there were a growing number of wealthy private clients who, returning from trips abroad to Paris and other European cities, began to commission sculptors at home to produce work in the contemporary style they had encountered on their travels. Also aiding the development of Art Deco sculpture in America was the contemporary influence of architecture. The great steps that were being taken in that period by American architects created a demand for modern sculpture that would complement and

right: *Paul Philippe,* **Danseuse au Bandeau,** *a cold-painted bronze and ivory figure, 1930s*

emphasize the streamlined forms and structures of the cloud-breaking skyscrapers. Foyers, gardens, and entrances all provided space for the work of radical new sculpture.

One of the leading American sculptors in the Art Deco period was Paul Howard Manship (1885–1966). Like many young American sculptors at that time, he went to Europe to learn his trade, eventually spending more than six years training in Italy. The realism and the scale of classical sculpture in Rome and other Italian cities greatly impressed Manship. Likewise the work of the French sculptor Auguste Rodin, an idol to a whole generation of sculptors, made a deep impact on the young American. On his return to the United States, Manship started his career by combining both these schools of sculpture. He began to create a highly individualistic style that was characterized by controlled, linear forms, stylized drapery, and sharp modeling. Many of his bronzes found their inspiration in mythological subjects such as hunters and archers. His animal sculpture, such as his figures for the Bronx Zoo in New York, reflected the stylized approach of French Art Deco *animaliers*. He was most probably introduced to their work during his travels and through the constant supply of art magazines and journals, which were available at that time. Manship was responsible for many important commissions such as a centerpiece for Rockefeller Center in New York and the Bronx Zoo. Much of his work was produced by the Roman Bronzes Works in New York, many of his large public works being reproduced in smaller-sized or shrunk-down limited editions.

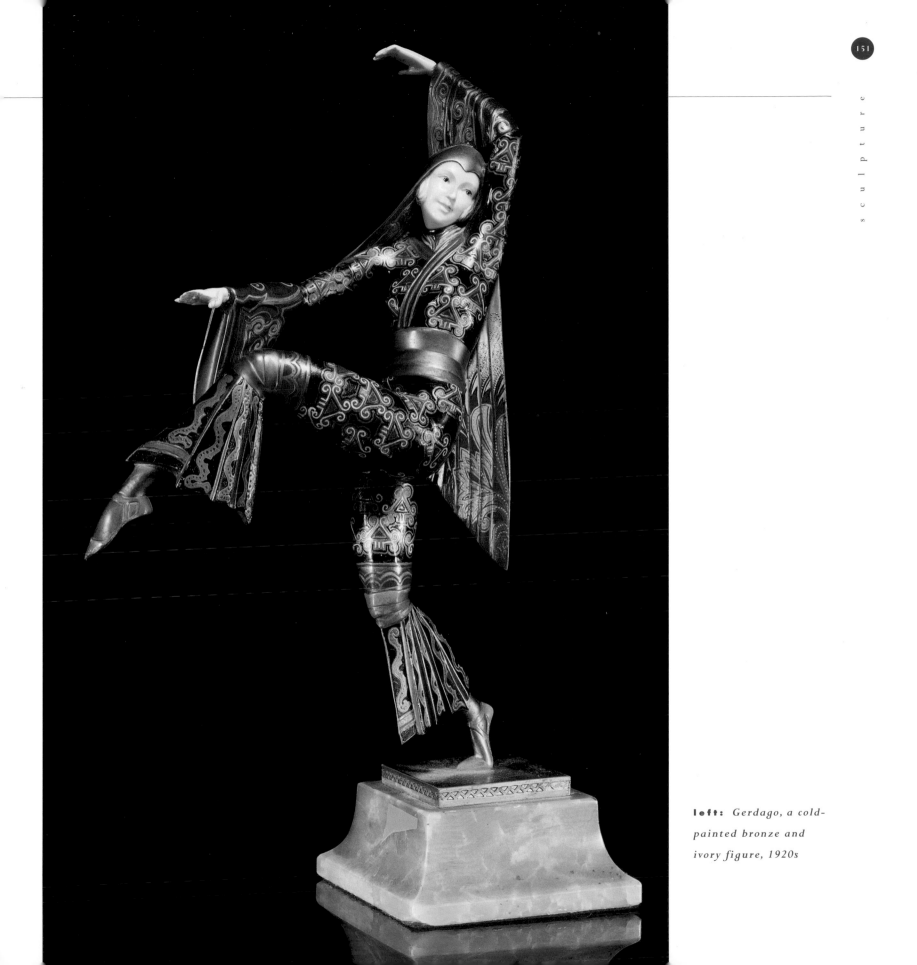

left: *Gerdago, a cold-painted bronze and ivory figure, 1920s*

Just as the large number of American sculptors who went to Paris and Europe to further their education in the 1920s and 1930s heralded the introduction of many of the influences of the Art Deco style into the vocabulary of the American decorative arts, so too did American sculpture in this period benefit from the large influx of immigrant sculptors who left their native countries in order to find fame and success in the New World. The German-born Carl Paul Jennewein is one such example of these immigrant sculptors. Having initially arrived in America in 1907, he produced a number of Art Deco pieces that displayed classical undertones. This characteristic of his work most likely resulted from a four-year period that he spent studying in Rome. Like Manship, Jennewin also produced work for Rockefeller Center in New York. The sculptor Gaston Lachaise was following his heart when he emigrated to the United States from France. His muse, Isabel Nagel, who became his wife, was a constant source of inspiration to him throughout his lifetime. Lachaise produced numerous undulating figures of her—all characterized by their exaggerated roundness and fullness.

right: Bruno Zach, two patinated bronze figures, 1920s

Among the many sculptors working in America in the Art Deco period, particular note should be made of Harriet Whitney Frishmuth, Robert Laurent, Carl Milles, Sidney Biehler Waugh, and Elie Nadelman for their contribution towards the development of a modern style in the field of sculpture.

The sculpture of the Art Deco period was remarkable for drawing together the various different threads of influence that were circulating at that time, and successfully weaving them together to create pieces that are today instantly evocative of that particular period, yet retain a sense of timelessness. The sculptors of the Art Nouveau period in the earlier part of the twentieth century had freed artists from the straitjacket of traditionalism and conservatism. No longer were sculptors and artists forced to rely on religious or historical subjects for their inspiration. The sculptors of the Art Deco period fully enjoyed the freedom to explore different avenues of inspiration, from contemporary dance and fashion to the latest avant-garde artistic movements. Perhaps more so than other areas of the decorative arts, except perhaps graphic art, Art Deco sculpture opens a window onto the popular tastes and fashions of everyday life in the Roaring Twenties. The finely detailed bronze and ivory figures of Demetre Chiparus and Claire-Jeanne-Roberte Colinet and the erotic women of Bruno Zach conjure up visions of the smoky dance halls of Paris and Berlin. Likewise, the athletic, yet smartly dressed girls of Ferdinand Preiss illustrate the idealistic aspirations of society at that time as well as provide an accurate record of stylistic changes in contemporary dress and appearances.

The ever-growing popularity of the glamorous movie stars and their lifestyles and the deepening pockets of the nouveau riche lead to the increased public demand for luxurious interiors. The appetite for sculptural pieces grew as corner spaces, cabinet surfaces, and pillars demanded impressive, dramatic figures to complete the overall decorative scheme of opulence. Similarly the tremendous growth in architectural work, especially in America, created foyers, entrance halls, and gardens that would only be aesthetically complete with the addition of an impressive, stylized work by a sculptor such as Paul Howard Manship or Gaston Lachaise.

Just as in the field of glass, which saw the mass-production pieces of René Lalique and the studio glass of Maurice Marinot, the sculptors of the Art Deco period used the latest technological materials and techniques in order to produce figures that would meet the tastes of the burgeoning middle classes whilst at the same time searching for superior quality and fuller personal expression through the creation of one-off individual cast pieces.

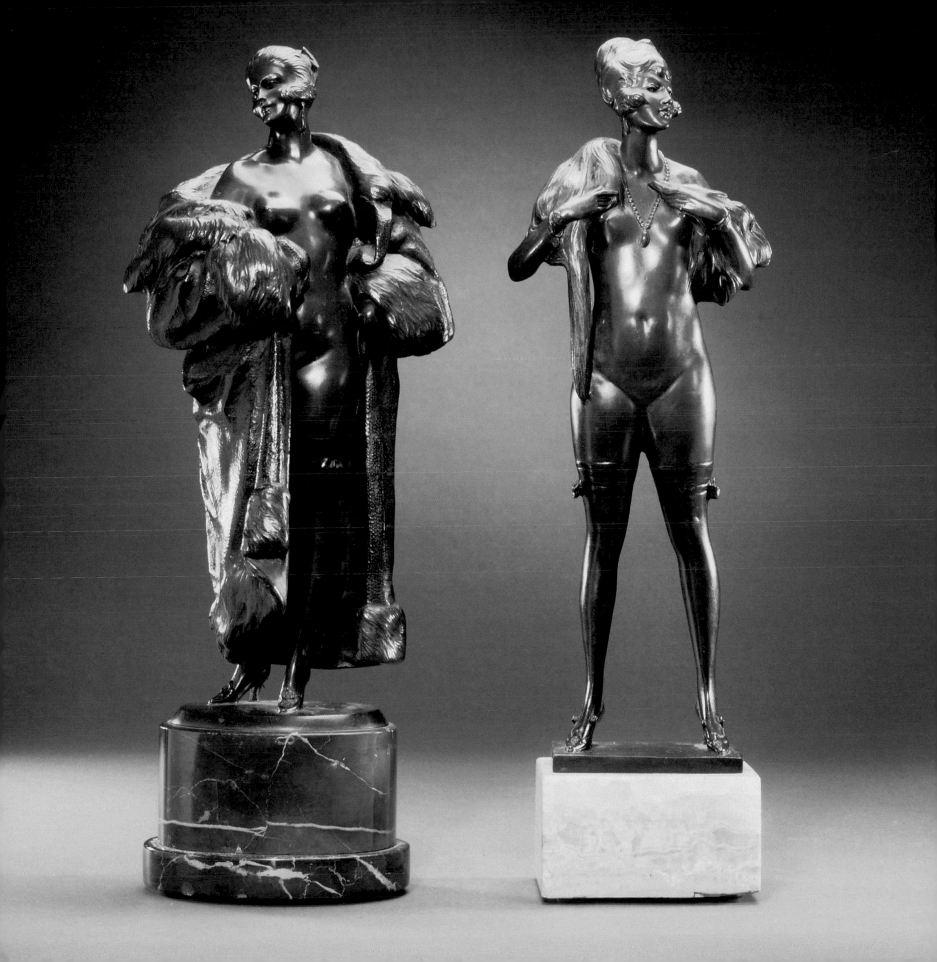

GRAPHICS
AND POSTERS

The Art Deco period was an important time in the history of vintage poster design, as most towns and cities had by then created an outdoor picture gallery in the hoards of billboards and poster kiosks. In the Art Nouveau period the advertising posters were organic in inspiration and in many cases the product was barely visible. In the 1920s and 30s a host of new items were being offered and dynamic design was therefore important to lure customers to buy a particular product. Simple lines, bold colors, and striking typography were used to give prominence to the merchandise. The posters were created by the new generation of graphic designers who were working for advertising agencies; by the 1920s commercial art was considered a respectable and sought-after profession. The designers were influenced by the growing impact of the machine, while power and speed became the primary themes in the movement that came to symbolize postwar prosperity.

Advertising designers were influenced by the world of fashion, the growing popularity of jazz music, Hollywood film-making, and the increased liberation of women. The arrival of the Ballet Russe, which took Paris by storm in 1909, particularly the exotic set and costume designs of Léon Bakst, incorporating Egyptian, Mayan, and Oriental ornaments, also exerted its influence, as did the avant-garde painting movements of Futurism and Cubism. Most of the posters of the period were printed using the stone lithographic process whereby each color of the design was drawn onto a separate section of porous stone. This design was then applied to the paper to create the image. The designer was able to use his artistic skills while serving commercial interests.

As France was considered the birthplace of the Art Deco style it was therefore no surprise that many of the renowned Art Deco poster artists were living and working in Paris during that period. At the end of the nineteenth century, Paris had

right: *Leonetto Cappiello, Parapluie-Revel, lithograph in colors, 1922*

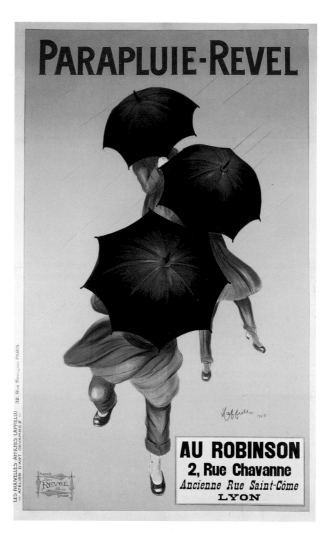

established itself as an artistic hotbed and a fashionable center of entertainment. This continued during the Art Deco years and performers involved in the worlds of cabaret, opera, musicals and ballet all commissioned leading artists of the day to promote their productions. Paul Colin (1892–1986) began working in Paris in 1913 and promoted the Casino de Paris and the dance hall Tabarin, but he was best known for his association with the black American jazz artist Josephine Baker. In 1925 he designed a poster to promote the dance performance

Revue Nègre at the Music Hall des Champs Elysées, which both promoted black American culture in Europe and, with its lively, angular style, signified a new style of jazz-inspired poster design.

The cabaret performer Mistinguett featured in many posters of the time, most of which were created by Charles Gesmar (1900–28) who produced 50 posters in his short career. Other well-known stage performers included Alice Soulie, Spinelly, Marguerite Valmond, Diane Belli, Colette Mars, and Bagheera, all of whom regularly commissioned leading artists such as Swiss-born Charles Loupot (1892–1962), Jean Carlu (1900–1997), and Jean-Gabriel Domergue (1889–1962) to promote their work. The last-mentioned lived in Monte Carlo and along the Côte d'Azur, where he was surrounded by chic and glamorous women who frequently provided the inspiration for his poster designs.

In addition to the booming entertainment industry in the Art Deco period the beverage market grew extremely strong and there was great competition between the producers of different brands of champagne, wine, liqueurs, cognac, and absinthe. Companies such as Bonal, St Raphael, Dubonnet, and Valmya, conscious of their public image, employed leading artists to grab the passerby's attention to their product, as a successful publicity poster was still often considered the most effective of all promotional vehicles. Likewise the stunning graphics employed by Art Deco graphic designers even succeeded in transforming mundane items such as electric ovens, car headlights, and heaters into irresistible objects. The French departmental stores Le Printemps and Galeries Lafayette became major patrons of the poster as they sought to be seen as the most stylish place to shop.

right: *A.M. Cassandre (Adolphe Mouron),* **Chemin de Fer du Nord,** *lithograph in colors, 1929*

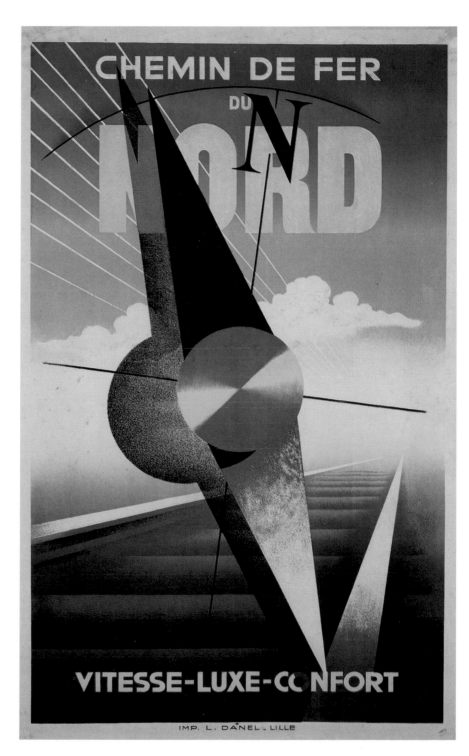

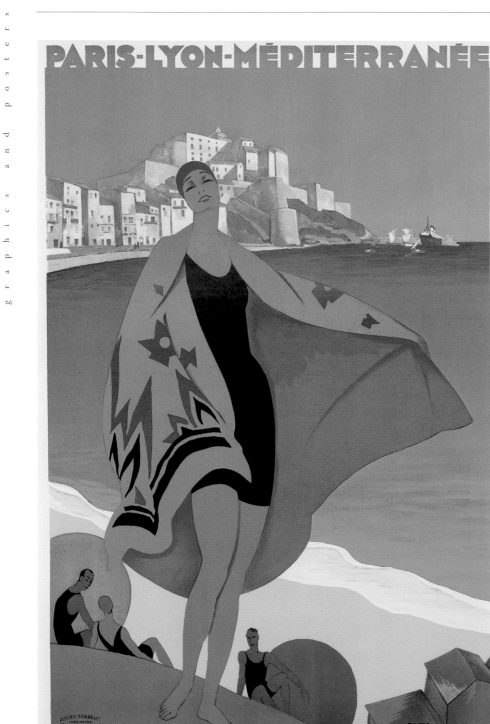

left: *Roger Broders,* **Calvi Beach, Corsica,** *lithograph in colors, 1928*

Leonetto Cappiello (1875–1942) was one of the most prolific poster artists during both the Art Nouveau and Art Deco periods in Paris. Cappiello was born in Livorno in Italy and moved to Paris in 1898. His style was characterized by bold strokes and the use of strong colors in his designs, all of which created a stunning visual impact. He was employed to advertise a huge range of products from Le Bas Revel stockings in 1929 to Cachou Lajaunie pastilles (which claimed to sweeten the breath after smoking) in 1920. His designs were often set against a black background that both emphasized the product being advertised and the brand name. Some of his most popular illustrations were Parapluie-Revel (1922), Chocolat Tobler (1933), and Peugeot (1925).

The Art Deco period coincided with a huge growth in travel for pleasure, and the shipping, automobile, and railway companies advertised heavily to gain a share of this burgeoning market. The most-acclaimed French poster designer during the period was Adolphe Mouron (1901–68), better known as Cassandre, who worked extensively for the French National Railway and various shipping lines. Cassandre was born in Russia and studied at the Académie Julian in Paris and, although he worked in many different mediums, it is his posters that are today considered masterpieces of Art Deco design.

Using the pseudonym A.M.Cassandre after 1922, he became a model for graphic designers worldwide as his architectural style, characterized by bold colors, simple design, and clean lines captured the viewer's attention and enabled them to comprehend the message instantly. *Etoile du Nord* (1927), *Nord Express* (1927), and *Normandie* (1935) are three of his most dynamic designs that capture the magnificence, speed, and comfort of the new trains and the ocean liners.

Cassandre was a master of integrating compositions of letter, text, and image. In his design for *Normandie* the new sans serif typeface immediately captured the viewer's attention. Although the text was separate from the illustration, he used it in a formal and decorative way, as well as making it a source of information on the destination of the ocean liner. Cassandre founded his own advertising agency, Alliance Graphique, in 1930 through which he promoted a host of varied commodities such as Sensation Cigarettes (1937), UNIC (1932) men's shoes, Miniwatt/Philips Radio (1931), the American magazine *Harpers Bazaar* (1937), the automobile safety glass Triplex, newspapers, light bulbs, and Italia sports equipment (1935). The work of Cassandre demonstrated the switch of influence from fashion to industry during the 1920s and 30s.

No less significant in French travel poster design was Roger Broders (1883–1953) who worked for the French State Railway (Chemin de Fer) and also extensively for the PLM (Paris Lyon Mediterranean) railway. Although both of these artists were promoting a service rather than a product, Cassandre focused his design on the specific means of transport being advertised, whereas Broders' posters captured a sense of place by showing the actual destination of the train. His posters often featured stylized fashionable women and incorporated purely geometric motifs in bold primary colors. His series of travel posters covered all the glamorous Riviera resorts, including Nice, Antibes, Sainte-Maxime, and Villefranche sur Mer. Some of his most stunning poster designs were those done for the glamorous seaside resort of Monte Carlo, which featured attractive, elegant ladies engaged in various sporting pursuits, such as tennis and golf.

Tourism posters were also important in Switzerland, a country that gave great prominence to poster design and encouraged careers in graphic art. The first exhibition of poster design was to seen at the Museum of Applied Arts in Zurich in 1911, and by 1914 the Swiss Government had established both a standard-sized poster format, which was uniformly adopted countrywide, and a national distribution company. One of the most prolific artists in Switzerland was Otto Baumberger (1889–1961) who, based in Zurich, was a founding member of the Swiss School of Graphic Design. Baumberger trained as a lithographer and poster artist and was one of the first exponents in Switzerland of the object poster, a term used to describe a work where the object occupies the entire image. Baumberger's stunning poster of 1923 for the Swiss men's clothing store PKZ was one of the best examples of this as the image was purely a detailed close-up of a lined tweed overcoat.

below: *Niklaus Stoecklin,* **PKZ,** *lithograph in colors, 1934*

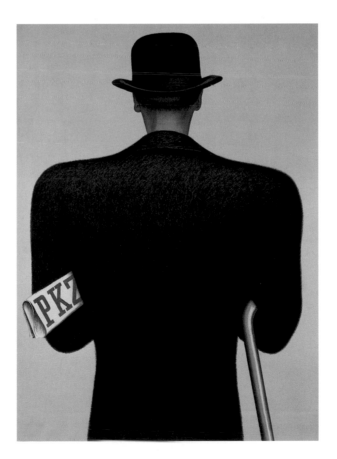

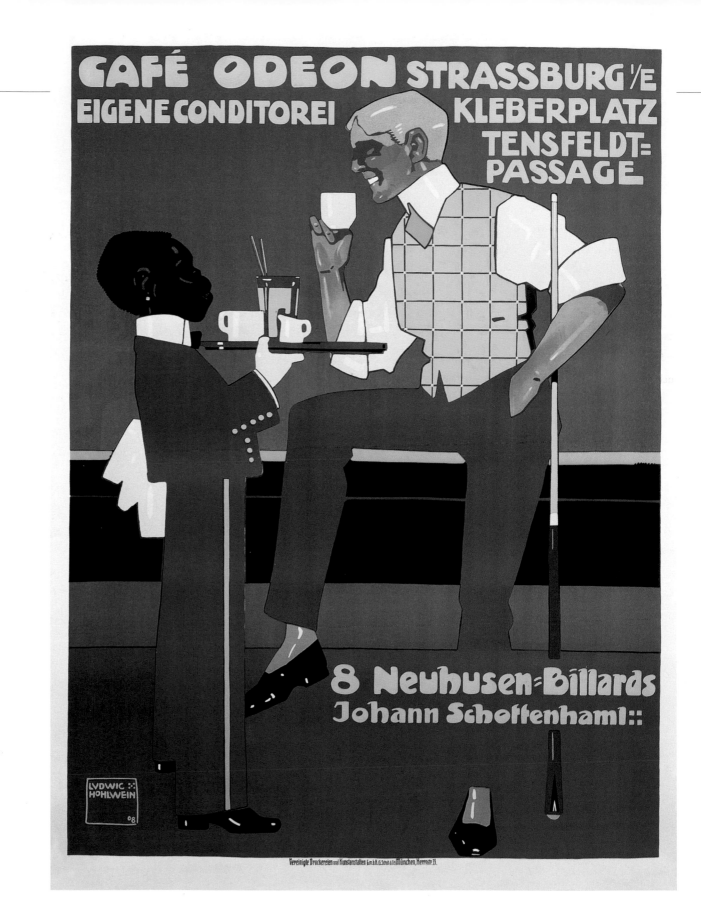

There was no text on the almost photographic image apart from the PKZ label inside the collar and Baumberger's signature, a solitary "B."

PKZ was one of the major patrons of poster art in Switzerland and commissioned a poster in 1934 from the leading Basel-based artist of the period, Niklaus Stoecklin (1896–1982). Stoecklin was a master of the object poster and produced one of PKZ's most powerful designs, an almost Surrealist image of the back of a smartly dressed, bowler-hatted man with a rolled paper under his arm with the letters "PKZ" upon it. PKZ also commissioned other leading Swiss artists such as Martin Peikert (1901–75), Karl Bickel (1886–1982), Otto Ernst (1884–1967), and Emil Cardinaux (1877–1936).

The artistic and literary Dada movement, although it only lasted from 1916 to 1923, had a great influence in Switzerland. The movement reacted against traditional cultural aesthetic values, and in visual terms it meant that artists experimented with both perspective and different combinations of imagery. The poster designer Herbert Matter (1907–84) was undoubtedly influenced by the Dadaists as he was the pioneer of photomontage posters, which combined photography and lithography. Matter studied in Paris with the painter Fernand Léger and Cassandre but returned to Switzerland in the 1930s where he produced many travel posters, using the photomontage process, for the Swiss Tourist Board.

The Swiss became recognized leaders in poster design and their work had a huge effect on other European countries. Many Swiss artists studied design and lithography in Germany. Commercial art in Germany was a large industry and was regulated by several groups such as the Association of Commercial Artists, which both encouraged competition and celebrated national artists. Ludwig Hohlwein (1874–1949) was the most prolific poster artist in Germany and produced posters for a huge range of German retailers and manufacturers. He began his career as an architect and was based in Munich. His designs were characterized by a strong use of color, flat pattern, and simplified lines and he succeeded in transforming ordinary objects such as light bulbs, typewriters, and work tools, into striking graphic images.

Fierce competition existed in Germany between commercial brands and here, as in France, the poster was seen as an important selling tool. Hohlwein produced posters for AEG Nitralampe (circa 1925), Marco Polo Tee (circa 1914), Toblerone chocolate (1927), and the Munich Zoo. Smoking was big business in Germany during the Art Deco period and companies such as Da Capo, Rossa, Sefira, Dibold, and Casanova undertook huge advertising campaigns to promote brand loyalty. They invariably required the artist to depict a relaxing scene, which portrayed the fashionable nature of smoking. Popular Munich social haunts, including Hauser's Bar-Restaurant, Café Glonner, and Café Odeon, were large patrons of the poster while other important designers in Germany at this time include Jupp Wiertz (1881–1939), who specialized in travel and film posters, Ottomar Anton (1895–1976), who specialized in posters for the Hamburg-America shipping line, Albert Fuss (1889–1969), and Hans Koch (1899–1977), whose style has been likened to that of Hohlwein.

left: *Ludwig Hohlwein,* Café Odeon, *lithograph in colors, circa 1920*

Lucian Bernhard (1883–1972) made an important contribution to the development of the German Art Deco poster as he was the first exponent of the *Sachplakat*, or object poster. Bernhard had studied in Munich and began work in 1901 in Berlin, which as well as being an important commercial center at this time was the home of Hollerbaum and Schmidt, Germany's foremost printer. Bernhard's 1905 poster for Priester matches is considered the first object poster as the image focuses directly on two red matches with yellow tips against a dark background and utilizes simple lines and flat

graphics and posters

colors. This poster was a forerunner of the object poster style later prevalent in Switzerland in the Art Deco period. Bernhard's ability to transform everyday objects was clearly seen in his work for Bosch-Licht (1913), which sold car headlights.

And Das Plakat was Germany's most powerful advertising and poster journal and regularly promoted *Sachplakat* artists such as Bernhard and Julius Gipkens (1883–1969) in its publications. In 1920 Bernhard was appointed Professor of Poster Art at the Berlin Academy before moving to America in 1923 where he taught

below: *Willem Frederik ten Broek, Holland-Amerika Lijn, lithograph in colors, 1936*

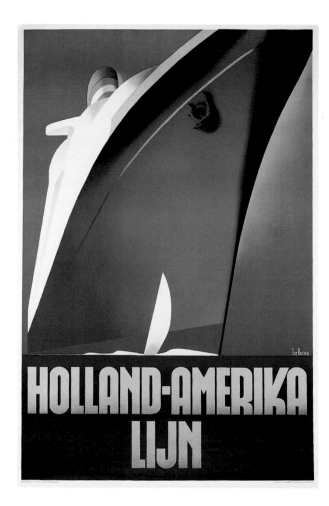

design at the Art Students' League in New York. Walter Schnackenberg (1880–1961) was another important German poster artist who was equally talented as a draftsman and illustrator. He created a small number of posters for his associates in the Munich film, theater and cabaret world, such as for the artiste Lena Amsel (1918), the Café Die Pyradie (1920), and the nightclub Bonbonnière et Eremitage. In his poster of the ballet performers Peter Pathe and Maria Hagen (1918) his remarkable dreamlike design perfectly captured the movement and feeling of the performance.

German designers were heavily influenced by the demands of industry and worked hard to produce an attractive design out of mundane products such as work tools and machinery. Colors played a significant role and artists used simplicity and abstraction to draw attention to the graphic image of the essential object. Designers in Germany were clearly influenced by the Bauhaus, the state-sponsored German school of architecture and applied arts that had been founded in Weimar in 1919 by Walter Gropius. A large proportion of the world's most advanced machinery was developed in Germany in the Art Deco period and posters became the primary advertising medium used to promote these technological advances. The Bauhaus style was characterized by its austere geometric forms and bold primary colors and the Bauhaus design courses undoubtedly influenced German advertising posters.

The Dutch poster tradition in the 1920s and 1930s period was very much influenced by the French Art Deco style. The size of the Dutch posters was considerably smaller than those in the rest of Europe, possibly due to the cities' proportionately smaller streets. The subject matter was more likely to be devoted to social causes and trade fairs than entertainment. The most visual appealing Dutch Art Deco posters were those created for commercial products and travel. Cassandre's agency Alliance Graphique had several Dutch clients, including Van

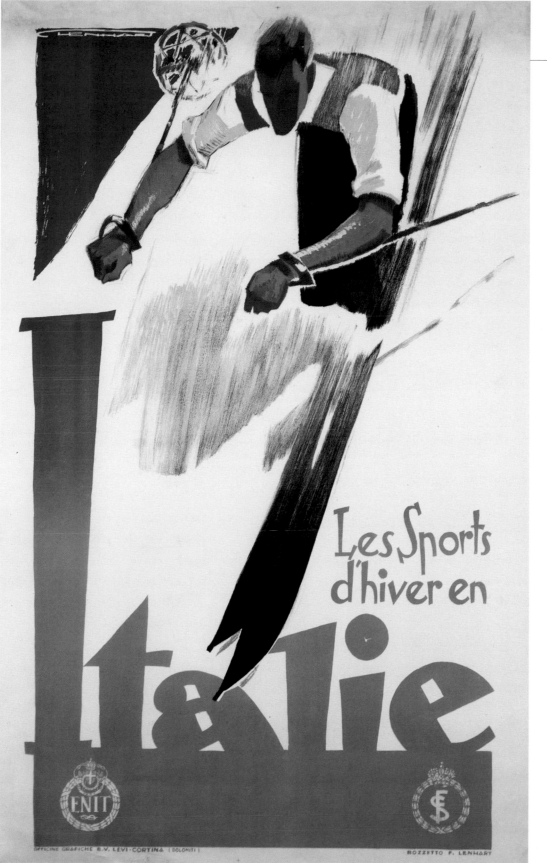

left: *Franz Lenhart,* **Les Sports d'hiver en Italie,** *lithograph in colors, circa 1930*

Nelle coffee, and his style had a strong impact on all aspects of Dutch graphic design.

The ocean liner was the only commercial means of traveling abroad and the Dutch shipping company Holland-America Line, exploited the poster to promote its floating palaces. Posters were directed both at Dutch residents traveling abroad and at foreigners to entice them to use the Dutch lines. Cassandre's 1928 poster promoting the New Statendam Holland-America Line, is one of the best examples of ocean liner posters as the stylized smokestacks and the careful integration of the text give a stunning visual impact. A notable Dutch designer who also produced many posters promoting the Dutch shipping routes was Willem Frederik ten Broek (b. 1905) whose style was similar to that of Cassandre. Other Dutch Art Deco artists of note include Johann von Stein (1896–1965), who worked for the Lloyd shipping line, Jan Wijga (1902–78), and Agnes C. Canta (1888–1964).

right: Plinio Codognato, Fiat, lithograph in colors, 1927

Across the border the most acclaimed Belgian poster artist was the Swiss-born Leo Marfurt (1894–1977) who moved to Belgium in 1927 and started his own agency, Les Créations Publicitaires. His clients included Belga cigarettes, Chrysler automobiles, and Remington. The Belgian National Railway was a significant patron and Marfurt created a stunning image for them, Les Grandes Communications, in 1925. This vibrant and colorful poster, primarily in pink, blue, and yellow, combines Marfurt's innovative design with a map of the railway lines connecting Belgium to the other major European cities. Other designers working for the railway network included Francis Delamare (1895–1972), and Lucien de Roeck (b. 1915), who were both commissioned to design posters to entice passengers to travel by train to resorts on the Belgian coast such as La Panne, St Idesbald Plage, Middelkerke, Bray-Dunes, and Heyst and Duinbergen.

Art Deco designers in Italy were influenced both by the German Bauhaus and the Italian Futurist movement, whose themes were speed, power, and energy. Although the Futurist movement began in 1909 it was not until the late 1920s that it fully manifested itself in graphic design. One of the most important Italian artists working during the Art Deco period was Marcello Dudovich (1878–1962) whose career spanned both the Art Nouveau and the Art Deco periods. Dudovich was born in Trieste but spent most of his working life in Milan where he founded the Star advertising agency. Major Italian businesses became important patrons and Dudovich worked extensively for Pirelli tyres, Borsalino hats, the Lloyd Triestino shipping line, and the Rinascente department store in Milan. The last-mentioned recognized the importance of consistent graphic identity and was one of Dudovich's most important clients; he eventually produced more than 100 posters for the store. Vivid colors and strong Art Deco stylized designs characterized much of Dudovich's work.

Marcello Nizzoli (1887–1960) was equally influential in Italy during the Art Deco period. His style successfully combined classicism and Modernism and, in addition to his poster commissions, he worked as a painter, textile designer, and decorator. Nizzoli worked for many important patrons, including Olivetti, Perugina confectionery, Citroën, Omega watches, and Campari, the last being renowned for employing the leading artists of the day to promote their products. Food and drink was a booming Italian industry and companies such as Buitoni, Motta (the Milan bakery), and liquor companies like Ramazzotti and Masera were not slow to recognize the potential power of the poster.

SEPO (Severo Pozzati, 1895–1983) was a leading Italian designer with a strong geometric style. He studied sculpture at the Academy of Fine Arts in Bologna and began working for the Maga agency in 1917. He designed posters for many different

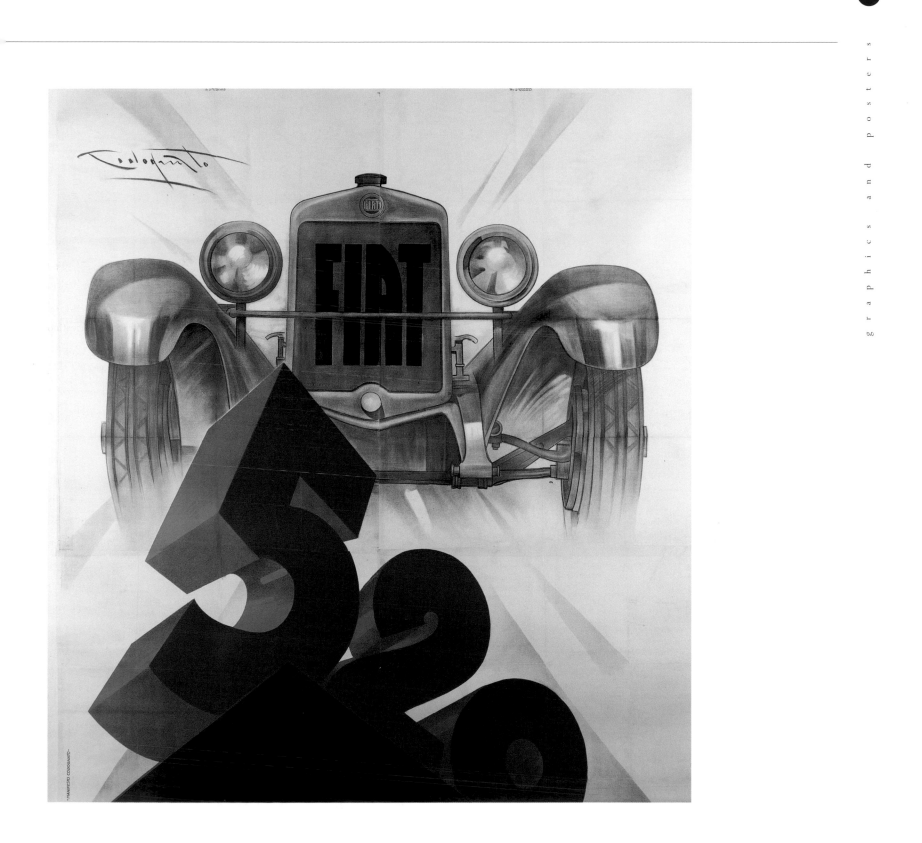

clients including Balto cigarettes (1932), La Lune spaghetti (circa 1930), the Bianco department store (1926), ANIC cigarettes (1938), and Tortonese, the clothing manufacturer (1934). Perhaps SEPO's most visually striking Art Deco image was his design for Noveltex, advertising collars for men, where the bold typography and streamlined image of the collar clearly showed the influence of the Futurist style.

As in Germany, smoking was a fashionable activity in Art Deco Italy and artists like Franz Lenhart (1898–1992) were employed by Modiano, the manufacturers of cigarette papers and tobacco, to present a chic, visually appealing image to their consumers. Lenhart was born in Bavaria but studied in Italy and became a permanent resident there in 1922. His striking 1935 poster for Modiano cigarettes in green and black portrays a sophisticated, affluent, well-dressed woman smoking and is one of the finest examples of the artist's work.

The boom in the leisure industry saw winter holidays become increasingly common in the 1920s and 1930s. Ski resorts, particularly in France, Switzerland, and Italy, provided fashionable destinations, and skiing posters began to appear on station platforms and billboards across Europe. The posters often portrayed the speed and exhilaration of a holiday on the slopes as well as provided textual instructions explaining how to reach the resort, usually by train. Lenhart's portrayal of a speeding downhill skier (circa 1930) that enticed the visitor to sample the delights of "les sports d'hiver en Italie" is one of the finest examples of an Art Deco winter sport poster.

The preoccupation with speed was a selling point for the extraordinary number of car posters that appeared during the Art Deco period, and manufacturers such as Renault and Peugeot in France, AC in Britian, and Buick in Germany used the poster to introduce the consumer to their new models. In

*right: Man Ray, **Keeps London Going**, London Underground, lithograph in colors, 1939*

-KEEPS LONDON GOING

Italy, Alfa Romeo, Lancia, Bugatti, and Fiat all competed for business but it was Fiat, Europe's largest automotive firm, that was the most prolific poster advertiser. Fiat was the first to have a special advertising department and employed artists such as Dudovich, Leopoldo Metlicovitz (1868–1944), and Plinio Codognato (1878–1940) to devise sleek, exhilarating posters. Often showing glamorous women at the wheel, the car provided the perfect model for the Futurist preoccupation with speed and power and the advertisements produced portrayed the cars as objects of elegance. Automobile racing was also

popular at this time. The French artists Geo Ham (George Hamel, 1900–72) and Robert Falcucci (1900–89) designed some of the finest posters in this genre during the 1930s, which perfectly visualized the glamour and excitement of the prestigious Monaco Grand Prix.

Modernism in Britain was influenced by Cubism, Vorticism, and Constructivism and the best of graphic advertising design in England between the two World Wars was to be seen in posters for London Underground, the regional rail networks, Shell Oil, and the fashion retailer Austin Reed. London Underground's reputation as a major advertising patron was due to the appointment of the forward-thinking Frank Pick as director of publicity between 1908 and 1946. Pick believed that the Underground had to promote its services in an artistic manner and employed the finest British, European, and American Modernist advertising designers of the day to promote the Underground as the most comfortable and convenient form of transport in the capital.

Edward McKnight Kauffer was an American who moved to England in 1914 as a painter and developed into the foremost "British" commercial artist of the Art Deco period. His style was abstract and advanced and he received his first commission from London Underground in 1915. McKnight Kauffer's progressive designs influenced a wave of graphic designers in Britain at this time. Another notable artist employed by Pick to illustrate London's sights in a unique and amusing way was Austin Cooper (1890–1964) who, having emigrated to England from Canada, developed a style that was characterized by flat masses of brilliant colors. Both McKnight Kauffer and Cooper designed posters that enticed the traveler to a wide range of attractions such as the London Museum, the National History

right: *Gregory Brown*, The Zoo, *London Underground, lithograph in colors, 1924*

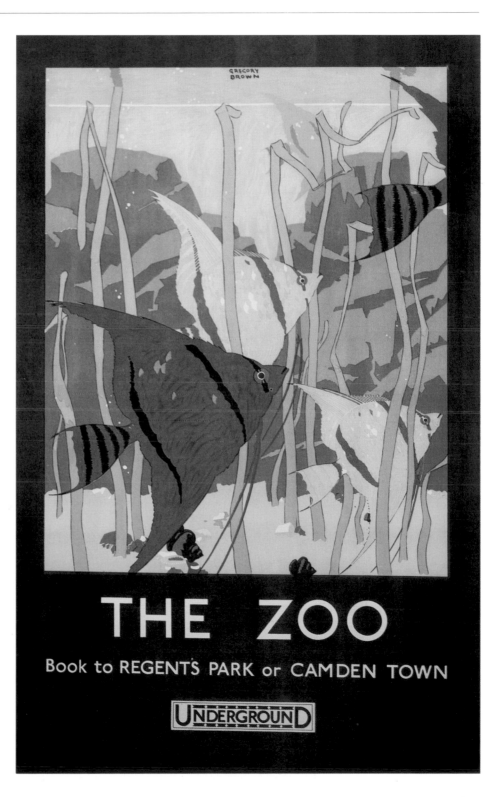

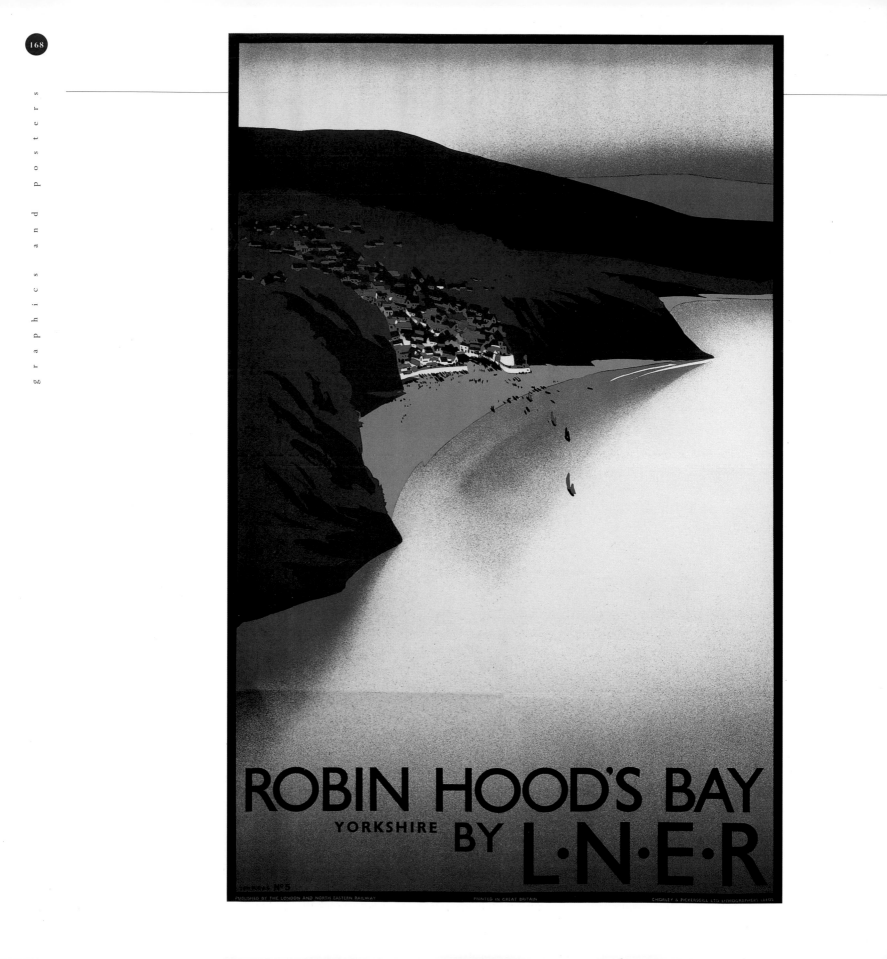

Museum, and the Victoria and Albert Museum. Posters advertising major sporting events, like the Wimbledon tennis championships and cricket at Lords, were also produced, but in small panel sizes to allow them to be displayed inside the carriages of the train.

Pick's vision was to educate and raise the public standard of taste and the Underground posters were displayed both on billboards at station entrances and on the platforms, creating a veritable picture gallery throughout the capital. Other important artists who worked for London Underground during the Art Deco period were Paul Nash (1889–1946), Frank Newbould (1887–1950), Fred Taylor (1875–1963), Charles Pears (1873–1958), Gregory Brown (1887–1941), and the French artist Jean Dupas (1882–1964). One of the most visually striking of the London Underground posters was that created by the Surrealist artist Man Ray. His poster *Keeps London Going* transformed the London Underground emblem, the familiar bar and circle, into a planet from outer space.

Towards the end of the 1920s London Underground posters were gaining international recognition in advertising competitions and British travel posters in general were considered the best worldwide. This included those that were designed for the Big Four British regional train companies that constituted the reformed railway network in 1922. Holidays were important for the British public and during the Art Deco period the travel-for-pleasure market developed rapidly and travel companies began to advertise extensively in order to gain a share of this new market. Many of England's towns and cities, as well as the traditional beach resorts, featured heavily in the posters of this period, notably Bournemouth, the Norfolk Broads, the Scottish Highlands, Edinburgh, Oxford, and Cambridge, all of which today act as an interesting record of the locations that were the most popular holiday destinations of that time.

Tom Purvis (1888–1959) was one of the leading artists working for the railway companies during the Art Deco years. Some of his most stunning images depicted golfing scenes at St. Andrews, Cruden Bay, and Berwick Upon Tweed. He used bright colors, simplified silhouettes, and a massing of colors to perfect effect. Both the railway companies and London Underground commissioned artists to supply images in their own style, only the actual subject and accompanying textual information being provided by the patron. Other important artists employed by the British railway companies include Norman Wilkinson (1878–1971), Frank Henry Mason (1876–1965), Paul Henry (1876–1958), and Claude Buckle (b. 1905).

Austin Reed, the gentlemen's outfitters, also employed Tom Purvis to forge an image of the company as a quality establishment conscious of its public image. Purvis had studied at Camberwell School of Art in London and had worked for the printers Avenue Press. His practical understanding of the lithographic process undoubtedly contributed to his style as his simplified representations of Austin Reed's elegant, tailored men were easy to comprehend and provided a striking eye-catching design, which was effective both close up and at a distance. In his work for Austin Reed, Purvis employed the object poster idiom popular in Switzerland and Germany at this time.

left: *Tom Purvis,* **Robin Hood's Bay,** **LNER,** *lithograph in colors, circa 1931*

One of the most famous of the French Art Deco painters, Jean Dupas, worked for the London Underground, producing six designs that promoted travel by Tube to locations such as Richmond, Chalk Farm and Regent's Park. Dupas fitted the definition of a true Art Deco artist, as his work was highly decorative and, as seen at the Salon des Artistes Décorateurs, provided the perfect visual accompaniment to the furniture and other decorative arts simultaneously exhibited in these highly sophisticated interiors. Dupas was born in Bordeaux and he

"Establish a picnic
and pass the day together."

Go out by "General" Bus

studied at the Ecoles des Beaux-Arts in his hometown and later in Paris. His style was very distinctive, depicting stylized, elegant figures that appeared almost statuesque.

The finest artist of the Art Deco period was Tamara de Lempicka who was born in Poland, married a Russian, and then moved to Paris in 1923 to escape the Russian revolution. Lempicka studied painting in Paris at the Académie Ransom where she worked with André Lhote, the master exponent of Cubism. In 1927 she was awarded first prize at the Exposition International des Beaux-Arts in Bordeaux and after this date went on to win many other international awards. Her style was characterized by bright colors, angular images, and stylized flowers and displayed a clear Cubist influence. Between 1924 and 1939 she painted more than 100 portraits and nudes, many with a highly charged sexuality, the streamlined architecture of the New York skyline frequently providing her backdrop.

The self-taught painter and printmaker Louis Icart (1887–1951) was equally well known as a symbol of the Art Deco style although, in contrast to Lempicka, he represented the more flowery version. Icart was born in Toulouse and moved to Paris where he worked in oil, gouache, and engravings, though he was to become best known for his erotic lithographs, drypoints, and etchings that he produced during the 1920s and 1930s. Most of his images feature perfectly proportioned pretty young girls, often scantily clad, relaxing in their boudoir and surrounded by their pets. His women are shown as relishing their social independence and newly found liberation following the First World War. Icart's own horse, Rossinante, was featured in the etching *Thoroughbreds* (circa 1938), which, depicting the horse in full motion with a beautiful woman clutching its reigns, perfectly captured the general exuberance of the period. His light-hearted images with titles such as *My Model*, shown either as a blonde or a brunette, and *Tennis* and *Zest* likewise reflected the gaiety of the Roaring Twenties. Other

distinguished artists producing paintings in the Art deco period include Eugène Poughéon, René Buthaud, Raphael Delorme, and the artist-sculptor Jean Lambert-Rucki.

A name equally synonymous with the Art Deco period was Romain de Tirtoff, better known as Erté (1892–1990). He was born in Russia and moved to Paris as a young man to study architecture at the Ecole des Beaux Arts. However, on his arrival in Paris he instead enrolled at the Académie Julain where he studied painting for three months before beginning work as an illustrator. His career in fashion illustration took off when he was approached by the master couturier Paul Poiret in 1913 to work for him as a full-time designer. Erté's childhood, which was spent in the artistic world of St Petersburg in Russia, clearly influenced his style, as did his awareness of Russian ritual and religious art. All of Erté's drawings were done for a specific purpose, ranging from opera stage design, designs for jewelry, the ballet, and haute couture dresses. Some of his most popular designs were those commissioned by the showgirl Mata Hari and the American magazine *Harpers Bazaar*.

The Art Deco style was particularly popular in America and by the end of the 1920s the decorative and modern elements of the style were in evidence in graphic design. Joseph Binder, an Austrian by birth, was one of the most important designers at this time. He had been working in Germany before moving to the United States and was a distinguished travel poster designer whose style was both highly geometric and industrial. Binder served as graphic arts lecturer at the Art Institute of Chicago in 1933, and his design for the poster of the 1939 New York World's Fair was the wining entry.

Joseph Leyendecker (1874–1951) was another influential artist working in America in the Art Deco period. Also an immigrant he had been born in Germany before moving to Chicago with his family at the age of eight. It was his work for the leading magazine, *Saturday Evening Post*, for whom he

eventually created 322 covers between 1899 and 1943, which established his reputation as one of the most popular illustrators of the time. He began producing posters in 1905 for his leading client, Cluett, Peabody & Co., the makers of Arrow brand shirt collars. Leyendecker created a prestigious image for the company as he always depicted an elegant, handsome man in his Arrow collar, often accompanied by a fashionable and beautiful young lady, who was the epitome of polished manners and good taste. His Arrow posters were hugely successful and, continuing to work for the company for 25 years, he influenced many American artists of the period, including Norman Rockwell.

In Europe in the Art Deco period the state-owned railways were major patrons of the poster; however, this was not the case in the United States. There the motorcar was extremely popular and the railway system did not benefit from the extensive promotion and publicity that it had received in the Old World. However, some of the best posters, from the limited number that were produced, were by Leslie Ragan (1879–1972) and Adolph Treidler for the New York Central Railroad, Sascha Maurer (1897–1961) for the New Haven Railroad, and Gustave Krollman (b. 1888) for the North Pacific and Boston-Maine railroad. One of Ragan's most stunning designs depicts a view from the sky looking down upon Rockefeller Center against the New York cityscape and the Hudson River. This poster was commissioned by the New York Central Line to entice passengers to visit the newly completed Art Deco building and gardens.

The posters created by Charles Matter in Chicago between 1923 and 1929 differ from other Art Deco posters in America as they were not designed to sell a product but to educate, motivate, and inspire workers. It was essential that the posters had a striking visual impact as the literacy of the factory workers was limited. Every poster followed the same format, a

left: *Jean Dupas,* **Establish a picnic and pass the day together,** *lithograph in colors, 1933*

bold headline, followed by a short message and a punchy caption. A clear image in bright colors would then reinforce this message. Matter commissioned Chicago-based artists Willard Frederic Elmes, Frank Beatty, Robert Beebe, and Henry Lee Jr., to create the design and, as he had trained as a copywriter, devised the captions himself. Matter aimed to sell his posters to manufacturers in the United States and in other English-speaking countries, claiming that they would save them time and money and develop morale amongst the workforce. In his successful series of 75 posters produced in 1929 he claimed to have one to correct every negative or ruinous practice in the workplace.

The Art Deco style had spread quickly through both Europe and America as the machine age was increasingly embraced. The posters of the 1920s and 30s were sleek and streamlined and succeeded in introducing many new products to the public. The Art Deco posters produced by Cassandre, Purvis, Hohlwein, and Stoecklin were masterpieces of graphic design, their influence still visible today.

right: *Louis Icart, etching, printed in colors, 1930s*

COLLECTOR'S INFORMATION

COLLECTOR'S TIPS

1 Always buy the best that you can afford. It is better to own one good example of a factory/artist's work than several minor pieces.

2 Ceramics and glass objects are prone to damage, so look for restoration or damage to vulnerable extremities such as heads, fingers, or spouts.

3 Condition is very important when buying glass as this can be difficult to restore. Look for chips that have been filled with plastic resin or internal cracks that have been painted or enameled over.

4 Auctions are a great opportunity to view and handle a wide variety of objects at one time. Auctioneers are always happy to answer queries regarding age and condition. Past auction cataloges can be a great source of reference.

5 When buying bronze and ivory figures be aware that some of the ivory limbs, such as the hands or feet, may have been replaced at a later date.

6 Ceramic and glass vases or bronze figures that have been drilled and altered into lamp bases will be seriously reduced in value. Bright new screws can be a warning sign.

7 When buying posters avoid those that have been stuck or laid down on board. Linen or japan paper backing is the recognized restoration process.

8 When buying furniture check that the piece has not been cut down, for example, legs reduced or top rims removed. Check for marquetry panels that have warped due to extremes of heat and cold.

9 Should an item need repair/restoration, always seek professional advice. The appearance and a value of a piece can be considerably reduced by poor or inadequate restoration.

10 Collectors should buy what appeals to and interests them, rather than simply for investment purposes.

GLOSSARY

Alliance Graphique - The French advertising agency founded by A. M. Cassandre.

American Work Incentive Posters - A series of posters produced between 1923 and 1929 in the United States and designed to educate, motivate, and inspire the workforce.

And Das Plakat - Germany's foremost advertising and poster journal, which regularly promoted the "object poster."

Ariel glass - A variation of Graal glass.

Art Nouveau - European applied arts movement (circa 1880 1910), characterized by organic forms and sinuous lines.

Arts and Crafts - British applied arts movement (circa 1860–1910), which advocated appropriate design and honesty of materials. A significant influence in Germany and America.

Baguette - A form of diamond or precious stone cut that found favor with jewelers in the 1920s and 30s.

Bakelite - An early plastic made of formaldehyde and phenol. Used for many household objects throughout the Art Deco period, from fountain pens to light fittings and radios. Bakelite was developed in numerous bright colors.

Ballet Russe - In 1909 the Ballet Russe arrived in Paris, the company and stage sets were designed by Sergei Diaghilev in brilliant bright colors, causing a riot in fashionable Paris society.

Bas-relief - A type of carving, particularly found in panels and friezes, out of a shallow block and thus in low relief.

Bauhaus - Progressive German Arts and Crafts school (1919–33). The Chicago Bauhaus was established in 1937.

Chromium plated - A thin layer of chromium nickel that was developed as a stainless metallic surface, used as a decorative finish and on household products.

Chryselephantine - A term used to describe sculpture that combined bronze and ivory. This combination was particularly favored in the Art Deco period.

Chintz - Tightly packed design of flowers and foliage. Generally the term is associated with the textile and wallpaper industry or with the transfer-decorated ceramic ware produced in England in the 1930s.

Cire-perdu - A bronze or glass modeling technique where the shape of the object was first modeled in wax. This was then surrounded by a mold from which the wax melted away. The liquid glass or metal was then poured into this vacant space, resulting in a unique casting. Translates in French as "lost wax."

Constructivism - Russian artistic movement closely aligned with both the revolution and the Cubist artistic movement.

Coquille d'oeuf - French term used to describe a decorative surface technique which involved the application of crushed eggshell.

Craquelure - A glaze technique perfected to give a uniform finish of cracked ice, produced with the introduction of water to the glaze, this technique was developed by René Buthaud in the Art Deco period.

Cubism - Movement in French fine art (circa 1907–14), characterized by fragmentation of structural form. Pablo Picasso and Georges Braque were the founders of this movement.

Depression glass - Mass-produced press-molded glassware produced in America during the Art Deco period.

Electroplate - The coating of a base metal, such as pewter, with a thin deposit of silver particles by electrolysis.

Enamel - A hardened colored glass that can be applied to another glass or metal surface in a molten state.

Faience - An earthenware material used since the fifteenth century throughout Europe, covered in a tin glaze.

Fauvism - Movement in French fine art (circa 1905–7), characterized by the use of bold color. Henri Matisse, André Derain, and Maurice de Vlaminck were the leading Fauvist artists.

Femme-Fleur - A term used to describe the Art Nouveau figures found at the turn of the nineteenth century that were typically modeled as maidens emerging/evolving from flowers or plants.

Flambé - A French term for glazes of reduced copper, fired in a kiln rich in carbon monoxide that creates a bluish red glaze effect.

Functionalist - Design determined by practicality and the rational use of materials.

Futurism - Movement in Italian art (circa 1911–14), characterized by a preoccupation with speed and movement. Founded by the poet Tommaso Marinetti, the group included the artists Giacomo Balla and Umberto Boccioni.

Garçonne - Term used to describe the boyish appearance of women in the Art Deco period.

Graal glass - A type of glass developed by the Orrefors glassworks in Sweden, whereby a design was acid-etched into a vessel and then encased in a clear outer layer, the whole being polished to create a soft rounded effect.

Guilds - Small workers' cooperatives set up to pool both resources and information while providing an education to younger craftsmen/designers. Prevalent during the late nineteenth century and played a key role in the British Arts and Crafts movement.

High-fired stoneware - A technique developed by William Howson Taylor at Ruskin pottery, Doulton Lambeth, and Emile Decoeur where kilns are fired up to a tremendous heat in an attempt to recreate Chinese glaze effects.

Joaillerie - Term to describe traditional jewelry that only uses precious stones and metals in its design.

Intercalaire - Glass decorative technique, where the pattern is encased between different layers of glass.

Lacquer - Oriental technique of resilient glossy finish, applied in successive layers to wooden surfaces.

Lacque-burgante - A variation of the lacquer technique that involved the inlay of mother-of-pearl.

Lithography - A method of printing whereby each color of the design is drawn onto a separate section of porous stone. The design is then applied to the paper to create the image.

Minaudière - A form of vanity case that combined the roles of a purse, handbag, and compact. Comes from the French term "minauder" (to simper).

Modernist - Design in the progressive contemporary style, often incorporating the use of new materials and processes.

Mystery clock - Term used to describe clocks that create the illusion that the dials turn independently of any movement, those by Cartier being especially famed.

Niello work - Decorative technique where a thin layer of lacquer is inlaid into a silvered surface.

"Object Poster" or "Sachplakat" - A poster where the object or product advertised occupies the entire image.

Opalescent - Clear glass with a bluish/white tinge, often shading to yellow depending on the direction and strength of light shining on it.

Pâte d'émail - Glass decorating method where an enamel paste is used to fill the open cloisons of a delicate *pâte de verre* vessel and then refired at a low temperature to fuse the two compositions. Pioneered by Albert Dammouse.

Pâte de verre - A type of glass where finely powdered glass particles, metallic oxides, and a binding agent are mixed together into a malleable paste that is then packed into a mold and fired at a specific low temperature.

Pâte de cristal - A translucent, crystalline glass similar in composition to *pâte de verre*.

Peau de serpent - A ceramic glaze effect developed to imitate snakeskin.

Photomontage - A combination of the use of photography and lithography to create an image.

Plafonnier - French term for a bowl-shaped light fitting.

Platinum - A flexible yet resilent metal alternative to gold or silver in the Art Deco period. Silver-gray in color, it was often placed in contrast to black enamel or white diamonds.

Plywood - Synthetic material created from laminated birch, capable of being steam-bent.

Porcelain - A hard-fired ceramic with characteristic translucent body that, when held to the light, appears transparent, regarded as providing the finest quality finish.

Revivalist - Design based on the reproduction of historical precedents.

Rock crystal - A colorless quartz stone of the same family as citrines and amethyst.

Sang de boeuf - Literally ox blood, based on the deep rich Chinese glaze developed in the Ch'ing dynasty.

Shagreen - Shark skin; Oriental technique used as a surface decoration on luxury furnishings.

Spelter - A less expensive metallic body favored by lower quality sculptors in the Art Deco period.

Streamlining - The elimination of extraneous detail to create aerodynamic forms.

Tank-track bracelets - A type of chunky bracelet that was characterised by its large metallic surfaces and man-made appearances.

Traditionalist - Design in the contemporary style, but with an aesthetic and technique established by historical precedents.

Tutti-frutti - Term used to describe jewelry created from colorful combinations of different types of stone and material.

Union des Artistes Modernes - Founded in 1903, the union was set up to promote the Modernist principles and products, including bentwood furniture, glass, and silver.

White jewelry - Term used to describe jewelry formed purely from diamonds.

Wiener Werkstätte - Austrian artistic movement inspired by the British Arts and Crafts movement. Founded in 1903, the main contributors were Josef Hoffmann and Koloman Moser.

MUSEUM ADDRESSES

UNITED STATES

Art Institute of Chicago
Chicago, Illinois

Bass Museum of Art
Miami Beach, Florida

Brookgreen Gardens
(sculpture)
Pawleys Island, South Carolina

Brooklyn Museum of Art
Brooklyn, New York

Chicago Historical Society
Chicago, Illinois

Cincinnati Art Museum
Cincinnati, Ohio

Cleveland Museum of Art
Cleveland, Ohio

Columbia Museum of Art
Columbia, South Carolina

**Cooper-Hewitt National
Design Museum**
New York, New York

Corning Museum of Glass
Corning, New York

Cowan Pottery Museum
(of Rocky River Public Library)
Rocky River, Ohio

Cranbrook Art Museum
Bloomfield Hills, Michigan

Denver Art Museum
Denver, Colorado

Detroit Institute of Arts
Detroit, Michigan

Everson Museum of Art
Syracuse, New York

High Museum of Art
Atlanta, Georgia

Indianapolis Museum of Art
Indianapolis, Indiana

Mattatuck Museum
Waterbury, Connecticut

Metropolitan Museum of Art
New York, New York

Milwaukee Art Museum
Milwaukee, Wisconsin

Minneapolis Institute of Arts
Minneapolis, Minnesota

Museum of the City of New York
New York, New York

Museum of Modern Art
New York, New York

National Museum of American Art
(sculpture)
Smithsonian Institution
Washington, D.C.

Philadelphia Museum of Art
Philadelphia, Pennsylvania

Phoenix Art Museum
Phoenix, Arizona

Queens Museum of Art
Queens, New York

Virginia Museum of Fine Arts
Richmond, Virginia

Western Reserve Historical Society
Cleveland, Ohio

**The Wolfsonian/
Florida International University**
Miami Beach, Florida

EUROPE

Alvar Aalto Museum
Helsinki, Finland

**Brighton Museum and Art
Gallery/The Royal Pavilion**
Brighton, England

British Museum
London, England

Design Museum
London, England

Fondation Le Corbusier
Paris, France

Geffrye Museum
Shoreditch, London, England

Georg Jensen Museum
Copenhagen, Denmark

**MAK – Oesterreichisches Museum
für angewandte Kunst**
Vienna, Austria

Museo Art Nouveau y Art Deco
Salamanca, Spain

Musée Bouilhet-Christofle
Paris, France

Musée des Annees 30
Paris, France

Musée des Art Decoratifs
Palais du Louvre
Paris, France

Musée des Beaux-Arts
Nancy, France

Puiforçat - Orfevre
Paris, France

The Royal Pavilion
Brighton, East Sussex, England

Victoria and Albert Museum
London, England

CHRISTIE'S ADDRESSES

UNITED KINGDOM

Christie, Manson and Woods Ltd

8 King Street
St James's
London
SW1Y 6QT
Tel: (020) 7839 9060
Fax: (020) 7839 1611

Christie's South Kensington

85 Old Brompton Road
London
SW7 3LD
Tel: (020) 7581 7611
Fax: (020) 7321 3321

AUSTRALIA

Christie's Australia Pty. Ltd

1 Darling Street
South Yarra, Melbourne
Victoria 3141
Tel: (613) 9820 4311
Fax: (613) 9820 4876

GREECE

Christie's Hellas Ltd

26 Philellinon Street
10558 Athens
Tel: (301) 324 6900
Fax: (301) 324 6925

HONG KONG

Christie's Hong Kong Ltd.

2203-5 Alexandra House
16-20 Chater Road,
Central Hong Kong
Tel: (852) 2521 5396
Fax: (852) 2845 2646

ISRAEL

Christie's Israel Ltd

Asia House
4 Weizmann Street
Tel Aviv 64239
Tel: (9723) 695 0695
Fax: (9723) 695 2751

ITALY

Christie's (International) S.A.

Palazzo Massimo Lancellotti
Piazza Navona 114
Rome 00186
Tel: (3906) 686 3333
Fax: (3906) 686 3334

MONACO

Christie's Monaco S.A.M.

Park Palace
98000 Monte Carlo
Tel: (377) 97 97 11 00
Fax: (377) 97 97 11 01

THE NETHERLANDS

Christie's Amsterdam B.V.

Cornelis Schuytstraat 57
1071 JG Amsterdam
Tel: (3120) 57 55 255
Fax: (3120) 66 40 899

SINGAPORE

Christie's International

Singapore PTE Ltd
Unit 3, Parklane
Goodwood Park Hotel
22 Scotts Road
Singapore 228221
Tel: (65) 235 3828
Fax: (65) 235 8128

SWITZERLAND

Christies (International) S.A.

8 Place de la Taconnerie
1204 Geneva
Tel: (41 22) 319 17 66
Fax: (41 22) 319 17 67

Christie's (Int.) A.G.

Steinwiesplatz
8032 Zürich
Tel: (411) 268 1010
Fax: (411) 268 1011
Christie's Los Angele

THAILAND

Christie's Auction Co. Ltd.

Unit 138-139 First Floor
The Peninsular Plaza
153 Rajadamri Road
Bangkok 10330
Tel: (662) 652 1097
Fax: (662) 652 1098

USA

Christie's Inc.

20 Rockefeller Plaza
New York
NY 10020
Tel: (212) 636 2000
Fax: (212) 636 2399

Christie's East

219 East 67th Street
New York
NY 10022
Tel: (212) 606 0400
Fax: (212) 737 6076

Christie's Los Angeles

360 North Camden Drive
Beverly Hills
CA 90210
Tel: (310) 385 2600
Fax: (310) 385 9292

SELECT BIBLIOGRAPHY

Adam, Peter, *Eileen Gray: Architect/Designer* (Abrams, 1987).

Arwas, Victor, *Art Deco* (Abrams, 1998).

Arwas, Victor, *Art Deco Sculpture* (St Martin's, 1985).

Arwas, Victor, *The Art of Glass* (Rizzoli, 1997).

Bacri, Clotilde, *Daum: Master of French Decorative Glass* (Rizzoli, 1993).

Bayer, Herbert, *Bauhaus, 1919–1928* (Museum of Modern Art, 1938).

Bayer, Patricia, *Art Deco Architecture* (Thames & Hudson, 1999).

Bayer, Patricia, *Art Deco Interiors* (Thames & Hudson, 1998).

Becker, Vivienne, *Art Nouveau Jewelry* (Thames & Hudson, 1998).

Bentwood and Metal Furniture 1850–1946 (American Federation of Arts, 1987).

Berman, Harold, *Bronzes: Sculptors and Founders, 1800–1930* (Schiffer Publishing, 1994).

Bloch-Dermant, Janine, *G. Argy-Rousseau: Glassware as Art* (Thames & Hudson, 1991).

British Art and Design 1900–1960 (Victoria & Albert Museum, 1983).

Brunhammer, Yvonne, *Art Deco Style* (St Martin's, 1984).

Brunhammer, Yvonne, & Delaporte, Guillemette, *Les Styles des Années 30 a 50* (Paris, 1987).

Camard, Florence, *Ruhlmann: Master of Art Deco* (Thames & Hudson, 1984).

Casey, Andrew, *Susie Cooper Ceramics* (Jazz Publications, 1992).

Catley, Bryan, *Art Deco and Other Figures* (Antique Collectors' Club, 1978).

Cole, Beverley, & Durack, Richard, *Railway Posters, 1923–1947* (Rizzoli, 1992).

Dawes, Nicholas M., *Lalique Glass* (Crown, 1986).

de Guttry, Irene, & Maino, Maria Paola, *Il Mobile Italiano degli Anni Quaranta e Cinquanta* (Editori Laterza, 1992).

de Montry, Anne, & Lepeuve, Françoise, *Les Affiches de Roger Broders* (Syros, 1991).

Decorative Art – The Studio Yearbooks 1930–1939 (London, 1930–1939).

Decorative Arts Yearbooks (The Studio).

Duncan, Alastair, *American Art Deco* (Thames & Hudson, 1999).

Duncan, Alastair, *Art Deco* (Thames & Hudson, 1988).

Duncan, Alastair, *Art Deco Furniture* (Thames & Hudson, 1997).

Duncan, Alastair, *Art Nouveau and Art Deco Lighting* (Simon and Schuster, 1978).

Duncan, Alastair, *The Paris Salons 1895–1914* (Antique Collectors' Club, 1999).

Eatwell, Anne, *Susie Cooper Productions* (Antique Collectors' Club, 1997).

Fiell, Charlotte & Peter, *1000 Chairs* (Taschen, 1998).

Forsyth, Gordon, *20th Century Ceramics* (The Studio Publications, 1936).

Général Officiel Exposition Internationale des Arts Décoratifs et Industriels Modernes, Paris, Avril-Octobre 1925.

Goguel, Solange, *René Herbst* (Paris, 1990).

Green, Oliver, *Underground Art* (Studio Vista, 1990).

Griffin, Leonard, *Taking Tea with Clarice Cliff* (Pavilion, 1996).

Griffin, Leonard, *The Art of Bizarre* (Pavilion, 1999).

Griffin, Leonard, *The Fantastic Flowers of Clarice Cliff* (Abrams, 1999).

Griffin, Leonard, & Meisel, Louis, *Clarice Cliff: The Bizarre Affair* (Abrams, 1994).

Haslam, Malcolm, *Marks and Monograms: The Decorative Arts 1880–1960* (Collins & Brown, 1995).

Hawkins, Jennifer, *The Poole Potteries* (Barrie & Jenkins, 1980).

Hayward, Leslie, & Atterbury, Paul, *Poole Pottery* (Richard Dennis, 1998).

Heller, Steven, & Fili, Louise, *British Modern: Graphic Design between the Wars* (Chronicle Books, 1998).

Heller, Steven, & Fili, Louise, *French Modern: Art Deco Graphic Design* (Chronicle Books, 1997).

Heller, Steven, & Fili, Louise, *German Modern: Graphic Design from Wilhelm to Weimar* (Chronicle Books, 1998).

Heller, Steven, & Fili, Louise, *Italian Art Deco: Graphic Design between the Wars* (Chronicle Books, 1993).

Hillier, Bevis, *The World of Art Deco* (Dutton, 1981).

Industrial Architecture (The Twentieth Century Society, 1994).

Jewellery: Miller's Antiques Checklist, Great Britain (Reed, 1997).

Joel, David, *The Adventure of British Furniture, 1851–1951* (Benn, 1953).

Kjellberg, Pierre, *Le Mobilier du XXe Siècle* (Editions de l'Amateur, 1994).

Klein, Dan, McClelland, Nancy A., & Haslam, Malcolm, *In the Deco Style* (Rizzoli, 1986).

Knowles, Eric, *Miller's Victoriana to Art Deco: A Collector's Guide* (Antique Collectors' Club, 1993).

Krekel-Aalberse, Annelies, *Art Nouveau and Art Deco Silver* (Thames & Hudson, 1989).

Mackay, James, *The Dictionary of Sculptors in Bronze* (Antique Collectors' Club, 1992).

Mannoni, Edith, & Bizot, Chantal, *Mobilier 1900–1925* (C. Massin, 1977).

Marcilhac, Félix, *R. Lalique* (Editions de l'Amateur, 1989).

Margadant, Bruno, *The Swiss Poster, 1900–1983* (Birkhäuser Verlag, 1983).

McCready, Karen, *Art Deco and Modernist Ceramics* (Thames & Hudson, 1995).

Menten, Theodore, *The Art Deco Style in Household Objects, Architecture, Sculpture, Graphics, Jewelry* (Dover, 1972).

The Modern House Revisited (The Twentieth Century Society, 1996).

Morgan, Sarah, *Art Deco: The European Style*.

Mouron, Henri, *A.M. Cassandre* (Rizzoli, 1985).

Neuwirth, Waltraud, *Glass 1905–1925: From Art Nouveau to Art Deco* (Austrian Museum of Applied Art, 1985).

Raulet, Sylvie, *Art Deco Jewelry* (Rizzoli, 1985).

Renwick Gallery, *Georg Jensen Silversmithy* (Smithsonian Institution Press, 1980).

Rutherford, Jessica, & Beddoe, Stella, *Art Nouveau, Art Deco and the Thirties* (The Royal Pavilion, Art Gallery and Museum, Brighton).

Sembach, Klaus-Jurgen, Leuthauser, Gabriele, & Gossel, Peter, *Twentieth Century Furniture Design* (Cologne, 1991).

Silver of a New Era (Museum Boymans van-Beuningen, Rotterdam).

Spencer, Charles, *Erté* (Crown, 1970).

Stevenson, Greg, *Art Deco Ceramics* (Shire Publications, 1999).

The Decorative Arts Society Journal.

The Studio magazine.

Thirties (The Arts Council of Great Britain, 1979).

Uecker, Wolf, *Art Nouveau and Art Deco Lamps and Candlesticks* (Abbeville, 1986).

Vellay, Marc, & Frampton, Kenneth, *Pierre Chareau* (Rizzoli, 1985).

Voge, Peter, *The Complete Rietveld Furniture* (Rotterdam, 1993).

Watkins, Chris, Harvey, William, & Senft, Robert, *Shelley Potteries* (Barrie & Jenkins).

Woodham, Jonathan, *Twentieth-Century Ornament* (Rizzoli, 1990).

Youds, Bryn, *Susie Cooper: An Elegant Affair* (Thames and Hudson, 1996).

Zim, Larry, *The World of Tomorrow* (Harper & Row, 1988).

INDEX

ACKNOWLEDGEMENTS

All the works below are © ADAGP, Paris and DACS, London 2000

Andre-Léon Arbus, *Shagreen and gilt metal day bed, circa 1930s*
Demetre Chiparus, *Fan dancer, gilt and patinated bronze and ivory figure, 1920s; Les Girls, Bronze and ivory figure group, 1920s*
Joseph-Gabriel Argy-Rousseau, *Pâte de verre figure, circa 1928; Pâte de verre glass and bronze table lamp, 1928; Vagues et poissons vase, 1925*
Jean Dunand, *A lacquer panel, circa 1925; Lacquer vase, circa 1925; Lacquer vase, circa 1928; Monumental vase, 1913; Taming the horse, lacquer panel, circa 1935*
Jean Goulden, *Silvered bronze and enamel clock, 1928*
Jean Puiforçat, *Cannes French vermeil service, 1928; Silver and macassar teaset, 1926; Silver and mahogany table lamp, circa 1926; Silver, vermeil and rock crystal teapot, circa 1937*
Jan and Joël Martel, *Composition figure, 1920s*
Louis Icart, *Etching, printed in colours, 1930s*
Raymond Subes, *Wrought-iron hall lights, circa 1933*
René Lalique, *Glass soleil plaffonier, 1926; Glass vase, 1930; A clear and frosted car mascot, 1930s; Selection of glass jewellery, 1930s*
Roger Broders, *Calvi Beach, Corsica 1928*
Charles Schneider, *A selection of cameo glass vases, 1930s*

The following works are DACS © 2000

Ludwig Hohlwein, *Café Odeon, circa 1920*
Markus Daum, *Acid-etched table lamp, 1930s; Selection of acid-etched glass vases, circa 1925*
Ferdinand Preiss, *Lighter than air, bronze and ivory figure of Ada May, circa 1930*
Niklaus Stoecklin, *PRZ lithograph in colours, 1928*
Wilhelm Wagenfeld, *Black nickel-plated metal and glass table lamp, 1928*

© Estate of Eric Ravilious 2000. All rights reserved DACS

Eric Ravilious, *Cut and Etched glass vase for Stuart glass, circa 1934*

© Man Ray Trust/ADAGP, Paris and DACS, London 2000

Man Ray, *Keeps London going, 1939*

© London Transport Museum

Gregory Brown, *The Zoo, 1924*
Man Ray, *Keeps London going, 1939*

All efforts have been made to trace the copyright holders of the works featured in this book. The publisher apologises for any omissions and is happy to rectify this in any future editions.